LIFE IN COLOR

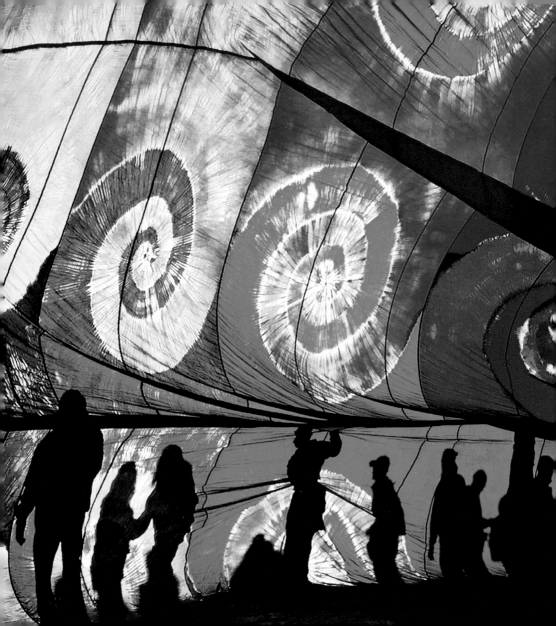

LIFE IN COLOR

NATIONAL GEOGRAPHIC
PHOTOGRAPHS

Foreword by Jonathan Adler

Curated by Annie Griffiths Text by Susan Tyler Hitchcock

NATIONAL GEOGRAPHIC

Washington, D.C.

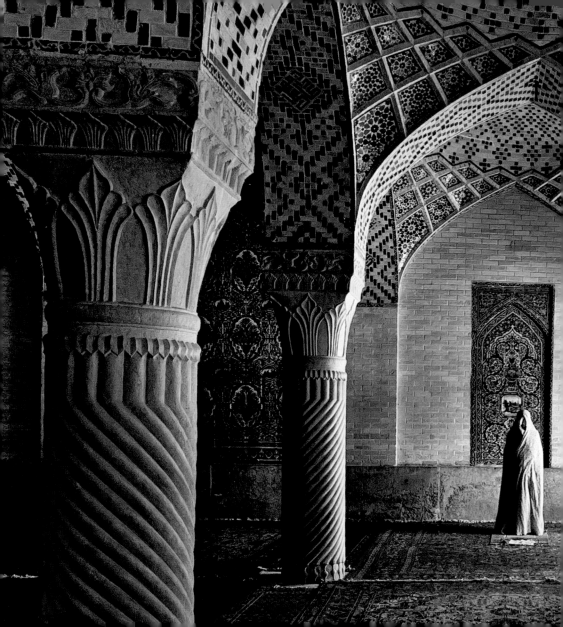

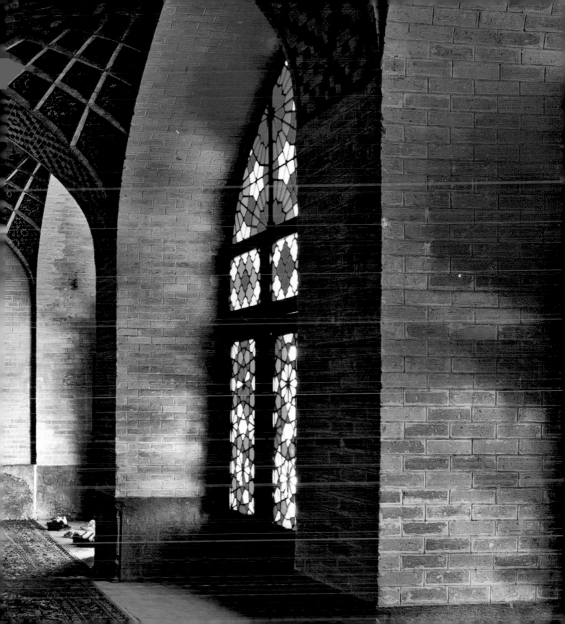

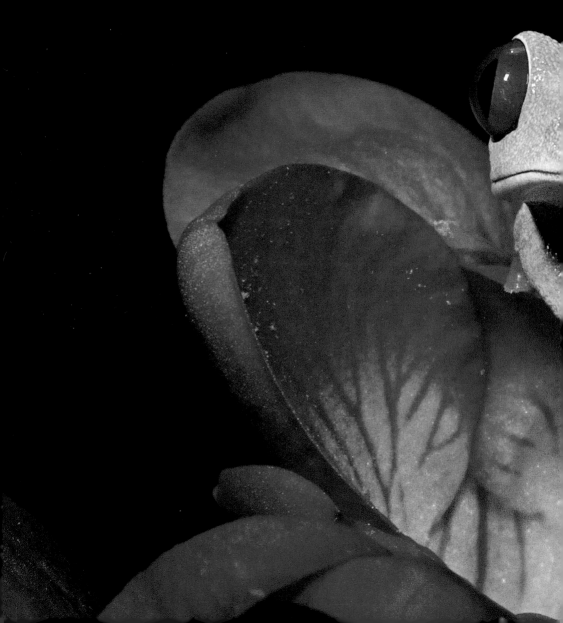

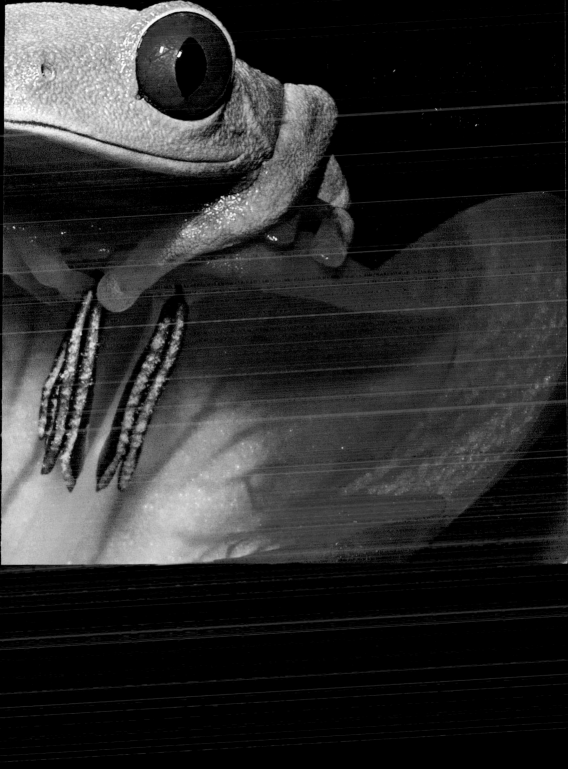

CONTENTS

Yellow	Purple	Red
270	342	416

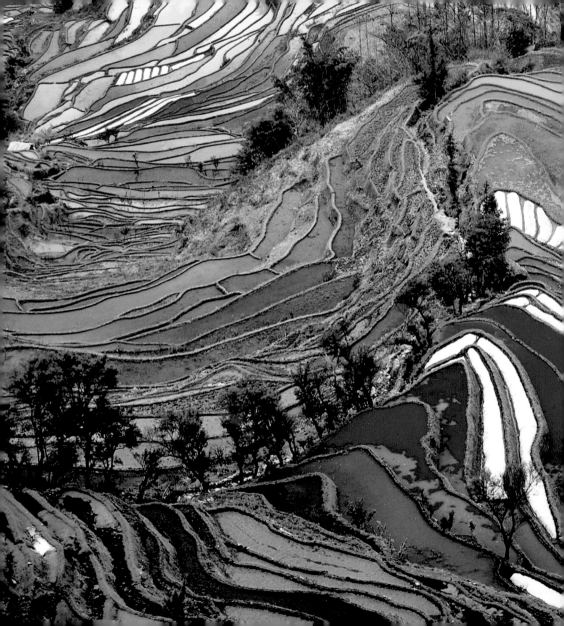

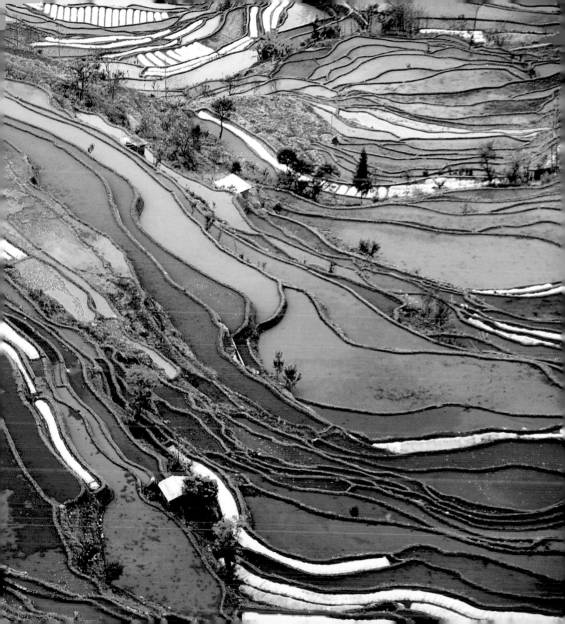

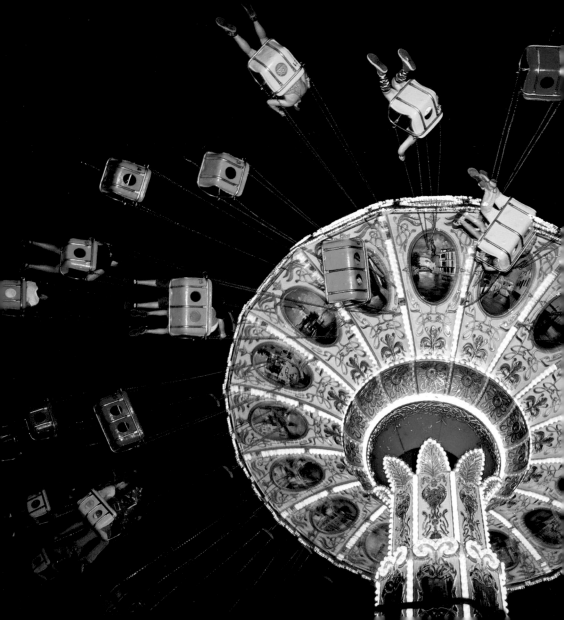

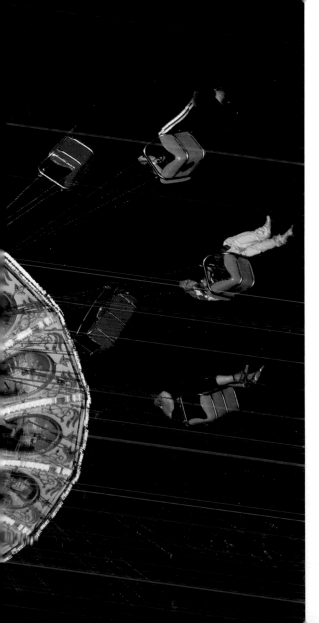

MARIE-MARTHE GAGNON

Ontario, Canada
An amusement park ride twirls
riders round and round.

Preceding pages (2-11)
BRUCE DALE

Albuquerque, New Mexico
People appear as silhouettes through
a translucent hot air balloon.

ROBERTO CATTANI

Shiraz, Iran
A woman in a chador prays in the
Vakil Mosque.

ANGI NELSON

Bristol, United Kingdom
A red-eyed tree frog perches on a
freesia blossom.

THIERRY BORNIER

Yunnan, China
Terraced rice fields create a colorful
mosaic of patterns.

Following pages
MICHAEL MELFORD

Vík, Iceland
A woman runs on the black sand
beach at the surf's edge.

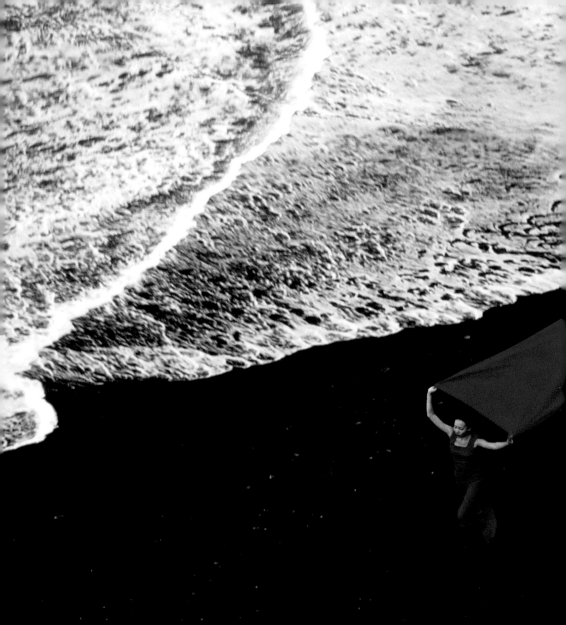

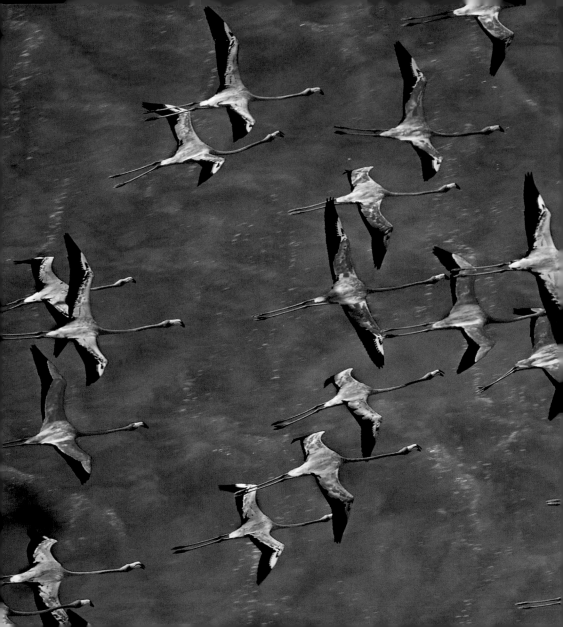

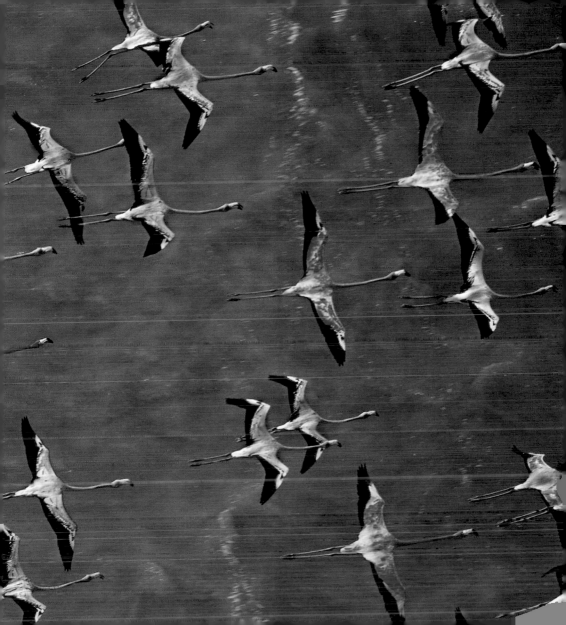

MILES HOLDER

London, England
Blue powder on a young woman's
face enhances her eyes.

Preceding pages
ROBERT B. HAAS

Los Flamencos Natural Park,
Colombia
Flamingos take flight along the
Caribbean coast.

Foreword

Colors have meaning. › Red is a dicey, dangerous color. Red is power, red is lacquer, red is alluring, red is a loaded gun. › Orange is the color of the sun. Orange is happy, orange is joy. Hare Krishnas twirl blissfully in saffron robes. Orange is California. › Blue is the Aegean Sea. Blue is chic. It's American denim, it's universal. Blue is refreshing and cool. › Colors define eras. › I have a synesthetic reaction to colors—for me, time equals vision equals color. Eau de nil (water of the Nile), a dusty blue-green, *is* wartime London. When I see eau de nil I am transported to the lobby of Claridge's Hotel in London with its signature eau de nil china, its melancholy glamour, its stirring portrait of Winston Churchill framed with an eau de nil border. › The muddy browns and burnt oranges of the 1970s perfectly captured our post-Vietnam malaise. Think of a beige Pacer with a brown racing stripe. › The '80s exploded with fluorescent colors—chartreuse, turquoise, fuchsia—that signified a new optimism. New Wave. "Frankie Says" T-shirts. "Wake Me Up Before You Go-Go." Fun. › Then grunge, dirty plaids, the early '90s recession, and the stolid Americana of Martha Stewart celadon. What colors will trigger our future nostalgia? I think that the cultural clutter, the technology overload, the sheer chaos of our time will be reflected in a jagged rainbow of clashing colors. › Colors are places. India is hot pink, Palm Beach is lemon yellow, Belgium is dove gray, Capri is turquoise, Tangier is tangerine, and Madrid is blood red. › Our relationships to colors change constantly. Had you asked me a couple of years ago how I felt about teal I would have gagged. Teal! How

could I possibly like teal, the color of airbrushed Nagel posters, the color of aerobics? I would have announced that I would never ever, *ever* use teal in my work or wear it or even think about it again. 🙠 But at this moment, as I am writing this sizzling foreword, I'm sitting in a teal room on a teal chair sipping out of a teal-colored mug and wearing a teal jumpsuit. What changed? Culture changed. The '80s started to look great, skinny jeans came back, and teal started to look just right. 🙠 Color is the lingua franca of the design world, a room's hue announces its mood. If I want a room to feel edgy I can always rely on good old black and white. A WASPy Chic vibe? Pink and green. For a louche Rich Hippie lair I turn to deep purple. 🙠 As a designer I strive to create objects and environments that are (I hope!) beautiful and uplifting. The message of my work as a designer is that your home, your environment, should bring you pleasure. Sometimes I feel like a doctor dispensing drugs for my patients' homes. I believe that happy hues are more effective than Prozac. 🙠 Colors ignite your senses, so prepare for sensory overload. The photographs in this book explode off the page; the saturated images will make you feel like you're there. Keep it on your coffee table and feel alive. Surrender to these photographs and go on a whirlwind tour of the world.

~ Jonathan Adler

Potter and designer

New York, New York

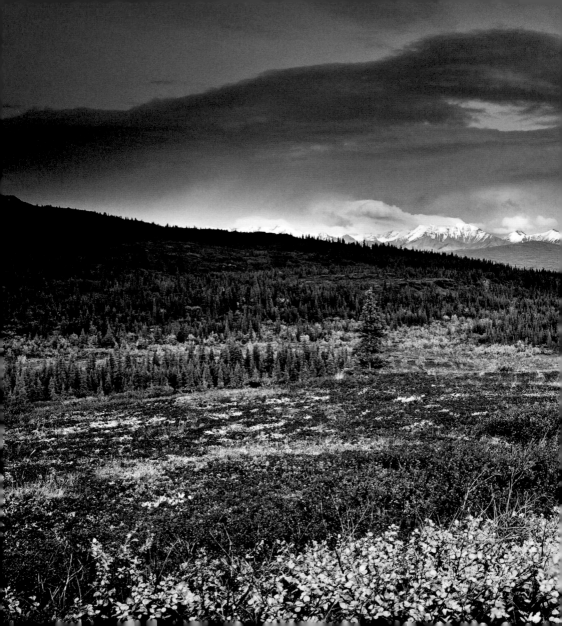

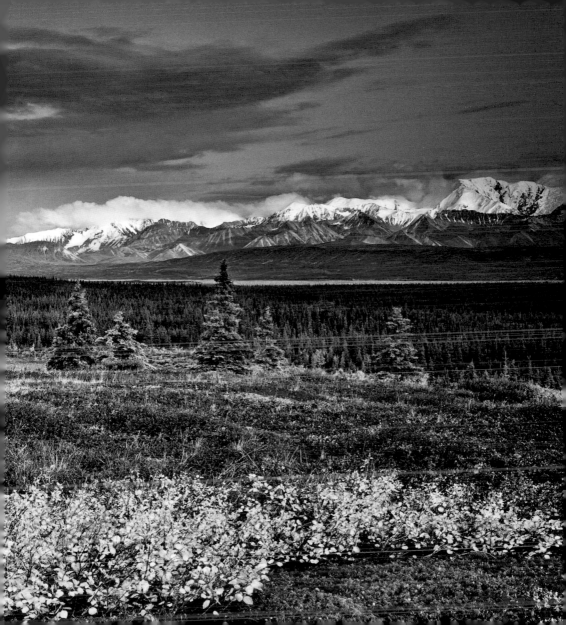

ANNIE GRIFFITHS

Cape Town, South Africa
Colorful homes line a street in South
Africa's capital city.

Preceding pages

ALASKA STOCK IMAGES

Denali National Park, Alaska
Alpenglow at sunset illuminates the
horizon and alpine tundra.

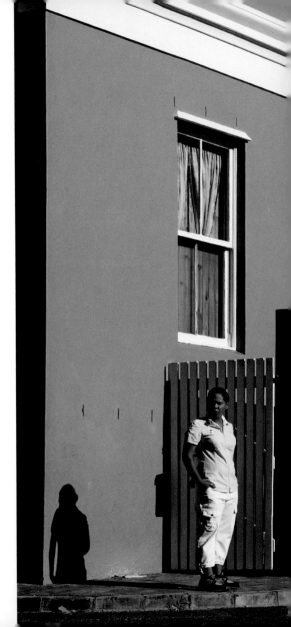

Introduction

We gaze out at a vast and ever changing kaleidoscope—life in color—every day. From the filmy pastels of a dream disappearing to the loud shocks of traffic lights, billboards, and fashion, color saturates our existence. Not only is color everywhere around us, but it is also in our minds and imaginations as well, an internal rainbow of appearances and meaning. ↝ Color moves and motivates. Color calms and quiets. Color sings, color dances, color takes center stage in the theater of our lives. It is so woven into the fabric of our speech and vision, choice and circumstance that we rarely stop to pay attention. ↝ Think about how the hazy blue of early morning street fog compares with the clear blue of a summer sky; how a still lake's surface, despite all logic, takes on the orange of the setting sun; how green dapples and drenches our world, from the tiny new leaves of wildflowers underfoot to the electric nighttime swaths of the northern lights overhead. Realize how red makes a statement—sometimes it whispers, like the spotted carapace of a tiny ladybug; sometimes it flaunts itself, like bright lipstick on a proud woman's smile. ↝ Photographers do notice. In the litany of principles that make a photograph great, color stands near the top of the list, at the service of both content and design. A photographer may look for color with care and attention, or color may burst on the scene as a serendipitous surprise. Either way, it stands as a primary character in many a great photograph. ↝ Colors speak directly to our hearts, without words and in many cases without meaning. Although scientists can second-guess the evolutionary advantage of certain patterns and colors within the

natural world, many examples seem to defy explanation. What is a dandelion flower saying with its yellow? What do the ruby red throat feathers of a hummingbird signify? There is something primeval and sensuous in paying attention to color. It is a celebration of the native senses without the filter of the intellect.　❧　And yet in our obsessively human way, nations, cultures, and traditions have made certain shades symbolic, layering meaning on top of impression.　❧　Some of those meanings may arise from biology, from the actual interaction of a color and the eyes and brain perceiving it. Colors are produced by light waves of different wavelengths, and those energetic differences likely trigger differing responses in the brain. Some say blue calms while red excites, for example —and in fact, some organizations have put those findings into action. Municipalities in Scotland and Japan installed blue lights in public spaces to discourage violent crime, highway speeding, and suicide.　❧　Those who study the psychology of color have an uphill struggle in separating out all the deeply held cultural connotations. Human beings carry some of these associations so strongly that they feel innate, but, in fact, many of the meanings assigned to colors turn out to be quite arbitrary, as shown by the contradictory symbolisms assigned by different traditions.　❧　Take red, for example, perhaps the most multivalent color in the world. Red has the longest wavelength visible to the human eye. Some evolutionary biologists believe that primates developed sensitivity to red for purposes of mating: The males who saw the red backside of a female in heat were more likely to procreate successfully.　❧　Cultural traditions still link red to mating behavior. It signals purity in India, and there as well as in China and

Japan, brides wear red. In the West, though, a red bridal gown would be anathema—worn by a strumpet rather than a virginal bride, red still indicates sexual potential. ᔕ Red gets even more complicated. In parts of Africa, red is the color of mourning. Yet elsewhere in the world, red signifies heroism and pride, so much so that people of many nationalities salute a flag that is primarily red. Political interpretations carry red in different directions: In Soviet Russia, red meant communist; in 21st-century United States, red means conservative. ᔕ In short, human beings have valued colors for centuries and for many different reasons. Many a quest has been driven by this universal passion—and many a person's health and livelihood sacrificed, too, as chronicled by history's amazing array of stories about painters, dyers, and other craftspeople in search of colors. ᔕ Ocher—iron-rich stone or clay—was the first pigment derived from nature. Clay or rock of yellow, red, or brown, literally earth colors, was ground to a powder, used like chalk, or even combined with other materials, including bone marrow. Ocher is the color we see on the walls of the caves at Lascaux and Chauvet and in the aboriginal artwork of Australia. ᔕ Humans have gone to great lengths to mine, gather, harvest, and process colors. One of the oldest processed dyes, Tyrian purple, comes from the gland of Mediterranean sea snails. Thousands of snails had to be collected to dye a single robe; hence, the color was reserved for those of wealth and power: royal purple. ᔕ Brilliant blue lapis lazuli has been mined in Afghanistan since ancient times; made from ground stone, the pigment was so rare and costly in the Renaissance that painters used it only to color the cloak of the Virgin Mary. ᔕ When Hernán

Cortés conquered the Aztec, one highly prized ransom was insects: the cochineal beetles raised on cactus plants and processed for an intense and colorfast dye. Estimates suggest it took 70,000 insects to make a pound of dye. European monarchs soon flaunted fashion colored with this "perfect red." ॐ Deep Indian yellow had been a European favorite for centuries, despite the pigment's offensive odor. When 19th-century investigators went to India to find out how it was processed, they discovered that the deep yellow pigment was from the dried urine of cows fed nothing but mango leaves and water. It was an inhumane practice that starved the cows, and the industry was banned by the 20th century. By then, synthetic pigments had been engineered that came close to replicating Indian yellow, cochineal red, lapis blue, and murex purple. ॐ Today, we take color for granted. We expect clothing in every color of the rainbow and wall paint in hundreds of shades. In a world so inundated by colors, how do we refresh our vision? How do we regain that ancient sense that every pigment, every shade is rare and precious, even if it is no longer manufactured through the tedious labor of many hands? ॐ We turn to our finest photographers. ॐ Here is your chance to revel in color, to pause and cherish each nuance, each variation in the spectrum that brightens our world. From the legendary National Geographic archive of photographic images—some dating back decades and others made just months ago—we present a collection of pictures carefully chosen, each one in its own way displaying the power of color. We hope you'll spend many hours paging through this book, enjoying each picture for its own personality—and then look out into your world, seeing its many colors in a new light.

BLUE

Blue is true, blue is clear,
blue is uninterrupted.
We gaze out into the heavens;
we gaze down into
the depths of the sea.

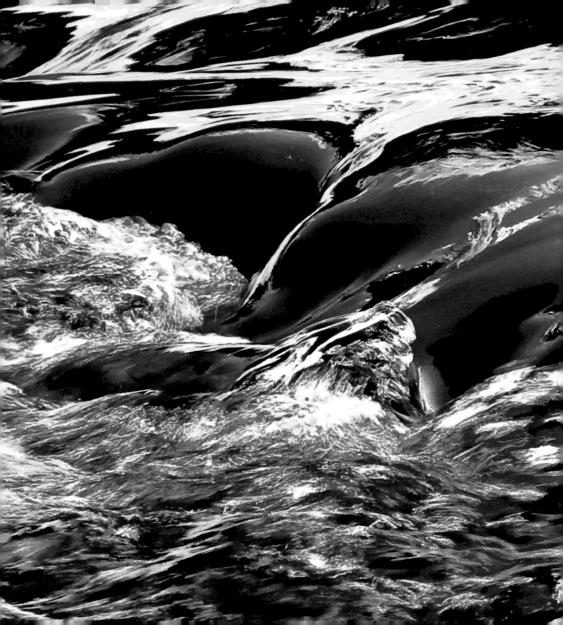

Blue

We gaze on blue every day of our lives. If the sky isn't blue, we imagine it to be. Blue is true, blue is clear, blue is uninterrupted. We gaze out into the heavens; we gaze down into the depths of the sea. Both become nature's truest mirrors into which we gaze to meditate upon eternity and our own inner being. Blue breathes slowly, deeply. It calms and caresses the eyes. ❧ Ancients connected blue with the chakra of the throat, through which communication and art emanate. In a surge of blue, meaning sings, a sky without cloud cover: no obstructions between heart and words, between inward feeling and outward expression. ❧ Such clarity does not always guarantee pleasure. Gazing far out past the horizon, we may see sadness, conflict, grief. Sensing the full range of the human condition, the songs we sing modulate to encompass it all, the beauty and the sorrow, the fierceness and the tragedy. ❧ There are blues considered sacred in every religion, from the quiet cobalt of a virgin mother's cloak to the electric cerulean of a dancing god's skin; from the pure turquoise of a mosque's tilework to the healing gaze of the Medicine Buddha, enlightenment blue. These blues are beyond human, near divine, envisioned by wise prophets and artists, made to signify a state we humans reach for but may not attain. ❧ Today such ramblings may seem superstition to some. But in our modern way, we have discovered another heavenly blue secret: When we move far enough away—when we distance ourselves, body and soul, and gaze homeward to see our one living planet as it spins in space—we recognize that the planet Earth is blue.

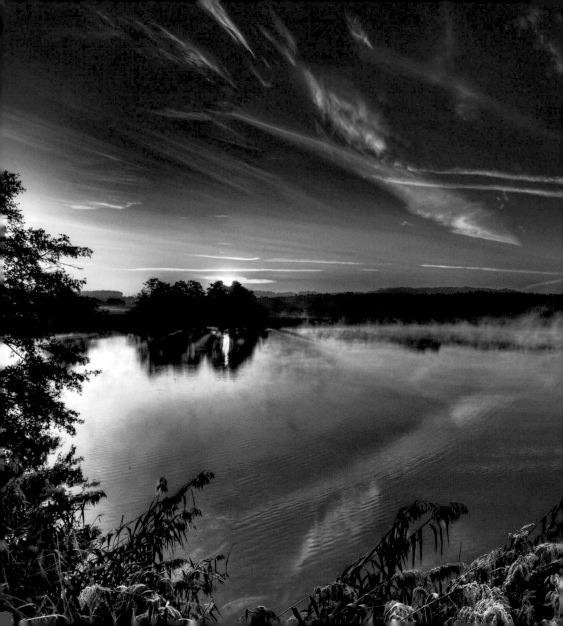

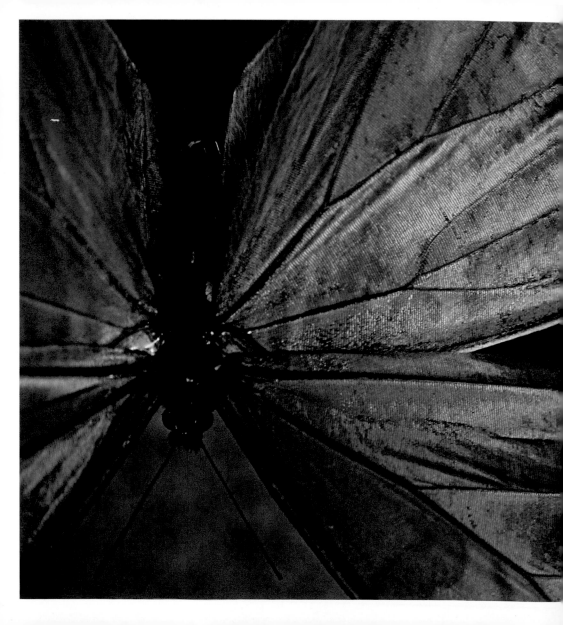

CARY WOLINSKY

Norwell, Massachusetts
Wings of a blue morpho butterfly
shimmer with metallic iridescence.

Preceding pages (32-35)
CRAIG BOGDEN

Goodrich-Loomis Conservation
Area, Brighton, Ontario
Blue-hued water flows over rocks in
a cold-water stream.

MARC HOFER

Seedorf, Switzerland
Mist rises from a lake ringed with
autumn colors.

Following pages
JAMES L. AMOS

Eisenach, Germany
A Bible sits open on a table in a
dimly lit room of Wartburg Castle.

ZORAN DJEKIC

Amager Beach, Denmark
Still waters lit by sunset surround
three boulders.

I will try to cram these
paragraphs full of facts
and give them a weight
and shape no greater than
that of a cloud of blue
butterflies.

~ Brendan Gill

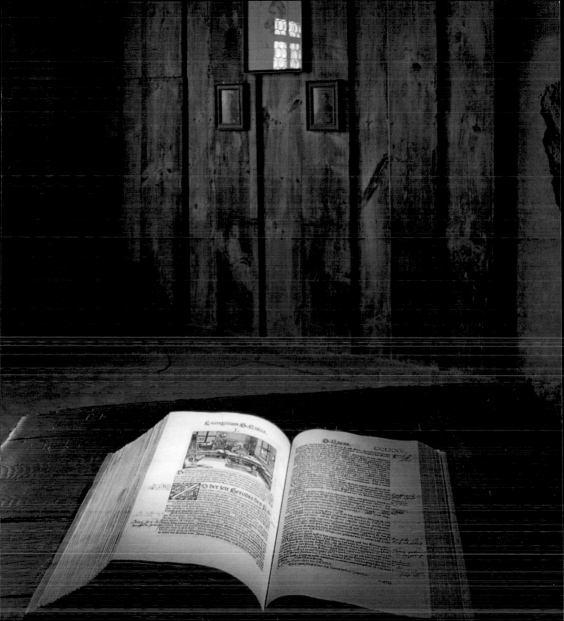

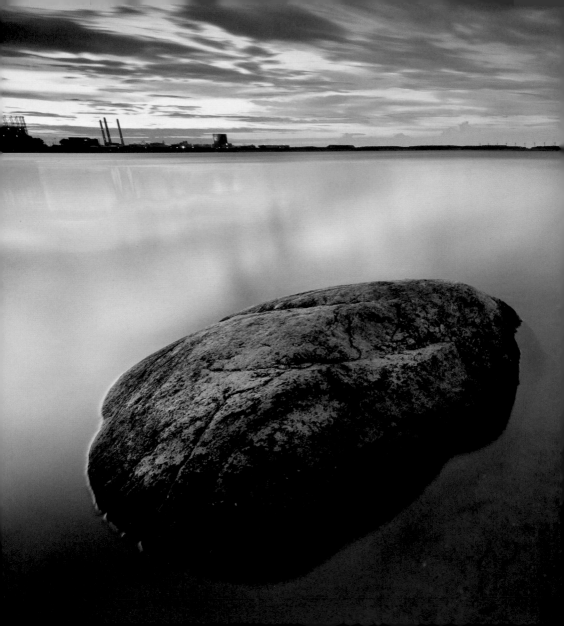

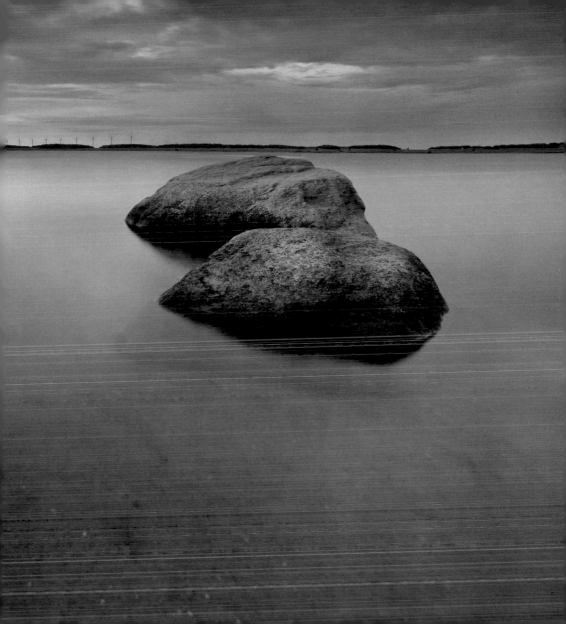

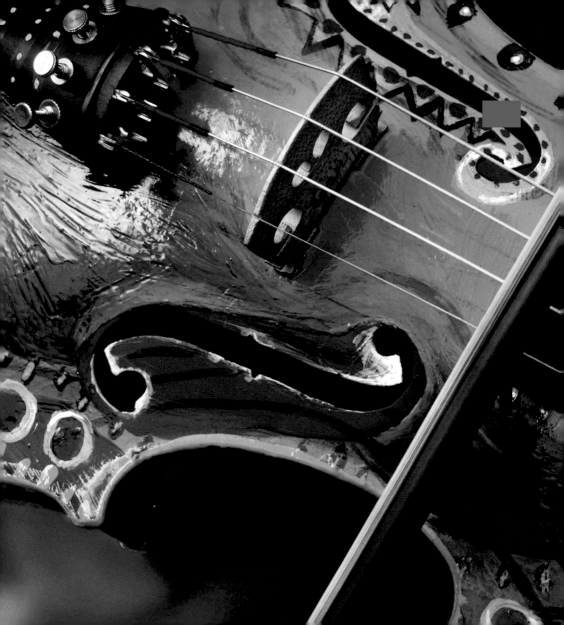

AMY WHITE AND AL PETTEWAY

Asheville, North Carolina
A bow draws a tune from the
strings of a painted violin.

THIERRY BORNIER

Hunan Province, China
Fog envelops a small lake and boat
early one morning.

Following pages

DAVID DOUBILET

Indonesia, Pacific Ocean
A translucent goby rests atop
a giant clam in the ocean.

DAVID DOUBILET

St. John Island, Virgin Islands
A hibiscus blossom floats on
turquoise waters.

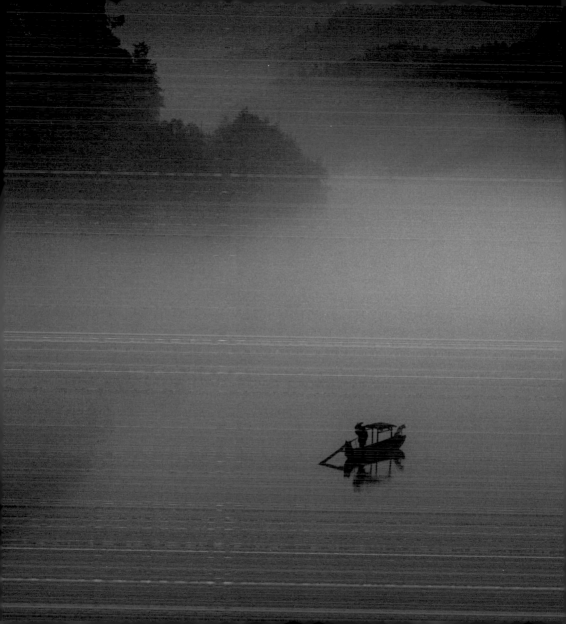

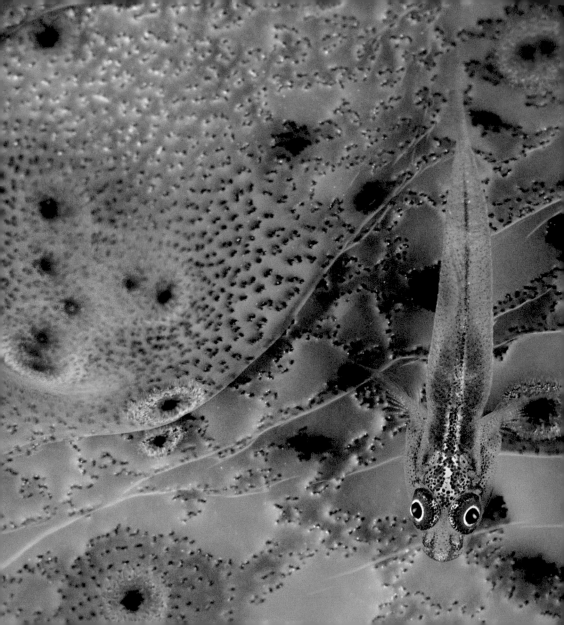

There is no blue

without yellow and

without orange.

~ Vincent van Gogh

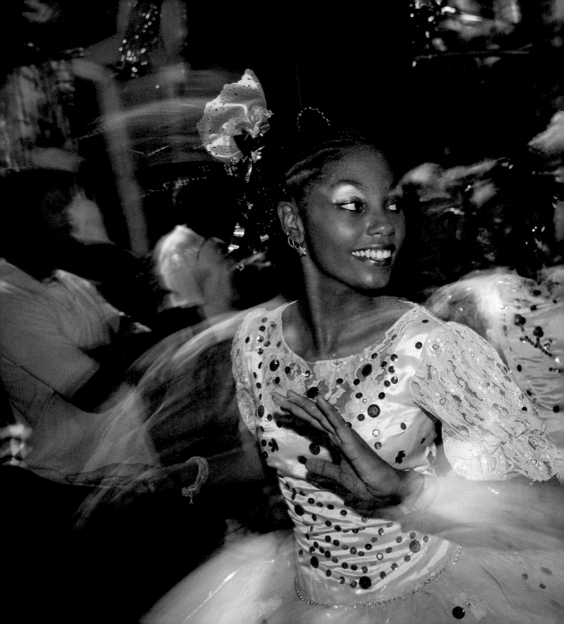

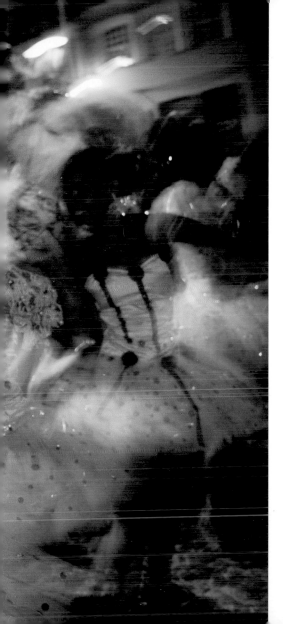

DAVID ALAN HARVEY

Salvador, Brazil
Painted dancers sizzle in Brazil's
Carnival street parade.

Following pages
DOUG OTTO

Point Lobos State Natural Reserve,
Carmel, California
Illuminated by the setting sun,
waves tumble ashore on a coastline.

LUIS MIGUEL CORTES

Sipadan, Malaysia
A green turtle floats in protected
waters near the oceanic island.

TINO SORIANO

Kimberley, South Africa
On a rainy day, a train awaits
passengers at Kimberley Station.

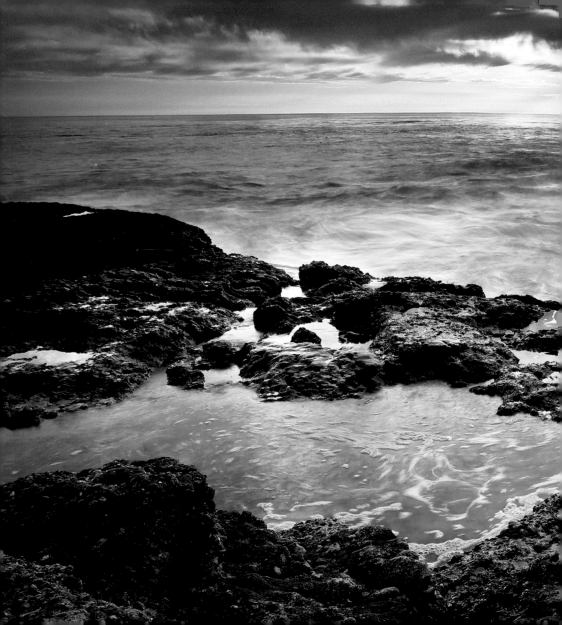

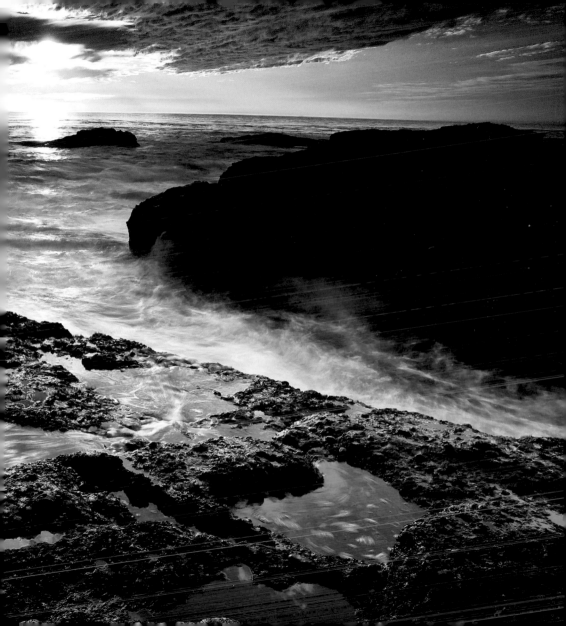

As we readily follow an

agreeable object that flies from us,

so we love to contemplate blue,

not because it advances to us,

but because it draws us after it.

~ Johann Wolfgang von Goethe

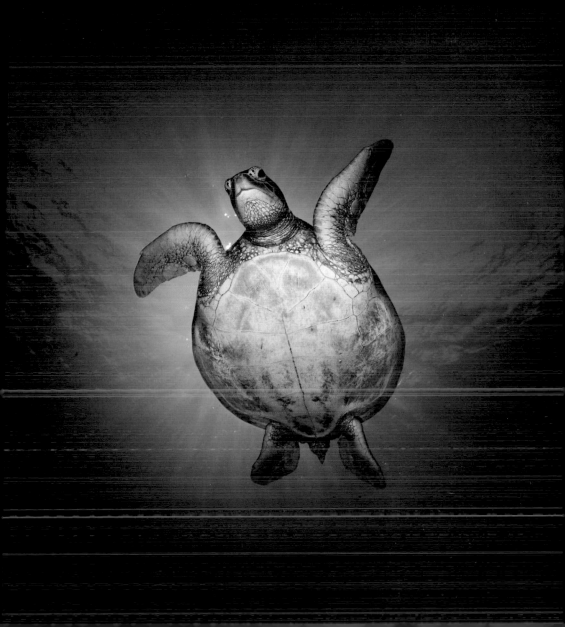

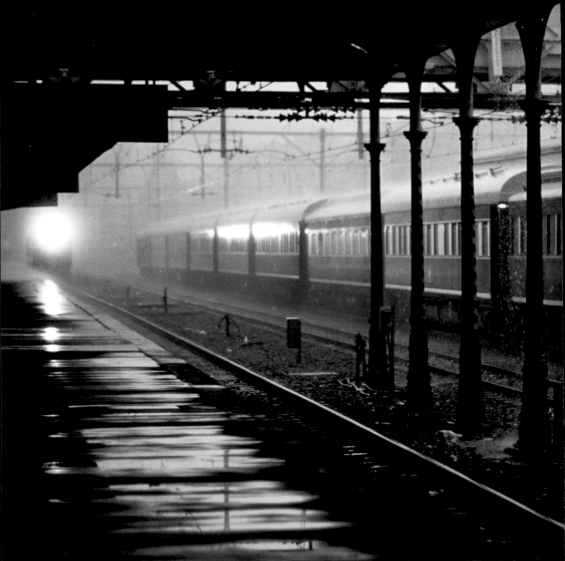

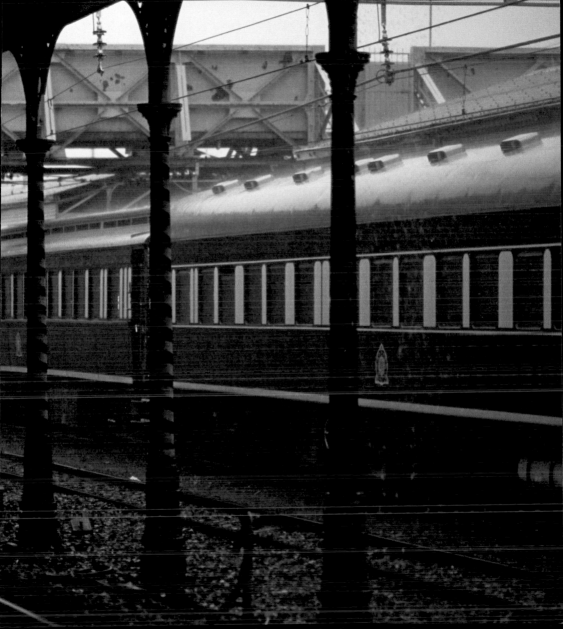

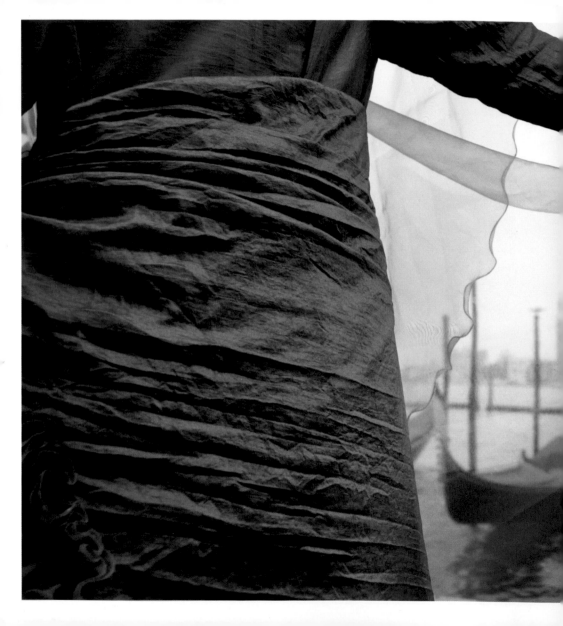

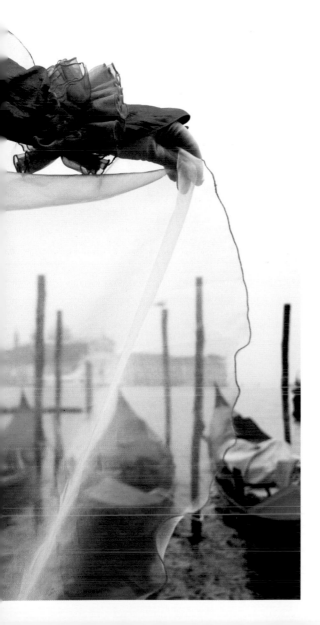

JODI COBB

Venice, Italy
A tourist unfurls a gauzy blue veil
near San Marco Basin.

Following pages
ANNIE GRIFFITHS

Chefchaouen, Morocco
Whitewashed houses with blue
accents typify the Moroccan town.

Colour is the place
where our brain
and the universe meet.

~ PAUL CÉZANNE

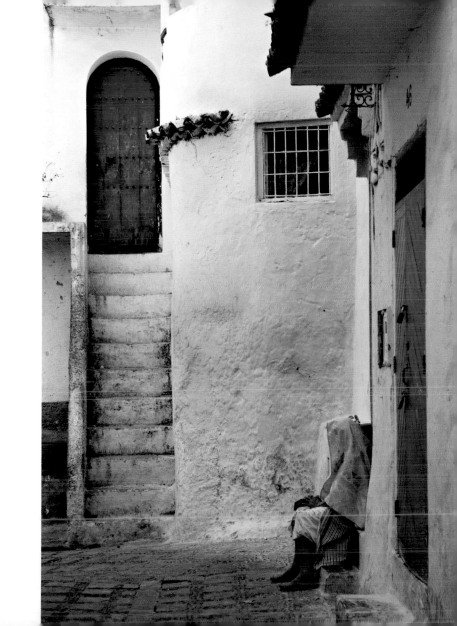

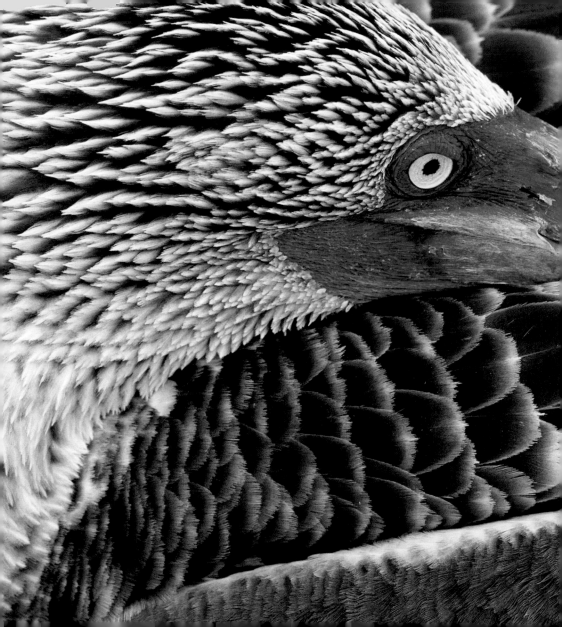

MATTIAS KLUM

Galápagos Islands, Ecuador
A blue-footed booby grooms its
dun-colored feathers.

MARC BOSSE

Sanguinet Lake, France
A lone tree takes root in a spot
of earth in the French lake.

Following pages
OLIVIER GRUNEWALD

East Java, Indonesia
A blue flame of burning sulfur glows
at Kawah Ijen volcano.

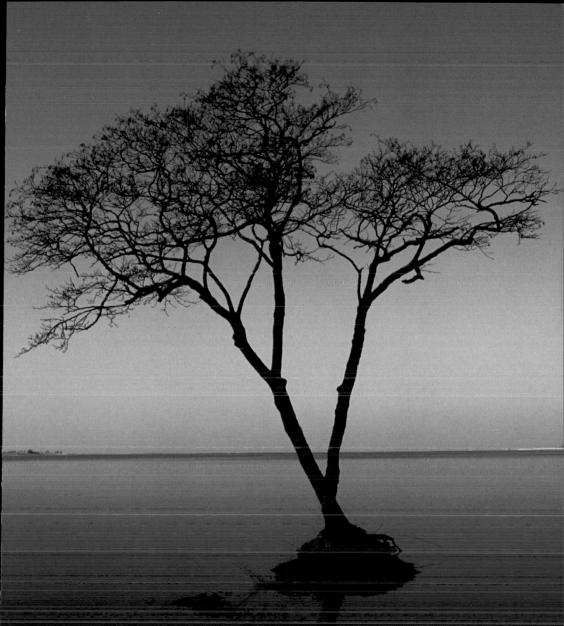

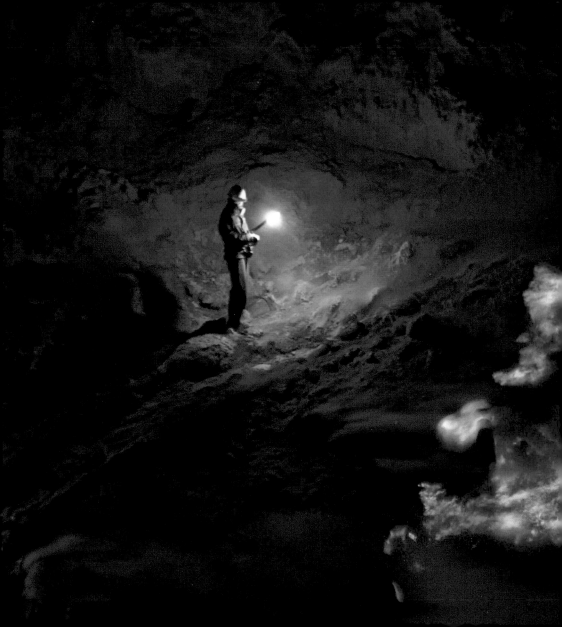

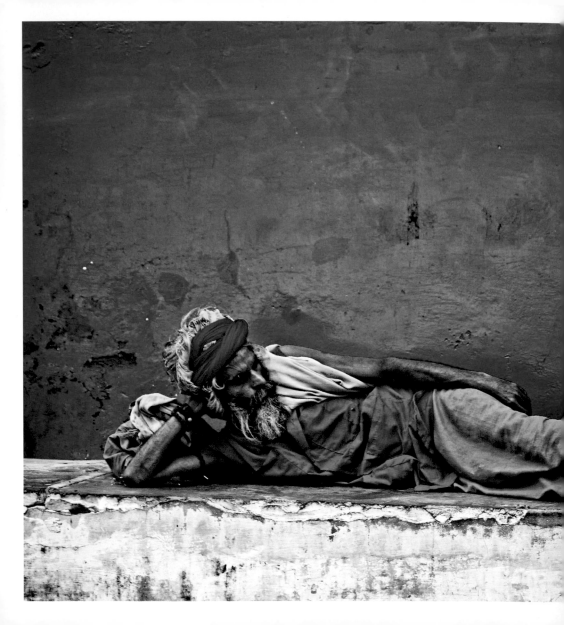

QUENTIN MICHALSKA

Pushkar, India

A Sikh dressed in colorful garb rests near a bright blue wall.

Following pages

CARI REID

Southport, England

A close-up of a soap bubble reveals a kaleidoscope of color.

TUNC YAVUZDOGAN

Sipadan, Malaysia

A cuttlefish glows blue against an underwater background.

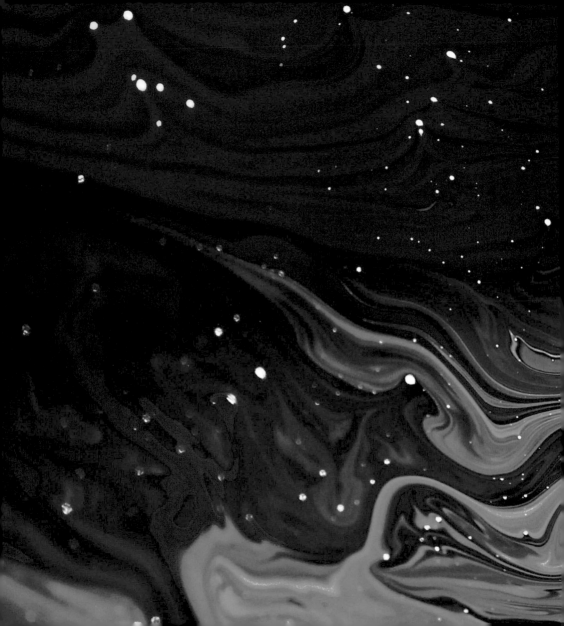

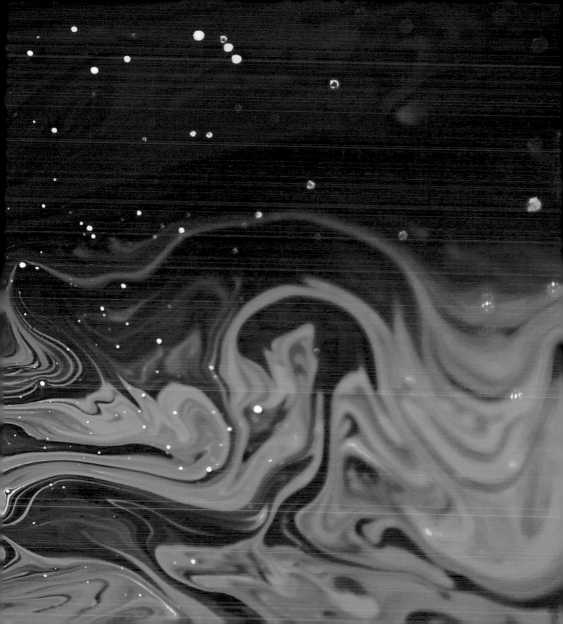

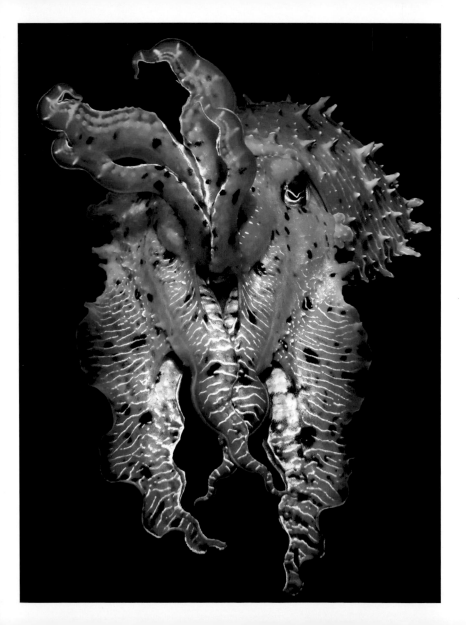

It is strange how deeply

colors seem to penetrate one,

like scent,

~ GEORGE ELIOT

ALEX WEBB

Comitán, Mexico
In the dark of night, a patron leaves
a bar in the red-light district.

Following pages
JASON EDWARDS

Melbourne, Australia
An airborne sign writer expresses an
apology in the sky.

TIFFANY AND DAVE DUSTAN

Jungle Cat World Wildlife Park,
Orono, Ontario
A cougar cub warms hearts at the
Canadian nature park.

Oh! "darkly, deeply,
beautifully blue,"

As someone somewhere

sings about the sky.

~ LORD BYRON

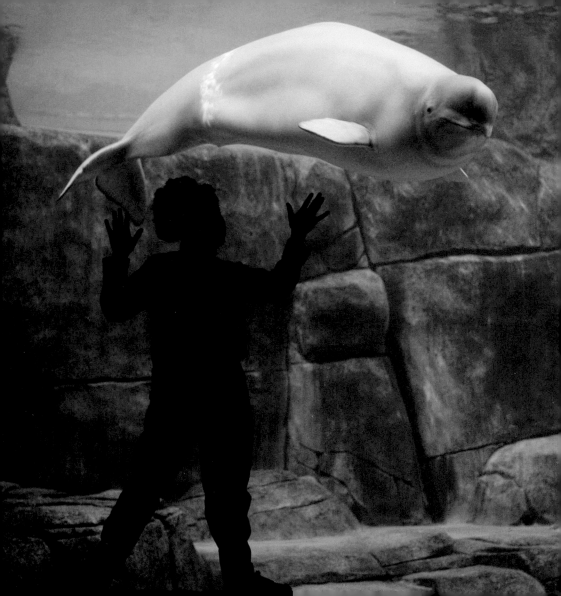

ANNIE GRIFFITHS

Vancouver Aquarium, Vancouver,
British Columbia
A youngster interacts with a beluga
whale at the aquarium.

Following pages
JAMES L. STANFIELD

Segovia, Spain
A Roman aqueduct seems to come
alive at twilight.

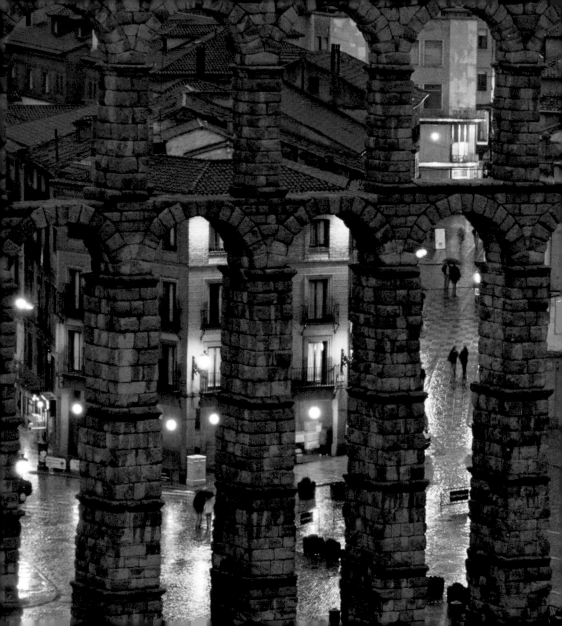

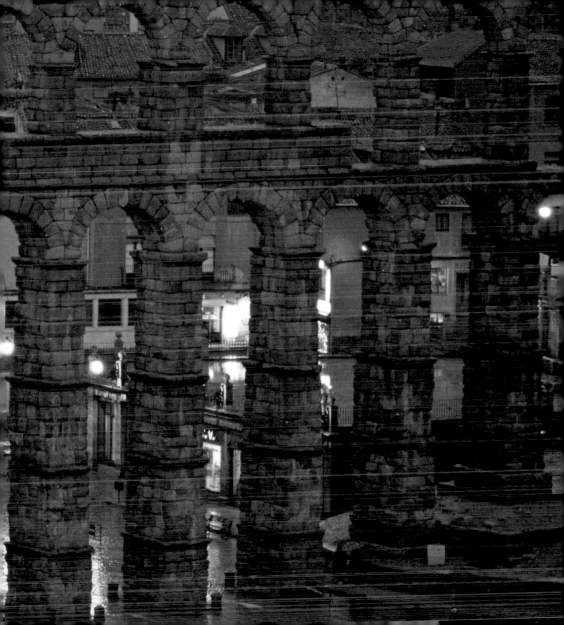

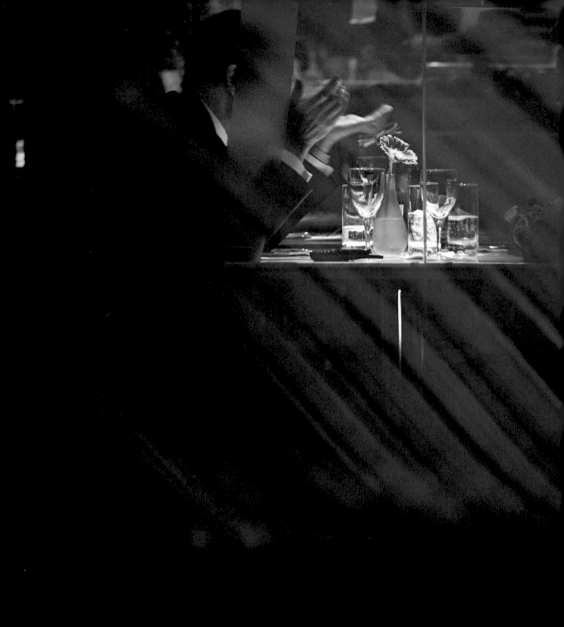

JUSTIN GUARIGLIA

Hong Kong

Two men conduct business at a
table decorated with a red flower.

Following pages

KAREN KASMAUSKI

Mount Fuji, Japan

Two hikers in traditional dress make
their way through a fog.

Blue oblivion,

largely lit,

smiled and smiled

at me.

~ WILLIAM R. BENÉT

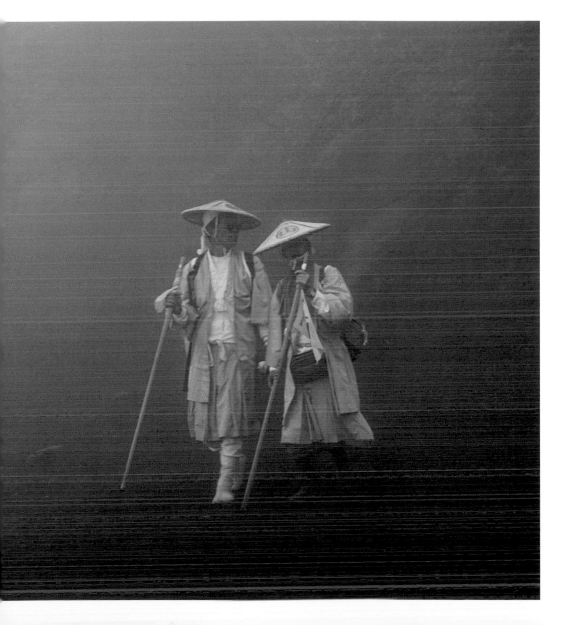

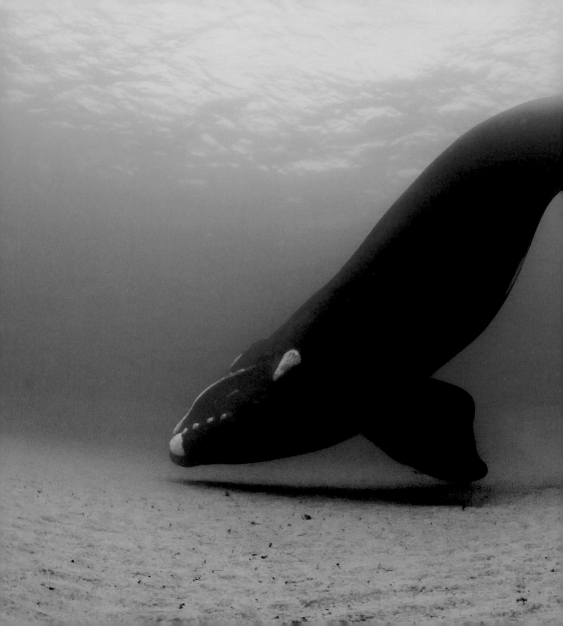

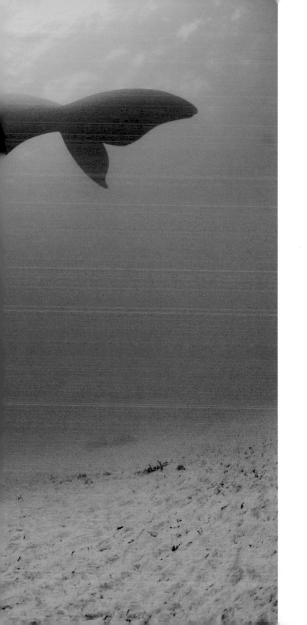

BRIAN J. SKERRY

Auckland Islands, New Zealand
A southern right whale hovers
inches above the sandy seafloor.

VALDRIN XHEMAJ

Donje Ljubinje, Kosovo
According to custom, a bride's face
is painted to ward off bad luck.

Following pages
ANNIE GRIFFITHS

Great Barrier Reef, Australia
An aerial view reveals a sandbar in
the watery national park.

WES SKILES

Andros, Bahamas
Divers use flashlights to illuminate
the underwater Stargate Blue Hole.

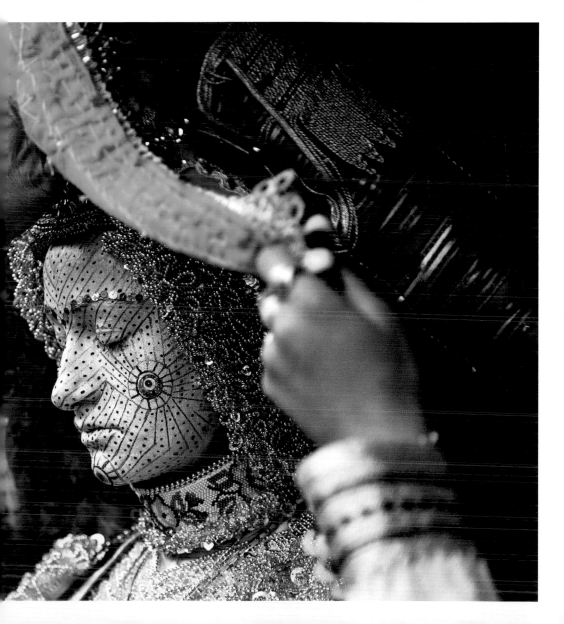

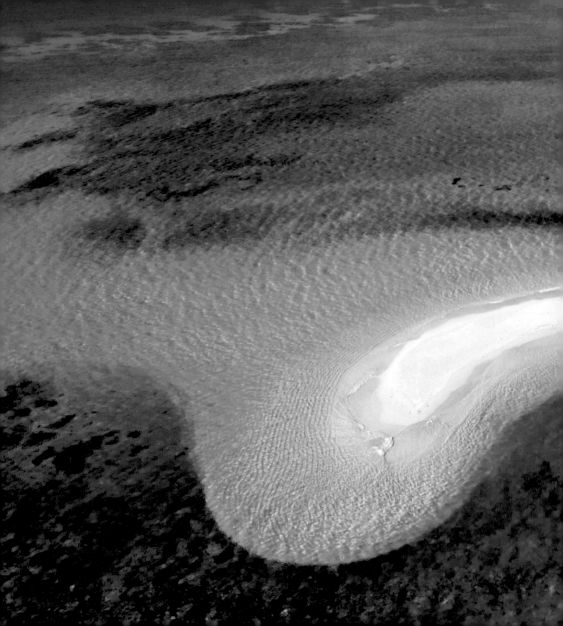

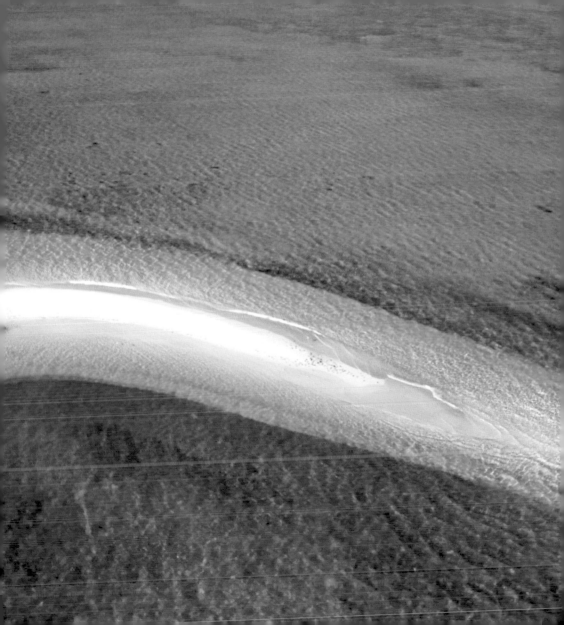

Much effort has gone into looking for life elsewhere in the solar system and beyond, always preceded by the question:

Where's the water?

With water, there could be life;

no blue, no life.

~ Sylvia Earle

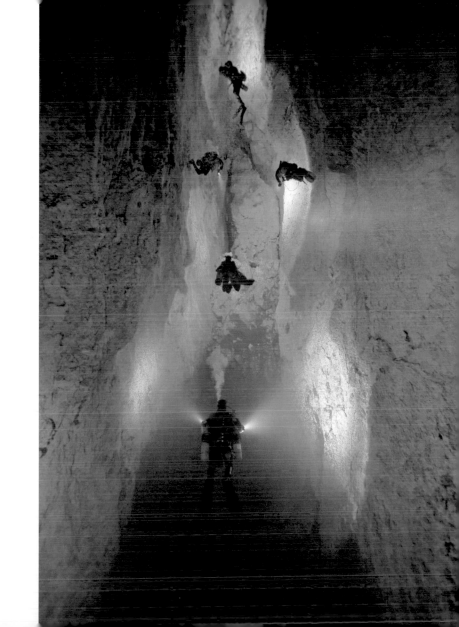

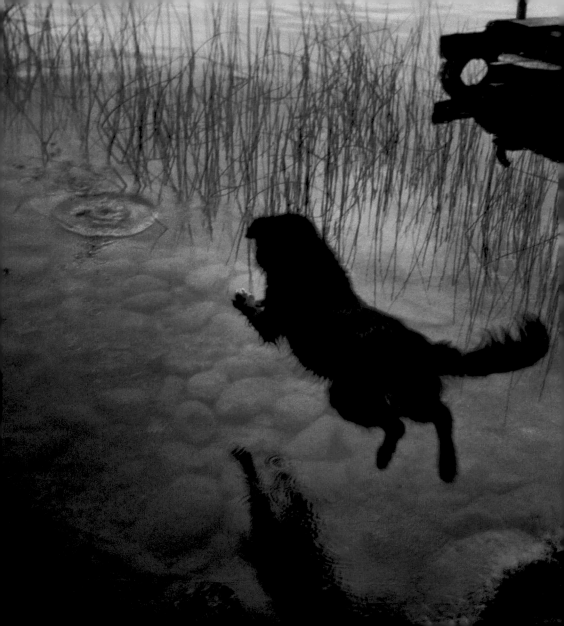

TINO SORIANO

Lake Banyoles, Girona, Spain
A dog jumps into the clear waters
of the Spanish lake.

Following pages
DAVID BURTON

McMinnville, Oregon
Frost in a swirling pattern decorates
the hood of a car.

KATE TURNER AND TOM GIBSON

Butterflies surround the whitened
face of an Asian woman.

JOEL SARTORE

Conasauga River, Tennessee
The bright blue color of a five-lined
skink's tail fades with time.

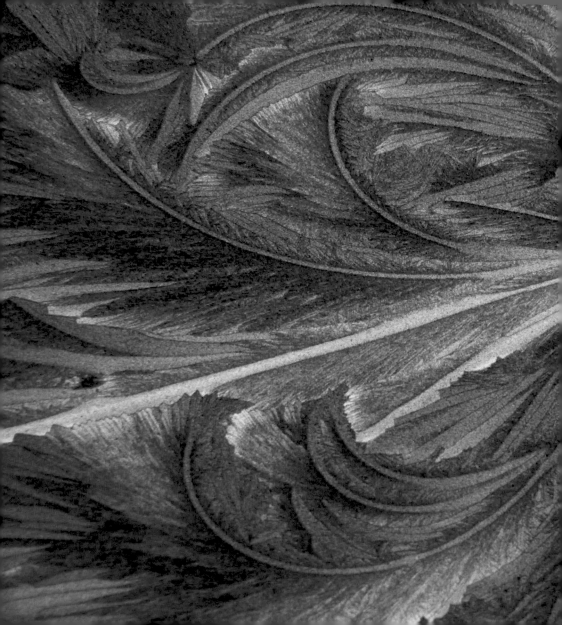

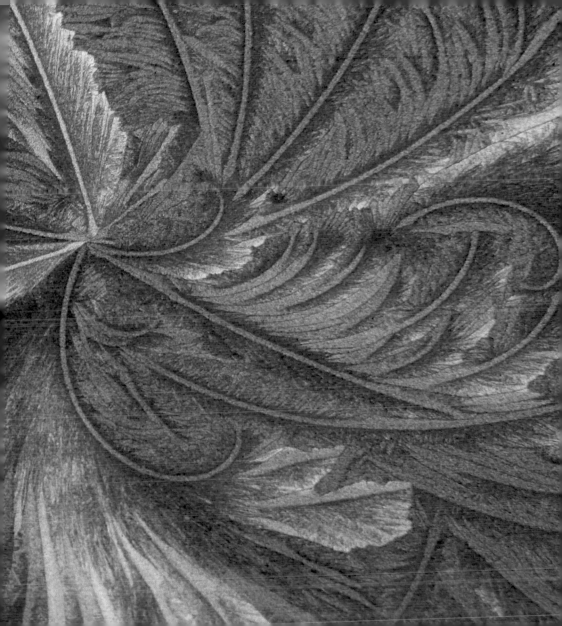

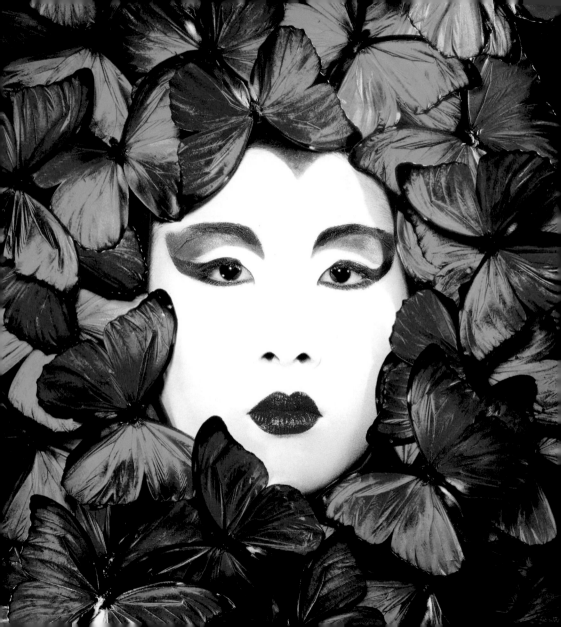

I cannot pretend to feel impartial

about the colours.

I rejoice with the

brilliant ones,

and am genuinely sorry

for the poor browns.

~ WINSTON CHURCHILL

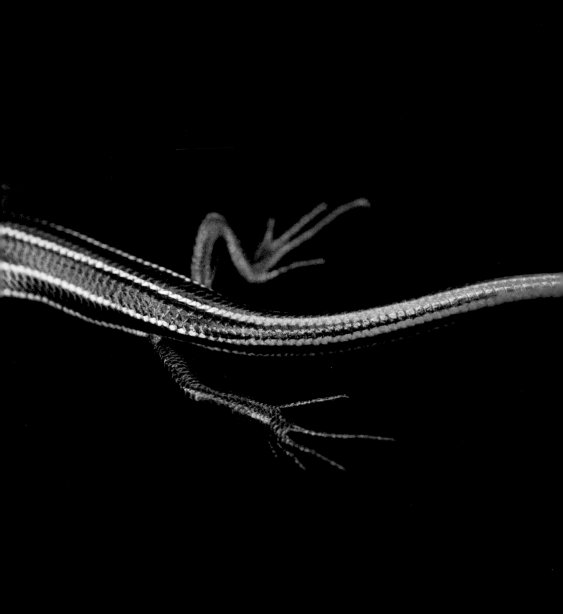

SILVER

Silver carries white, gray, or blue one step into heaven, adding otherworldly value to an earth-bound hue. And so we learn to cherish all the glints of silver strewn on the paths we travel, knowing that their luster may pass all too soon. In spring, silver shines in an early snowdrop that looks so fragile, yet thrusts up through the crust of melting snow. In summer, it glances off damselfly bodies darting by—darning needles, some folks call them, because they seem to stitch and shine. In autumn, silver burrows amid bright colors, stealthily muting the oranges, reds, and yellows of the leaves. In winter, silver flashes from an icy pond's surface and glows from the trunks of old sycamore trees. We would never attempt to quantify these gleaming reminiscences. They represent a silver standard of a different kind.

JIM RICHARDSON

**Cucapah village, Baja California
Norte, Mexico**
Silhouetted by the sun, Mexican
fishermen clean their nets.

Preceding pages
CRISTINA SANTINI

London, England
A rain puddle reflects the dome of
London's St. Paul's Cathedral.

JAMES L. STANFIELD

Tomahawk, Wisconsin
Patterns of heavy frost coat
a windowpane

Opposite
SARAH LEEN

San Nicolas de los Ranchos, Mexico
A man's torso glistens with silver
paint to celebrate Carnival.

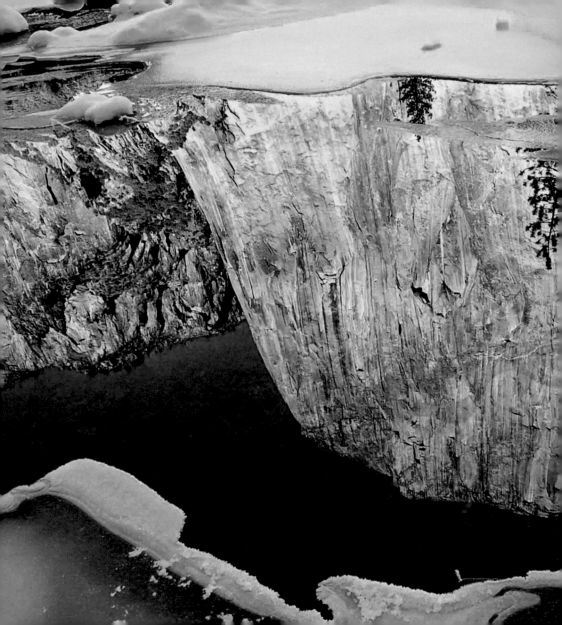

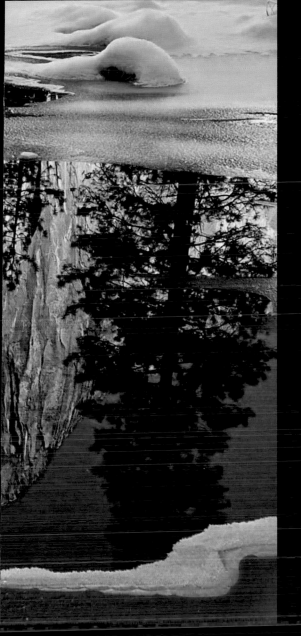

JEAN SLAVIN

Yosemite National Park, California
The Merced River reflects the granite monolith El Capitan in winter.

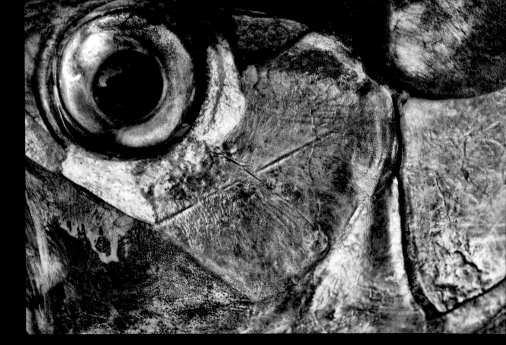

BRETT COLVIN

Bountiful, Utah

A detail of a tarpon's eye and gill shimmers
with metallic tints.

Opposite

KATHRINE LLOYD

Seattle, Washington

The gleaming curves of the EMP Museum
unfold into a pop culture center.

Following pages

AVI BENDER

Paris, France

The Louvre and the adjacent
Pyramid glisten under a cloudy sky.

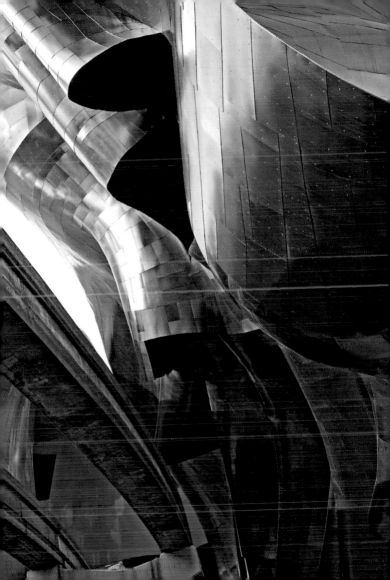

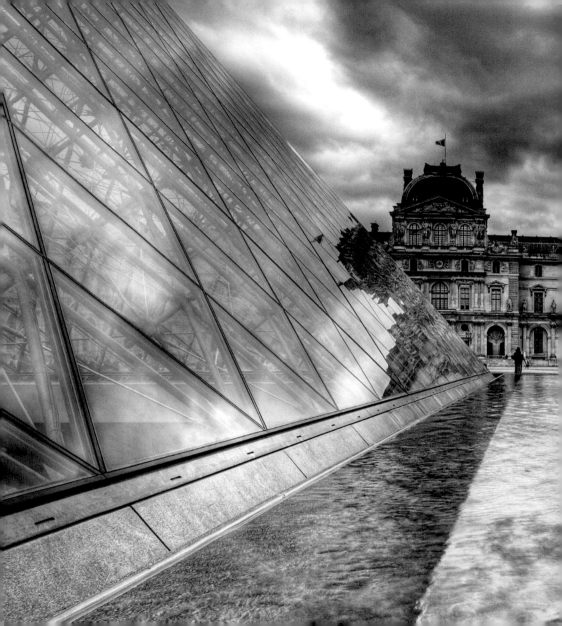

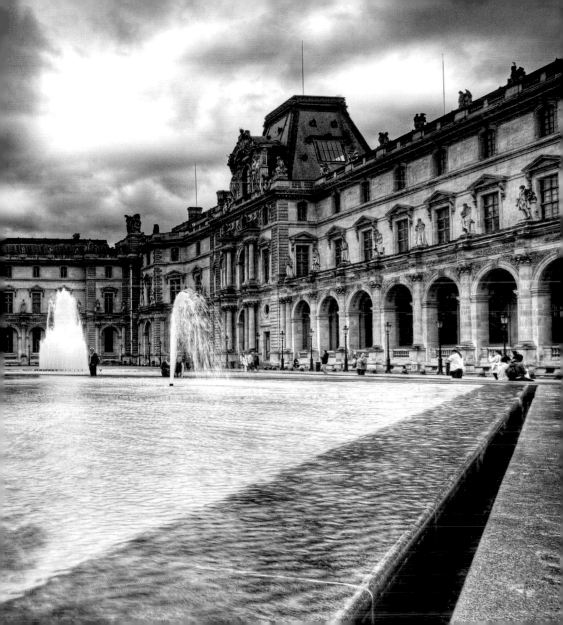

ORANGE

Orange can be a glow
that hints at heat and fire—
not a flame,
not an explosion,
but lasting warmth.

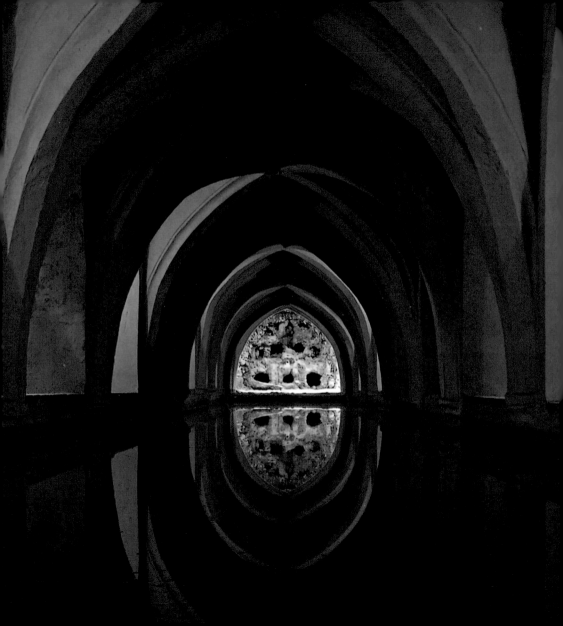

Orange

In the realm of brightly lit colors, orange is the friendliest. It's a brash color brought down to size. It can be bold, but it can also be friendly. It speaks loudly, but it's a pleasure to hear. Orange can be a glow that hints at heat and fire—not a flame, not an explosion, but lasting warmth. It might be the embers left in the fireplace. It might be the oak leaves turning. It might be a bulging tree bud, just coming into spring. Orange can be quiet and meditative, as in the soft drapes of Buddhist robes: soft, draped fabric hand-dyed with a color patiently drawn from the humble autumn crocus. In that quiet world, the orange of monks' robes breathes fire and snaps the mind into focus, signifying the soul's deepest center, the vortex within. Orange whispers at beginnings, as the dawn's light spreads the day's promise before the sun appears. It's the shade of things yet to come. And orange marks day's end as well, as echoes of daylight infuse the western sky, then melt into darkness. But, let's face it, orange can also be outrageous. A room painted bright orange would be anything but restful. Orange is city streets, honking cars, flashing lights. Orange cries out a warning. Orange points you to go another way. Orange is the shock of hair atop a true redhead—uncommon, audacious, and fun. Orange is a happy color. It brings together all peoples of the world. If you only had one color in which to paint them, you would choose orange. Go light, and you have the paler faces; go dark, and you reach the ebonies. In orange, all faces meet.

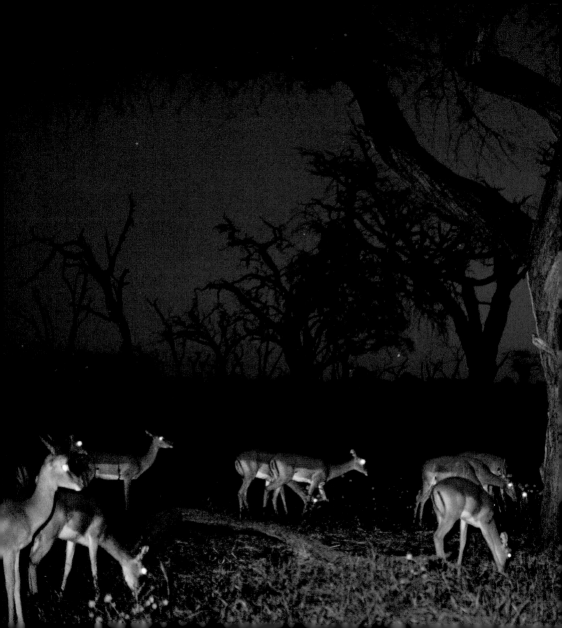

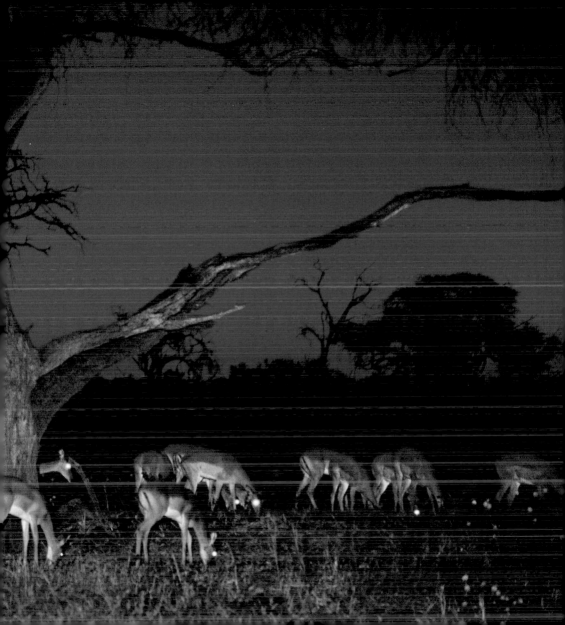

RAY CHUI

Chicago, Illinois
A light snow illuminates the Chicago
sky on a cold January night.

Preceding pages (122-125)
SEAN IVESTER

A golden idol marks the end of an
indoor temple's archway.

FRANS LANTING

Chobe National Park, Botswana
Impalas feed at twilight under an
orange sky.

Following pages
RONNIE PETERS

Ubud, Bali
Balinese girls wear colorful hats as
they make their way to worship.

RAYMOND GEHMAN

Chattahoochee National Forest,
Georgia
A skyward view reveals red maple
leaves resplendent in fall color.

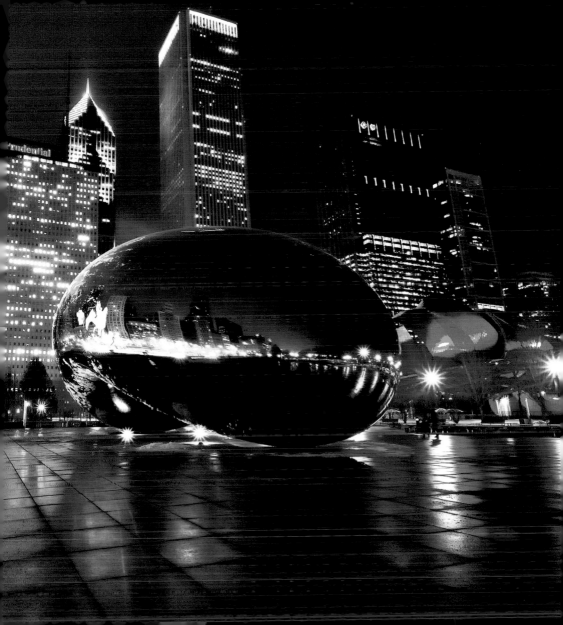

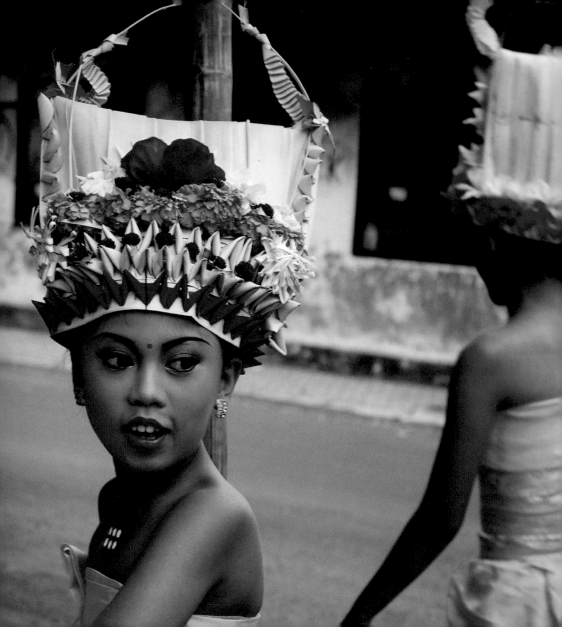

Color is a vital necessity.

It is a raw material

indispensable to life,

like water and fire.

~ FERNAND LÉGER

THEO WESTENBERGER

Venice, Italy
A masked Carnevale reveler carries
a matching stained-glass parasol.

Following pages

ATANU PAUL

Sravanabelagola, Karnataka, India
Bahubali, a huge monolithic statue,
dwarfs a worshipper.

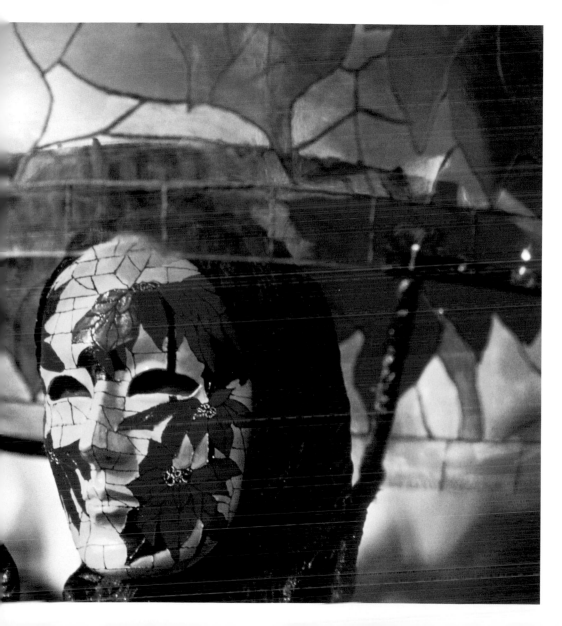

Orange is like a man, convinced of his own powers. Its note is that of the angelus, or of an old violin. Orange is red brought nearer to humanity by yellow.

~ WASSILY KANDINSKY

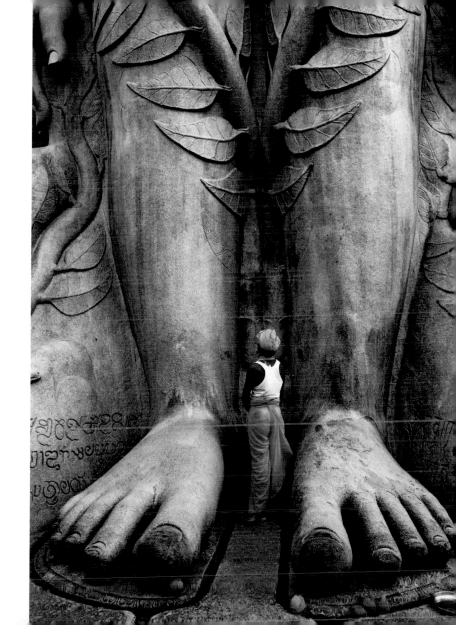

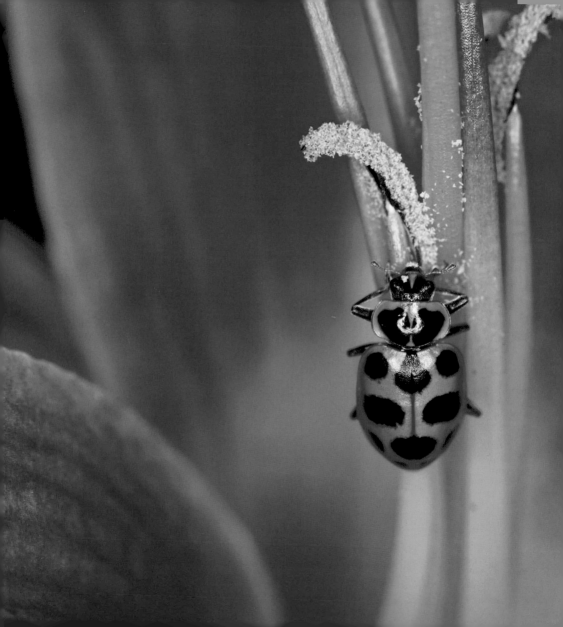

BULENT EREL
Roswell, Georgia
A ladybug rests on a flower laden with pollen.

Following pages
GUIDO TRAMONTANO
GUERRITORE
Monument Valley, Arizona
Vast sandstone buttes called the Mittens dot the red-rock valley.

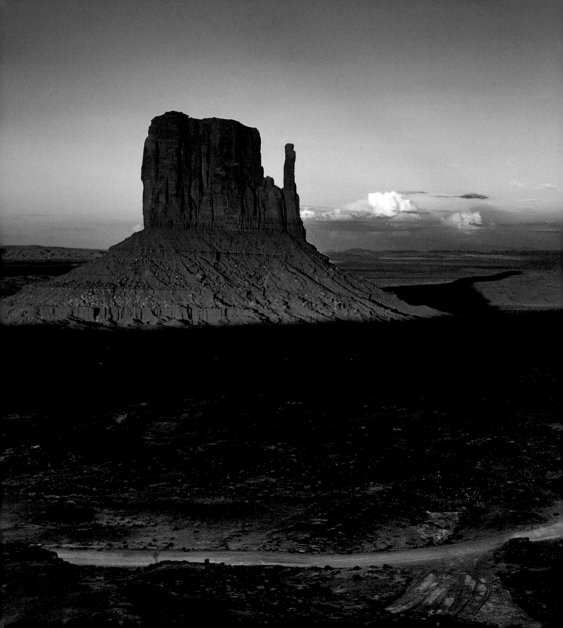

MELISSA FARLOW

Okefenokee National Wildlife
Refuge, Georgia
An alligator walks on the muddy
bottom of the St. Marys River.

Following pages
SERGIO AMITI

Beijing, China
A clear sky showcases the futuristic
Beijing Opera House.

NASA

Jupiter, Milky Way
A Voyager image reveals the
Great Red Spot, a persistent
atmospheric storm.

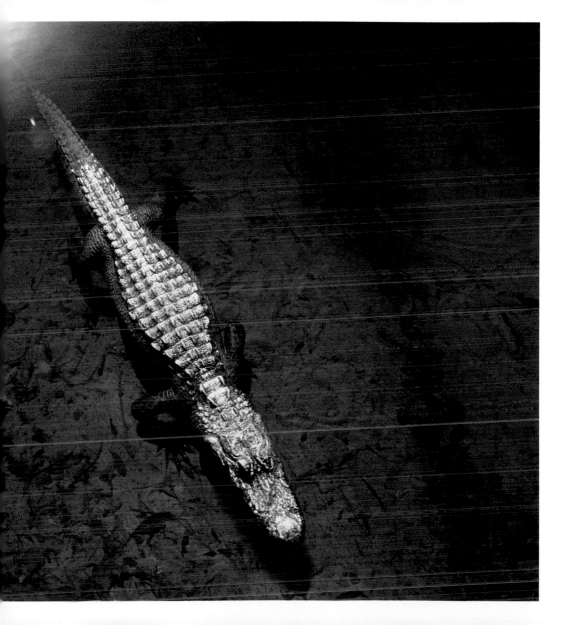

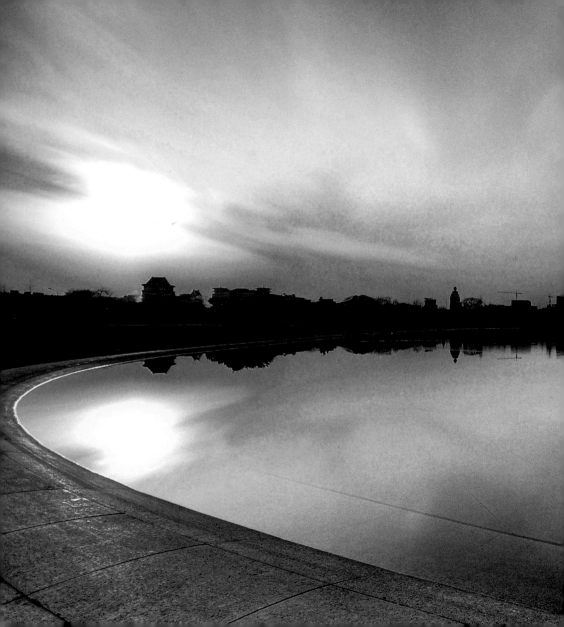

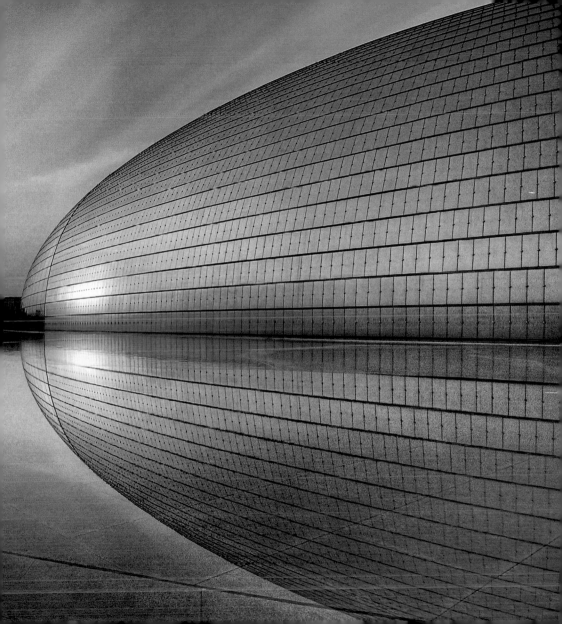

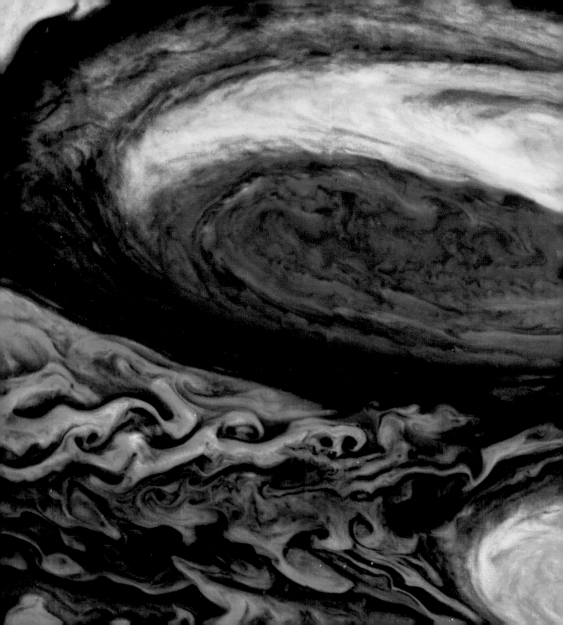

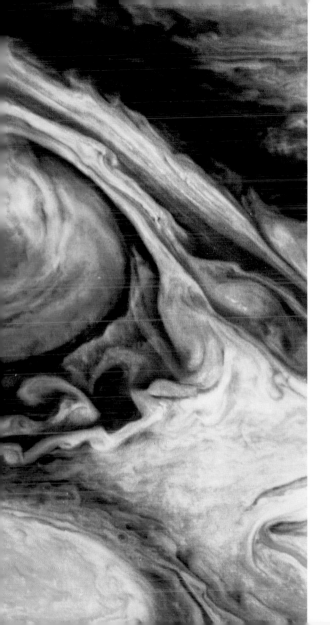

What is orange?

Why, an orange,

just an orange!

~ Christina Rossetti

LUKE TRAUTWEIN

Battambang, Cambodia
Young orange-clad Buddhist monks
take a nap on a bus.

Following pages
GLENN TRAVER

Columbia County, Pennsylvania
Three mallards come in for a landing
at Briar Creek Lake.

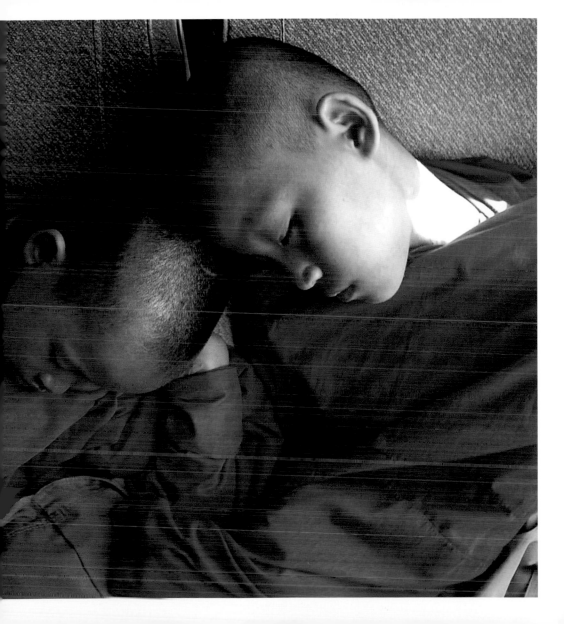

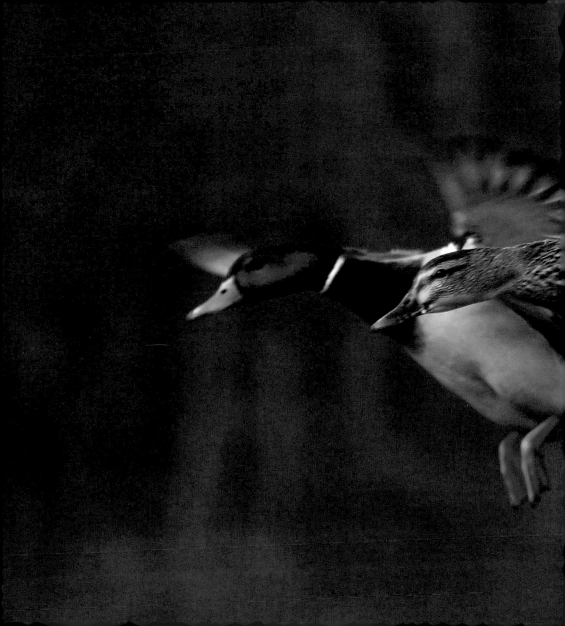

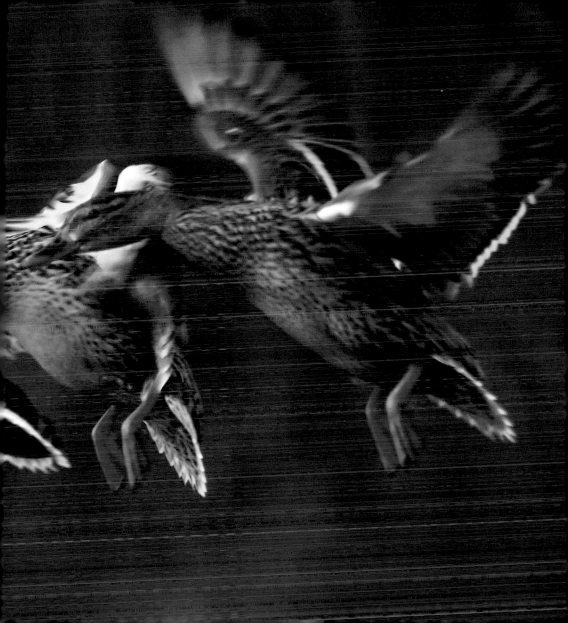

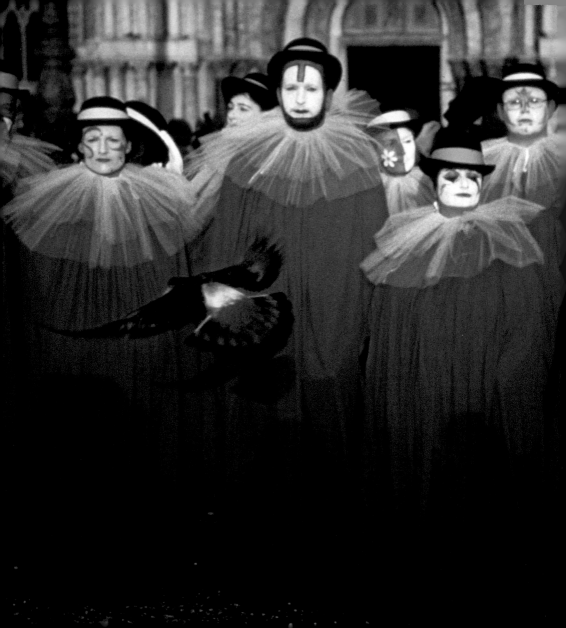

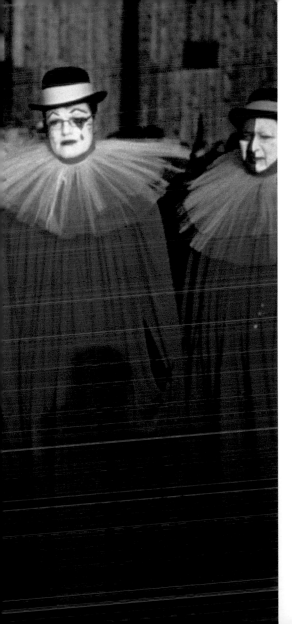

THEO WESTENBERGER
Piazza San Marco, Venice, Italy
A pigeon flies in front of
masqueraders dressed up
for Carnevale.

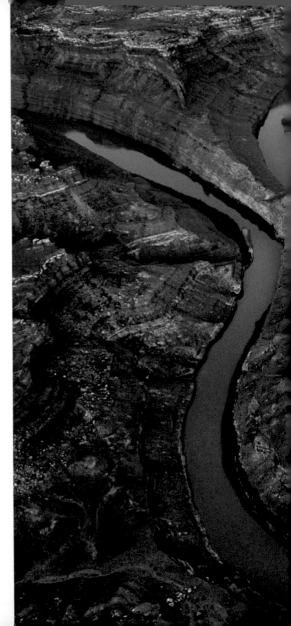

PETE MCBRIDE

Canyonlands National Park, Utah
An aerial view at sunrise highlights
the double-oxbow Loop.

Following pages
HELI HEINONEN

Turku, Finland
Frost creates a lacy flower design
on a window.

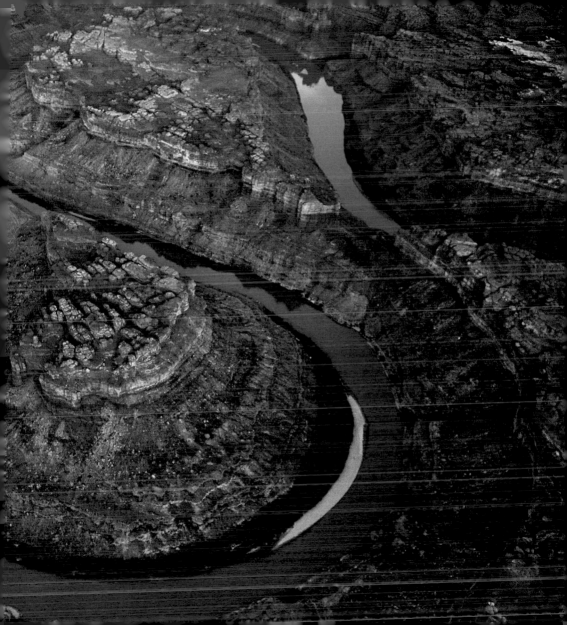

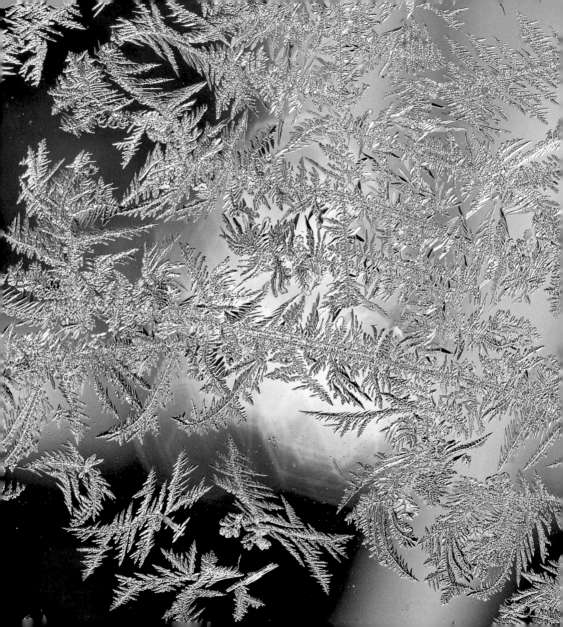

The day becomes more solemn
and serene When noon is past,
there is a harmony In autumn,
and a lustre in its sky, Which through the summer
is not heard or seen, As if it could not be,
as if it had not been!

~ Percy Bysshe Shelley

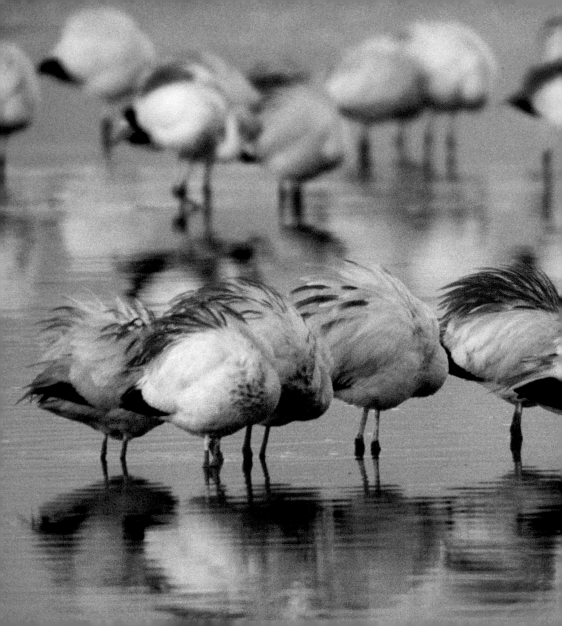

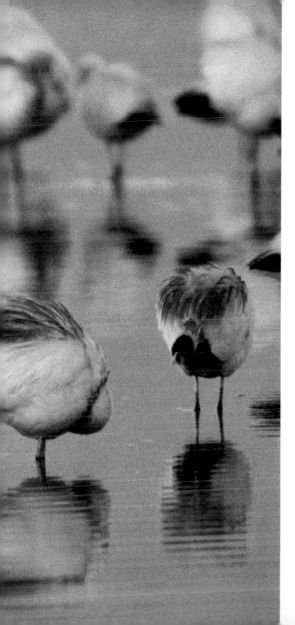

JOEL SARTORE

Atacama Desert, Chile
A flock of migratory flamingos
roosts in a high-altitude lake.

Following pages
AMY WHITE AND AL PETTEWAY

Fairview, North Carolina
Snow and ice coat a Blue Ridge
Mountain landscape at dawn.

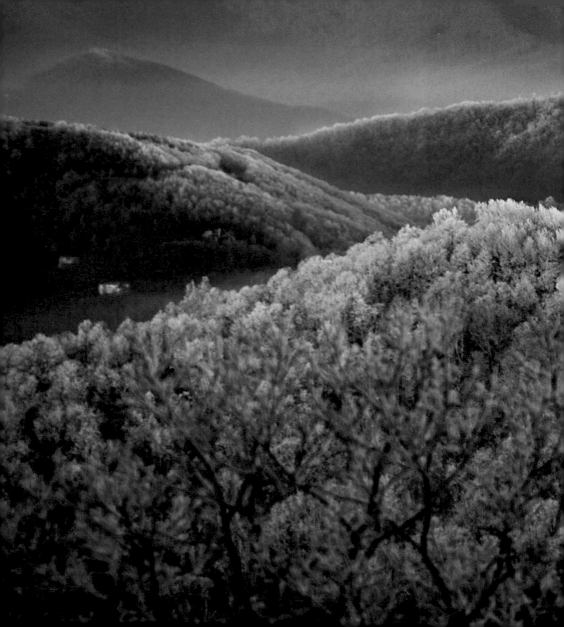

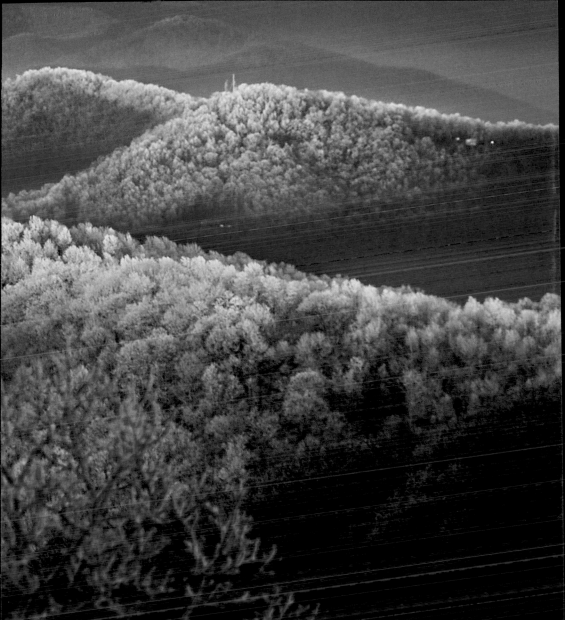

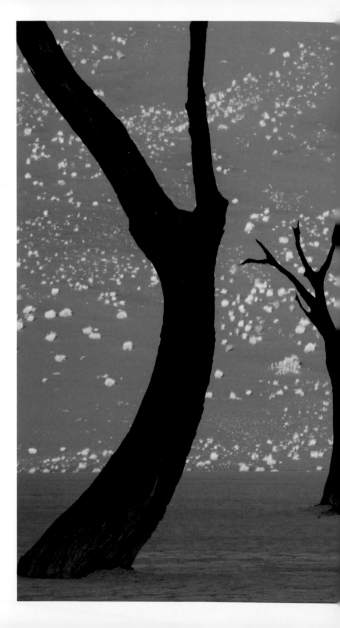

FRANS LANTING

Namib-Naukluft National Park,
Namibia
Orange dunes silhouette camel
thorn trees in the Namib Desert.

Following pages
WILLIAM ALBERT ALLARD

San Francisco, California
A girl looks out of a window in
San Francisco's Chinatown.

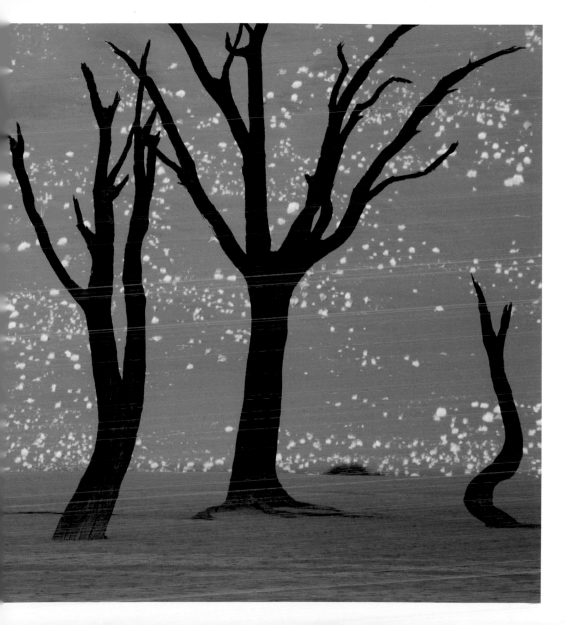

Colour possesses me.

It will always possess me.

That is the meaning

of this happy hour:

colour and I are one.

~ PAUL KLEE

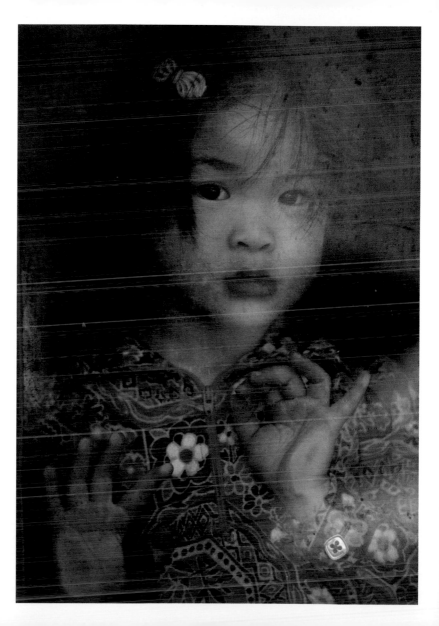

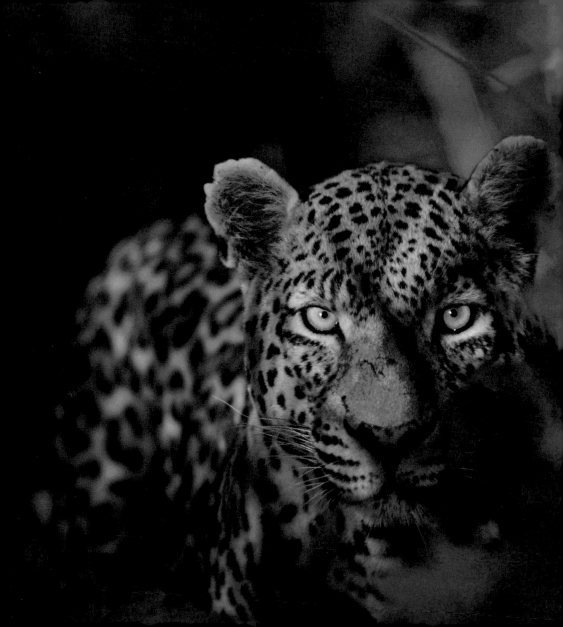

BEVERLY JOUBERT

Okavango Delta, Botswana
At twilight, a leopard emerges from
tall grasses at Mombo.

SARAH SEARS

Somers, New York

A goldfish with bulbous eyes
appears to be cross-eyed.

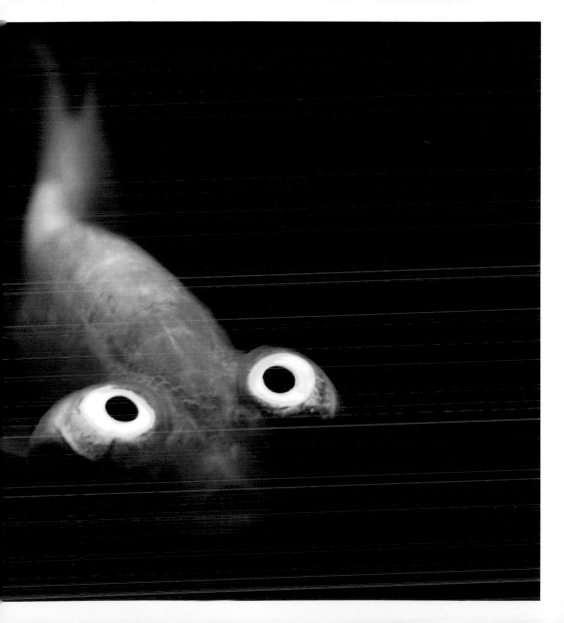

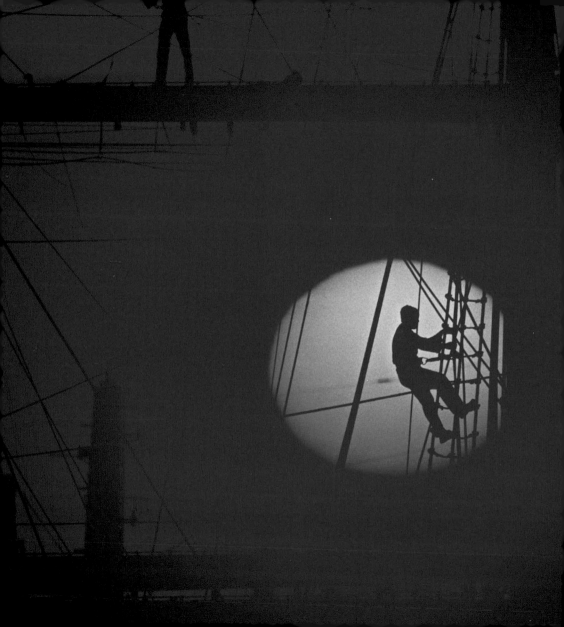

BRUCE DALE

Buenos Aires, Argentina
A sailor climbs the rigging of a ship
at sunset.

Following pages
GIULIANO MANGANI

Sassocorvaro, Pesaro e Urbino, Italy
A lone oak tree punctuates a
green valley.

THOMAS J. ABERCROMBIE

Near El Asnam, Algeria
A cartload of oranges travels from
orchard to market.

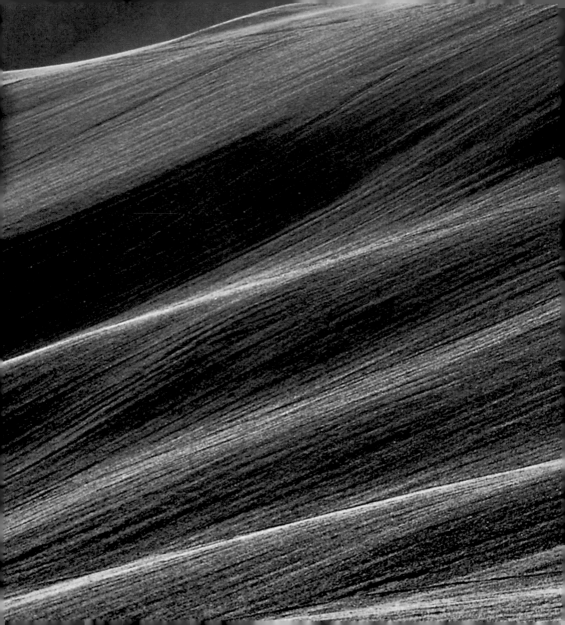

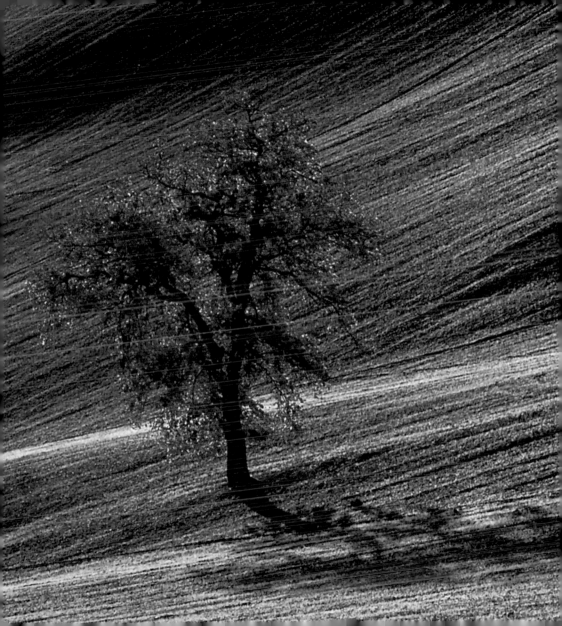

A man ought to carry himself

in the world as an orange-tree would

if it could walk up and down

in the garden—swinging perfume

from every little censer

it holds up to the air.

~ Henry Ward Beecher

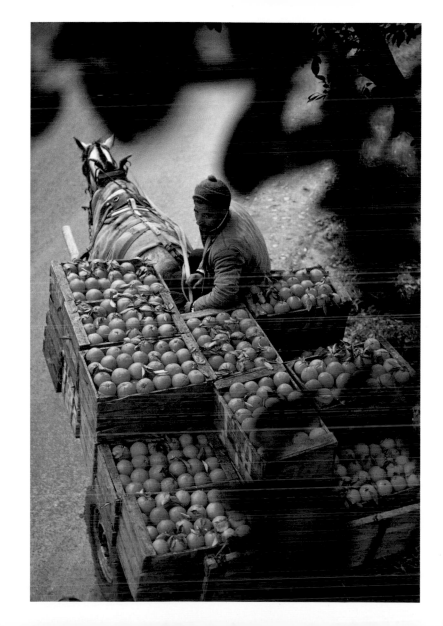

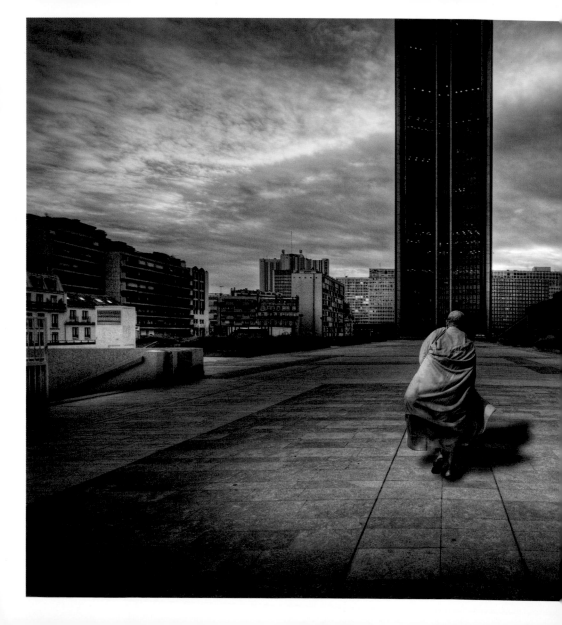

LAURENT HUNZIKER

Montparnasse, Paris, France
An orange-clad monk contrasts with
the steely gray of Montparnasse.

Following pages
ERIK HARRISON

Moab, Utah
The rising sun glows beneath
a sandstone arch in Arches
National Park.

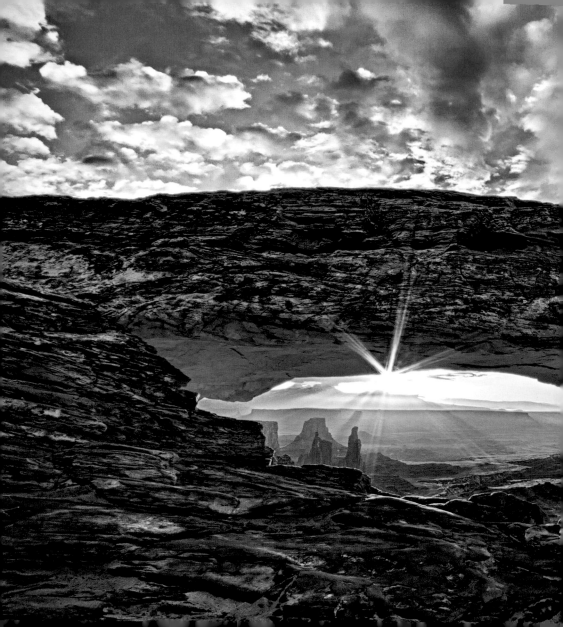

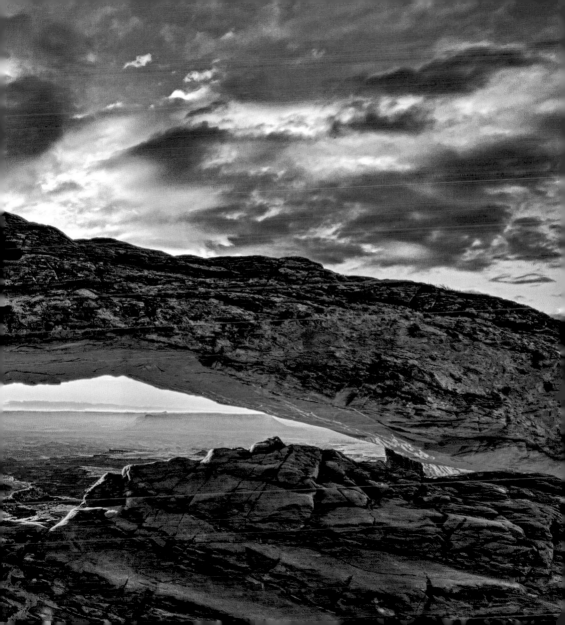

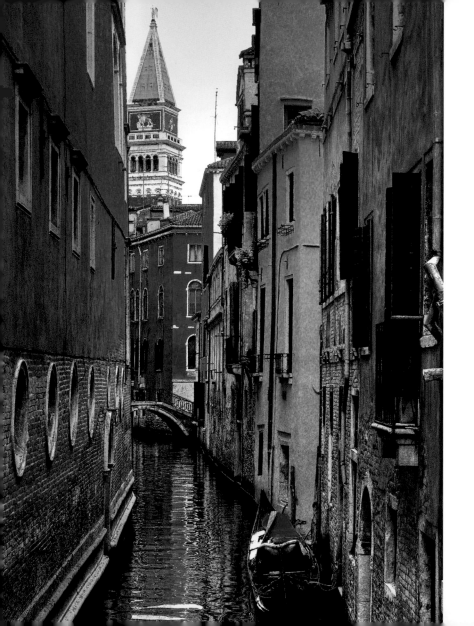

KEITH SPENCE

Venice, Italy
A narrow canal wends its way
through the watery city made up
of islands.

Following pages
GAVIN MARCHIO

Naremburn, Australia
A dust storm hits Sydney, creating
a golden glow of particles.

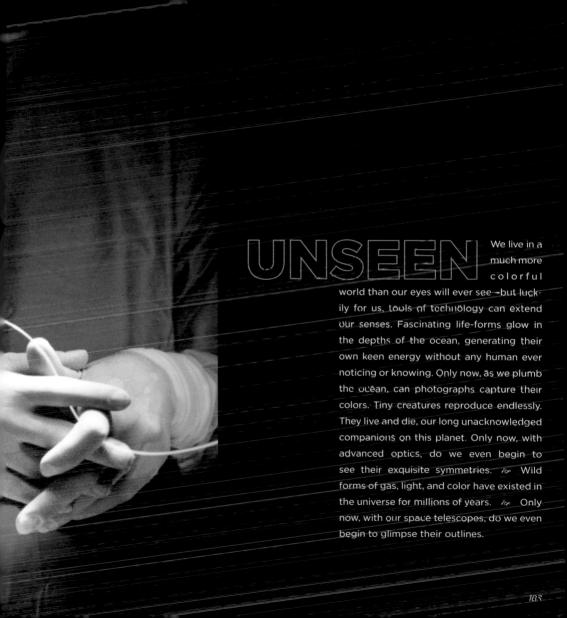

UNSEEN

We live in a much more colorful world than our eyes will ever see—but luckily for us, tools of technology can extend our senses. Fascinating life-forms glow in the depths of the ocean, generating their own keen energy without any human ever noticing or knowing. Only now, as we plumb the ocean, can photographs capture their colors. Tiny creatures reproduce endlessly. They live and die, our long unacknowledged companions on this planet. Only now, with advanced optics, do we even begin to see their exquisite symmetries. ≈ Wild forms of gas, light, and color have existed in the universe for millions of years. ≈ Only now, with our space telescopes, do we even begin to glimpse their outlines.

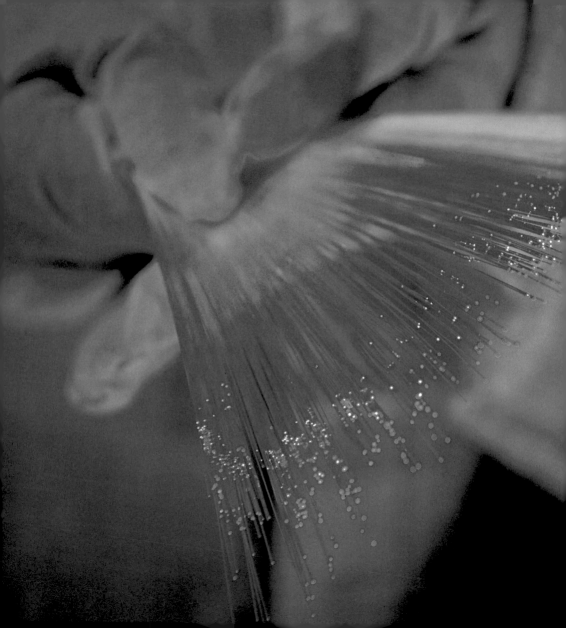

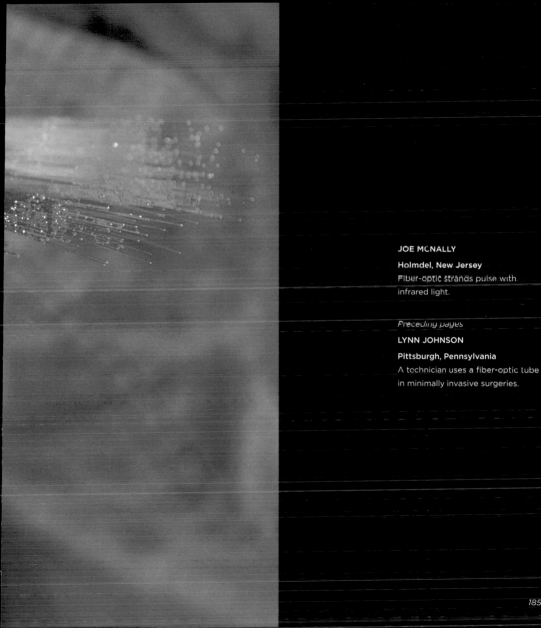

JOE MCNALLY

Holmdel, New Jersey
Fiber-optic strands pulse with
infrared light.

Preceding pages

LYNN JOHNSON

Pittsburgh, Pennsylvania
A technician uses a fiber-optic tube
in minimally invasive surgeries.

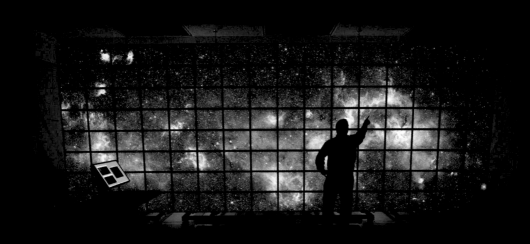

JOE MCNALLY

NASA Ames Research Center,
Moffett Field, California
Monitors help researchers visualize data
from the latest telescopes.

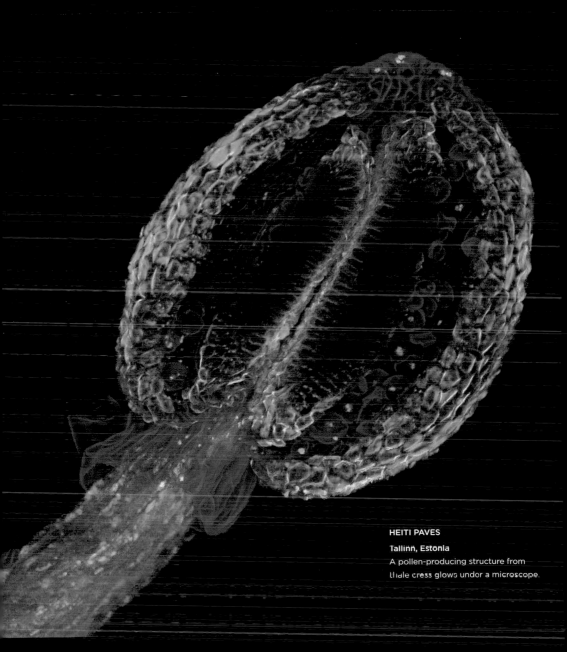

HEITI PAVES
Tallinn, Estonia
A pollen-producing structure from
thale cress glows under a microscope.

JOE MCNALLY

Austin, Texas
A storm of colored laser lights
flashes over dancers at a rave.

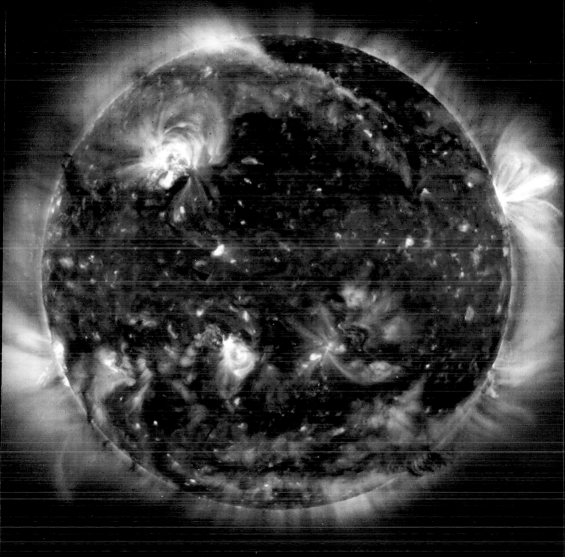

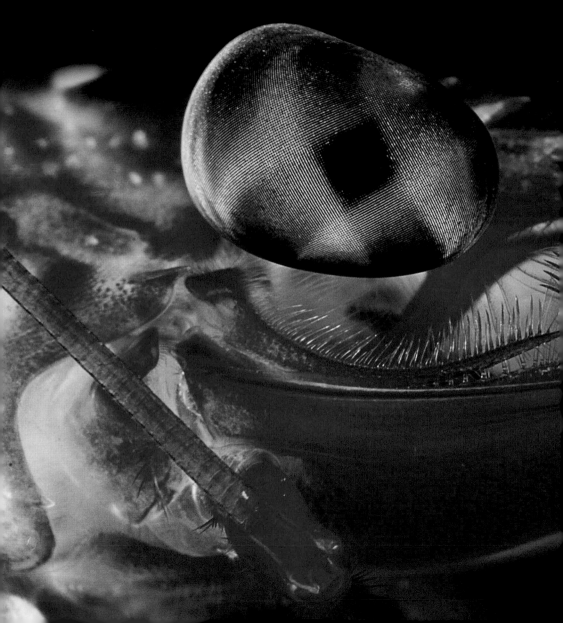

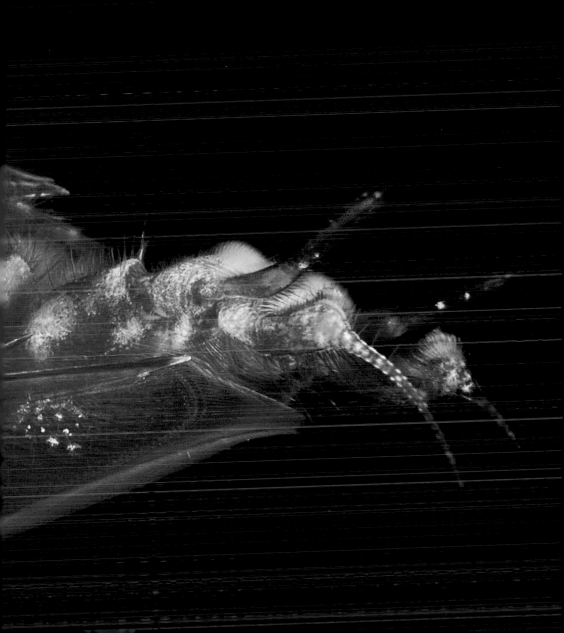

Green means we can breathe.
Green means moisture and shade.
A thriving green
signals life
in the world of nature.

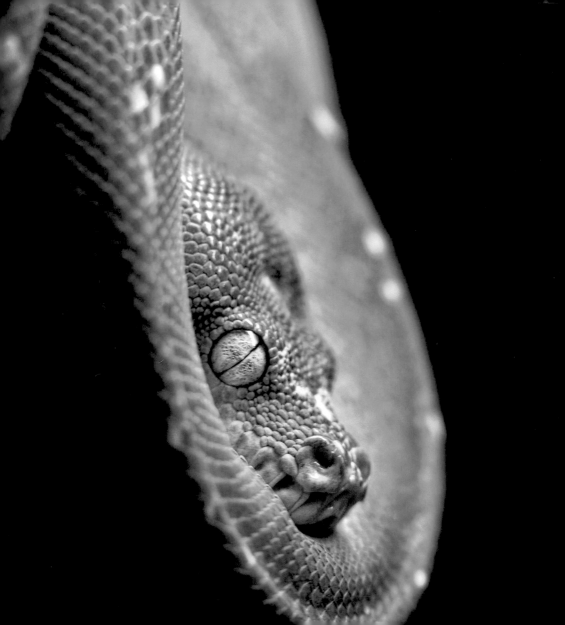

Green

Green grows on you. It's evidence of life, but a different sort of life from the one we live. It's the life we count on for our surroundings, not the life that throbs within. 🪶 As the days grow warmer, spring thaws—and from out of the brown thatch of winter, green appears: buds, blooms, tendrils, and blossoms. 🪶 Green can seem an otherworldly color, though: eerie, repulsive, and untouchable. Snakes and frogs, algae and mold, the tint of a witch's skin. In the wrong place—skin, scales, standing water—green can signal danger. In the right place, though, green assures us all's right with the world. 🪶 Celts of old imagined a Green Man, spirit of the trees and forest, his eyes fringed with a brow of moss, his beard a tangle of leaves, roots, and vines. He was a trickster, emerging out of a gnarled tree trunk and then disappearing into the landscape. He could turn from genial elder to tempestuous god in the blink of one green eye. He was at once human and not human. He stood as the embodiment of the other half of this world of nature: of the plants that breathe in what we exhale and at the same time give us back the oxygen we need. 🪶 Green means we can breathe. A thriving green signals life in the world of nature. With green around us, we rest assured that the other half of life's equation is breathing and growing and stretching and dying all the time, right along with us. Nature's great plant being—the combination of the algae, the moss, the ferns, the trees, the vines, the forest—is breathing deeply, forming a soft bed and shady canopy that cradles and protects the Earth we share.

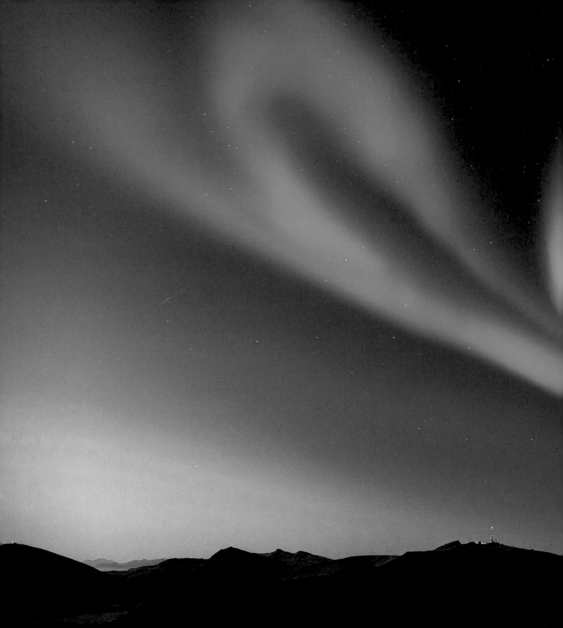

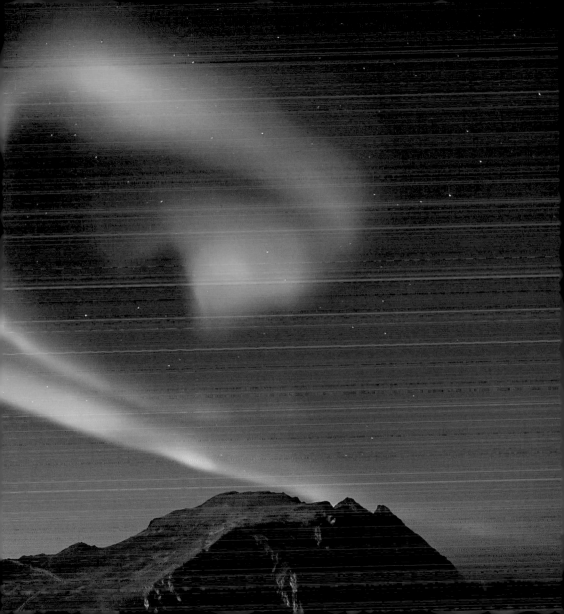

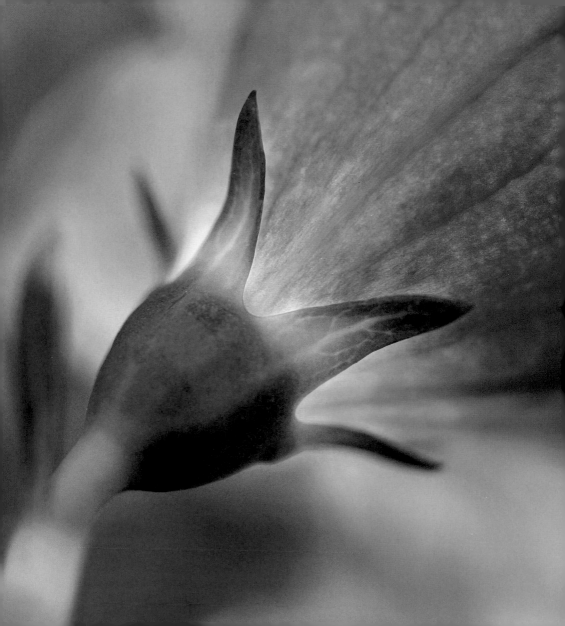

CHERYL MOLENNOR
New Port Richey, Florida
Light enhances the delicacy
of a purple flower.

Preceding pages (196-199)
HARSHAL DESAI
Singapore
A coiled bright green snake
rests its head in repose.

ROY SAMUELSEN
Mt. Andhue, Norway
An aurora borealis creates green
swirls in the Norwegian sky.

Following pages
KENNETH DEITCHER
Albany, New York
A chameleon faces an
enlarged version of itself in
a double exposure.

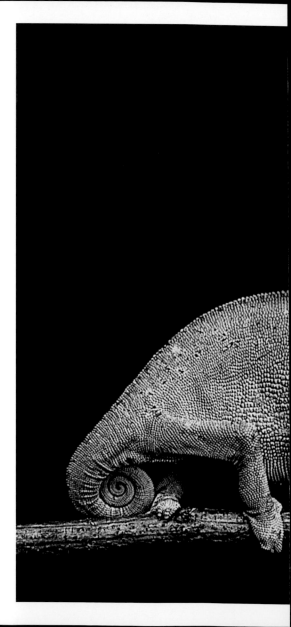

Green is
the most restful
color that exists.

~ WASSILY KANDINSKY

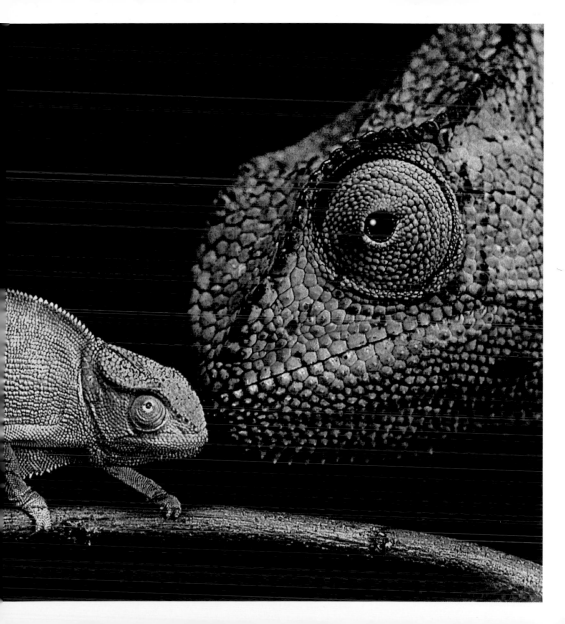

MANFRED KAEMPA

Siem Reap, Cambodia
Fish nibble the dead skin from a
visitor's feet at a local spa.

Following page
FRANS LANTING

Belize Zoo, Ladyville, Belize
A portrait of a cougar captures the
cat's stunning visage.

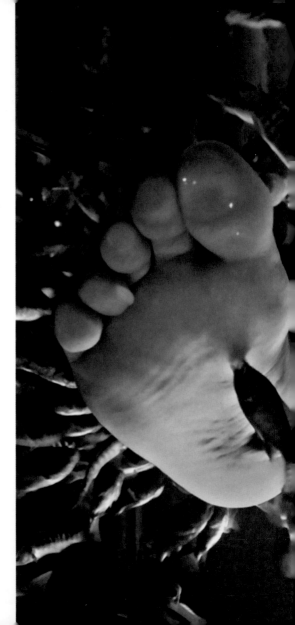

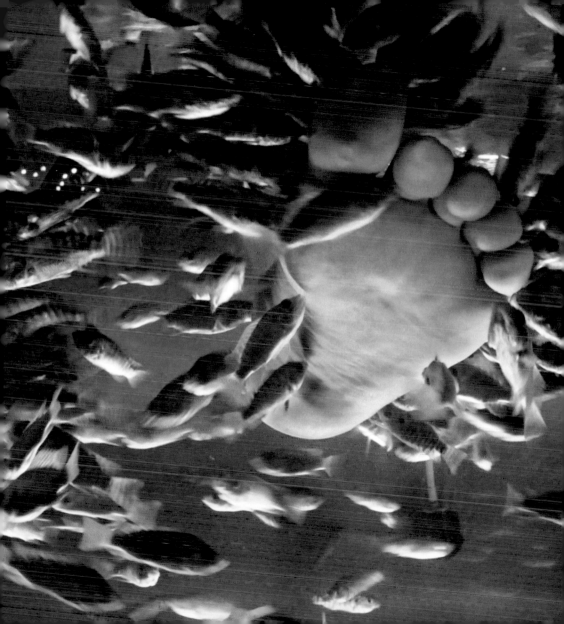

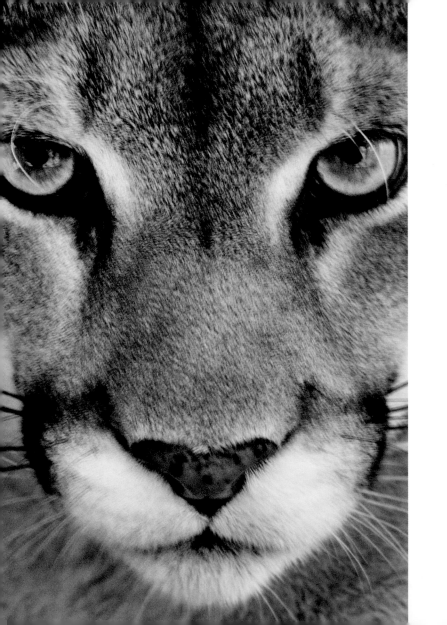

When have I last looked on

The round green eyes and the

long wavering bodies

Of the dark leopards of the moon?

All the wild witches, those most noble ladies,

For all their broom-sticks and their tears,

Their angry tears, are gone.

~ W. B. YEATS

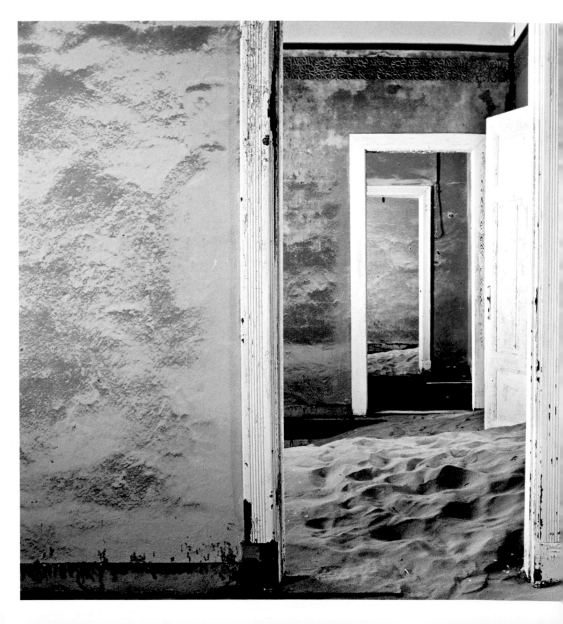

GEORGE STEINMETZ

Kolmanskop, Namibia
Sand fills a building in an old mining
town on the Skeleton Coast.

Following pages
ETHAN DANIELS

Ulong Island, Republic of Palau
A coconut sprouts and continues
to float.

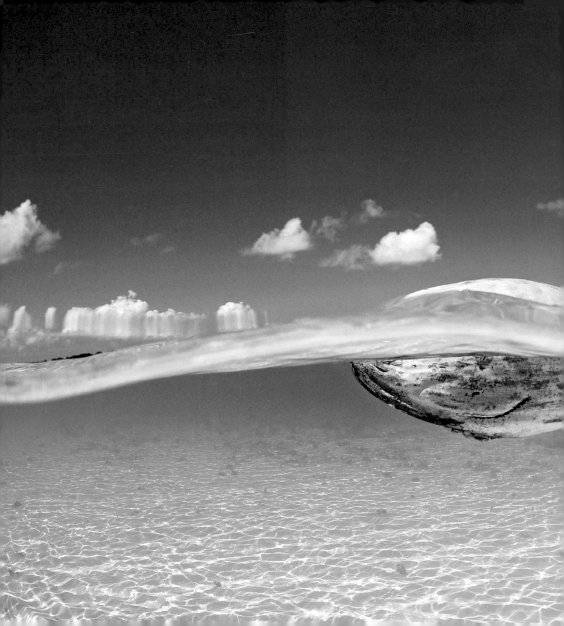

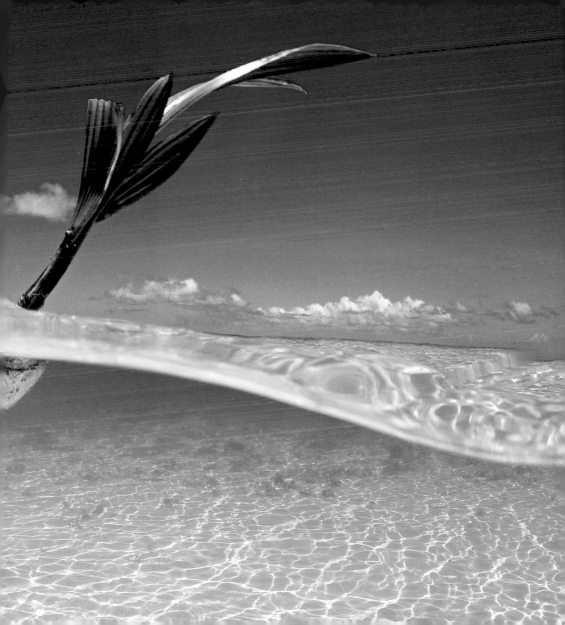

BRUNO SCHLUMBERGER

Kanata, Ontario
A man comes face to face with a
lifelike human sculpture.

Following pages
FRANS LANTING

California Academy of Sciences,
San Francisco, California
Up close, macaw feathers resemble
a verdant landscape.

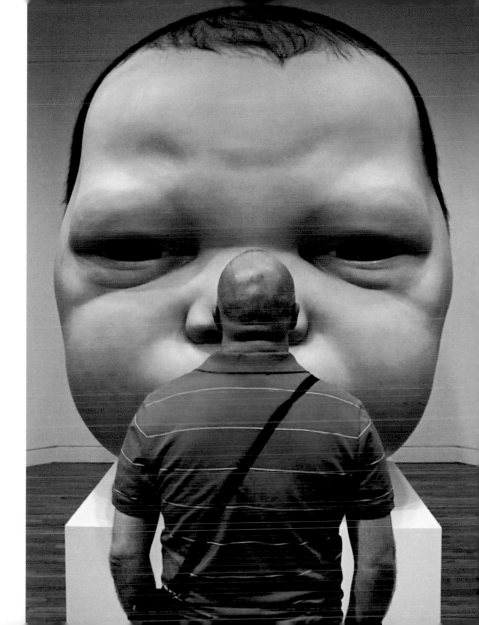

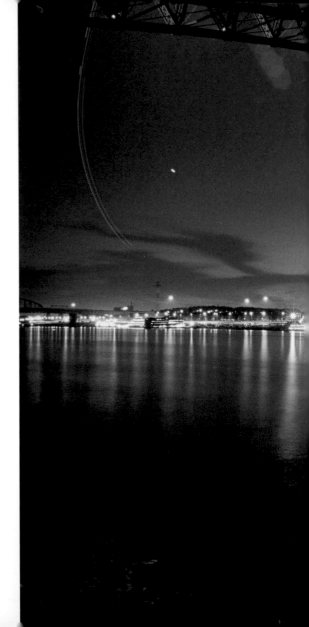

MICHAEL S. LEWIS

St. Louis, Missouri
Eads Bridge frames a nighttime
view of the Gateway Arch.

Following pages
BIJITENDRA MISHRA

Madras Crocodile Bank Trust, near
Chennai, India
A gharial moves toward the water's
surface to respire.

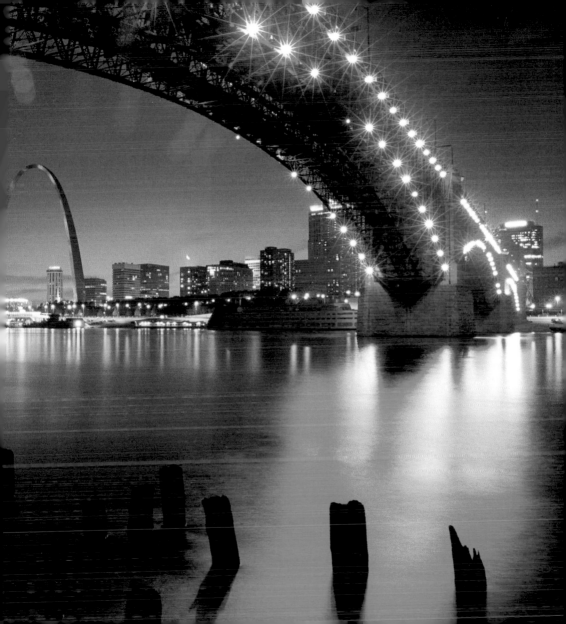

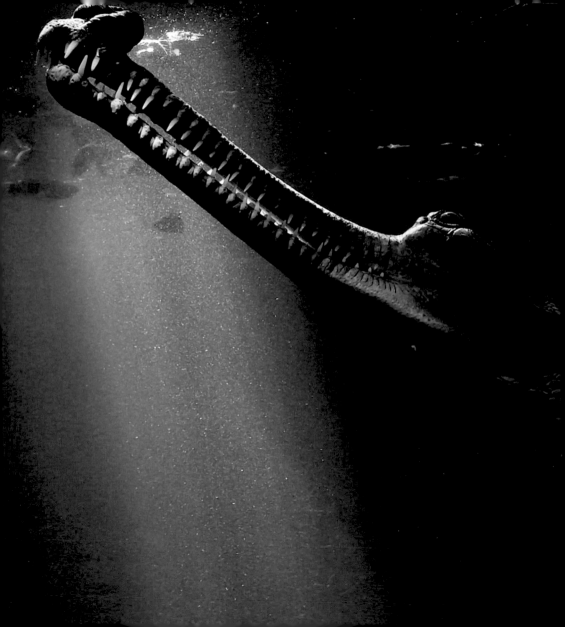

Dolphins were still my playmates;

shapes unseen

Would let me feel

their scales of gold and green.

~ JOHN KEATS

J. BAYLOR ROBERTS

Tallahassee, Florida
Swimmers in 1944 apply lipstick
underwater at Wakulla Springs.

Following pages
JOEL SARTORE

Pantanal, Brazil
Verdant lagoons dot patches
of elevated forest during the
wet season.

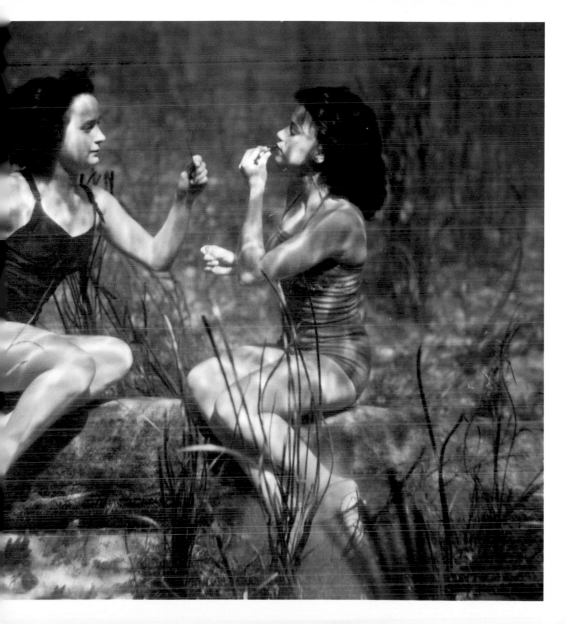

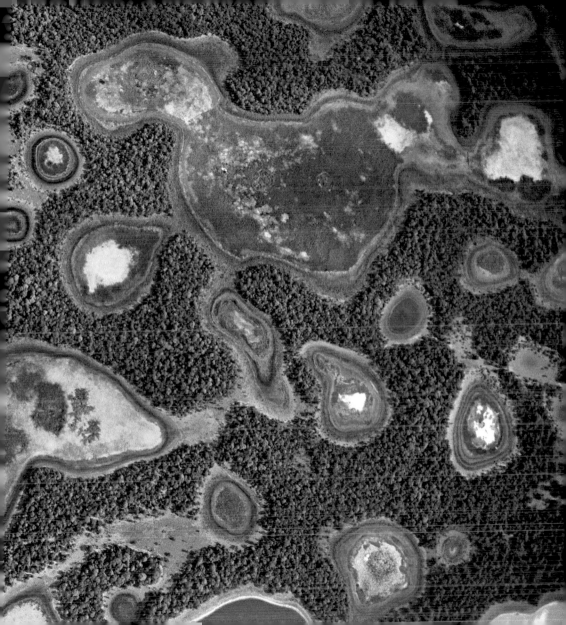

PETE MCBRIDE

Sonora, Mexico
An aerial of the dry Colorado River
delta creates an abstract design.

Following pages

REZA

Tora Bora, Waziristan, Afghanistan
A girl's knowing eyes make her
seem older than her years.

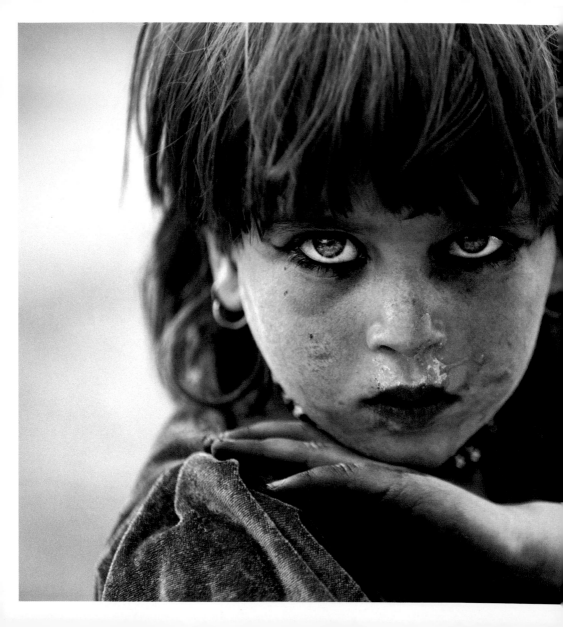

Of all of God's gifts

to the sight of man,

color is the holiest,

the most divine,

the most solemn.

~ JOHN RUSKIN

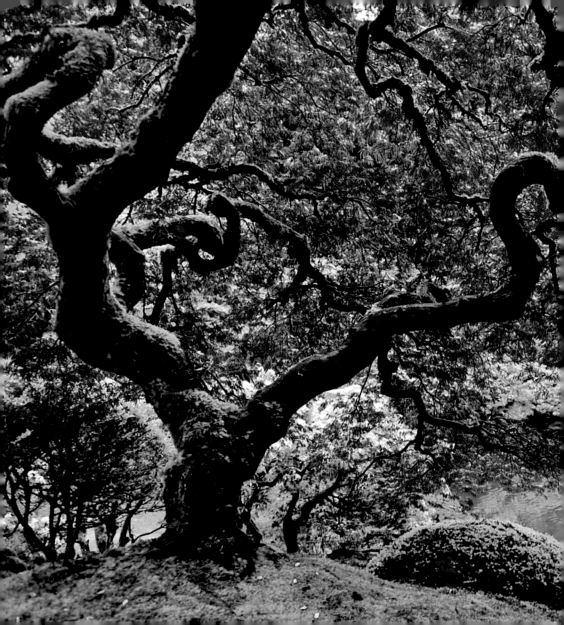

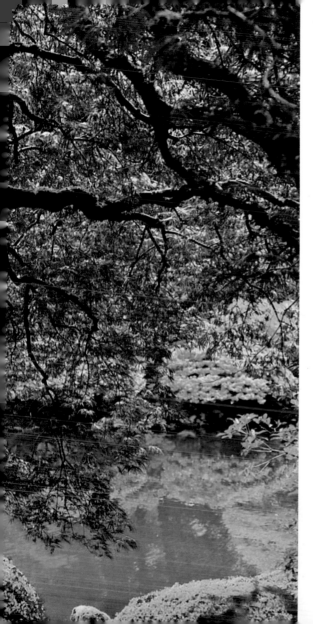

EMIR IBRAHIMPASIC

Portland, Oregon
Gnarled Japanese maples shelter a
moss-covered landscape.

Following pages
DAVID DOUBILET

Republic of Palau
Jellyfish envelop a scuba diver as
he dives in a lake.

MICHAEL S. YAMASHITA

Ishikawa Prefecture, Japan
Tall, straight trunks lead to a froth
of green leaves.

HEIDI AND HANS-JÜRGEN KOCH

Laboratory at Friedrich-Schiller-
University, Jena, Germany
An African aquatic clawed frog
pokes its head out of the water.

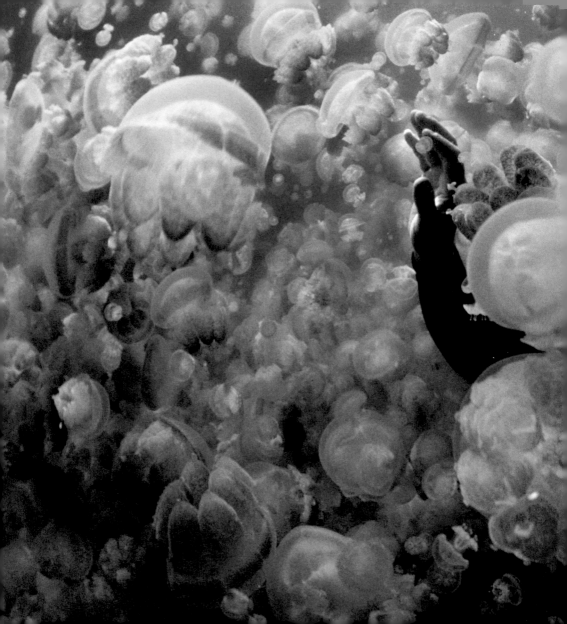

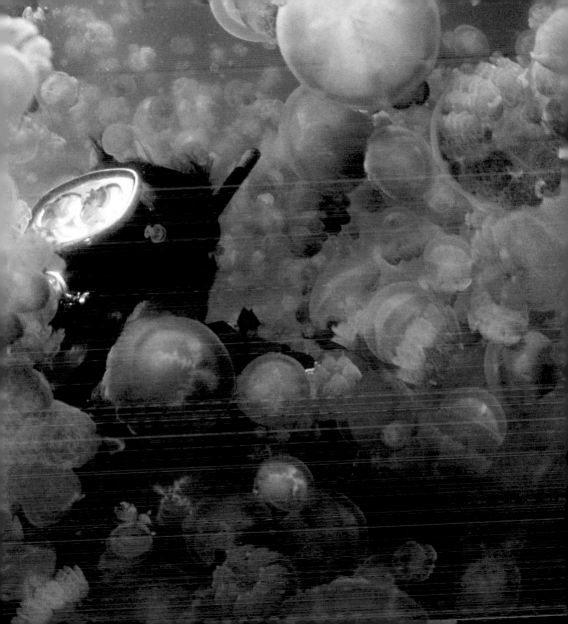

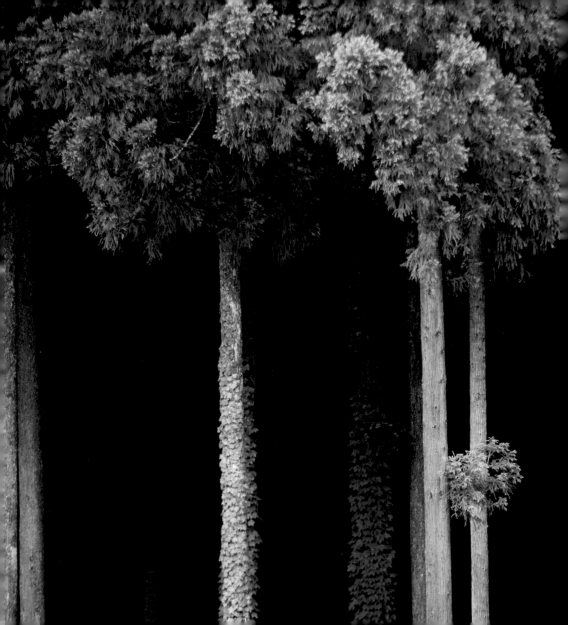

Meanwhile the mind,

from pleasure less,

Withdraws into

its happiness . . .

Annihilating all that's made

To a green thought

in a green shade.

~ ANDREW MARVELL

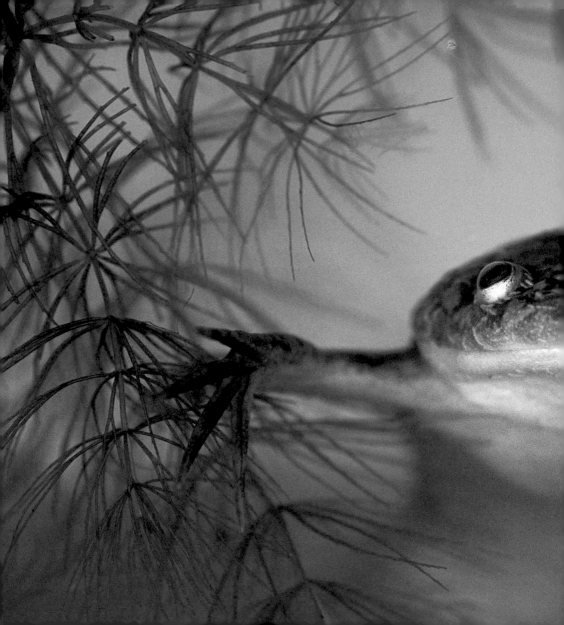

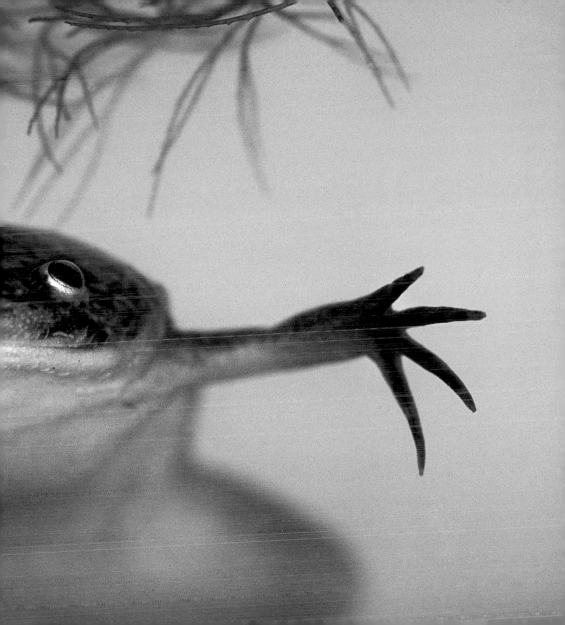

ANNIE GRIFFITHS
Angangueo, Mexico
A street scene creates a colorful still
life in the mining town.

Following pages
RAYMOND GEHMAN
Yellowstone National Park,
Wyoming
Antlers sheathed in velvet, a wapiti
grazes near the Gibbon River.

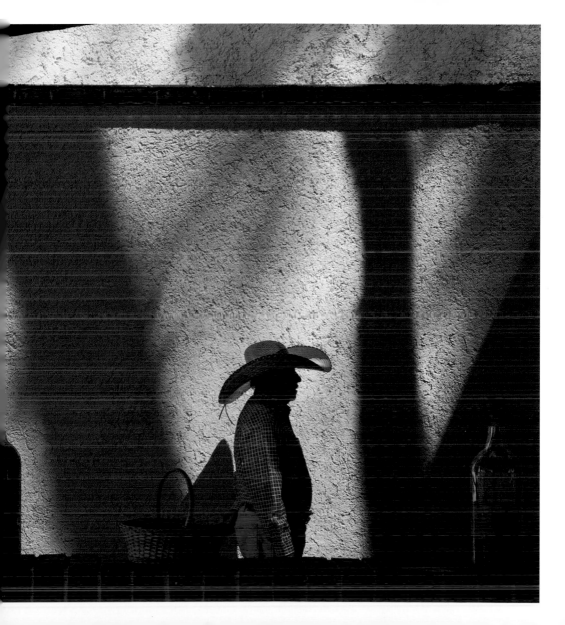

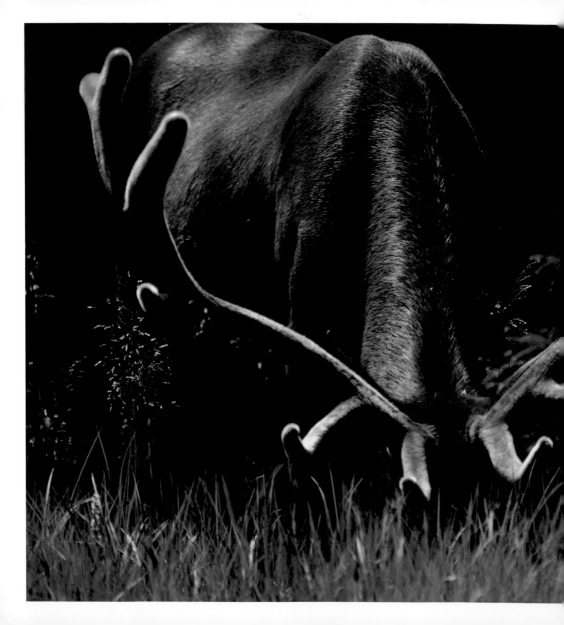

All colors turn
to green;
The bright hues vanish
and the odors fly,
The grass hath
lasting worth.

~ CHRISTINA ROSSETTI

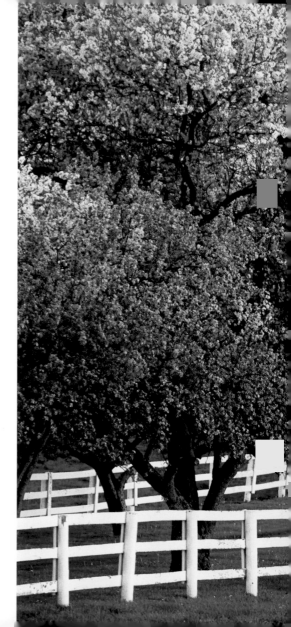

MELISSA FARLOW

Manchester Farm, Kentucky
Flowering crab apple trees bloom
on the horse farm's grounds.

Following pages
ROBERT B. HAAS

Cape Town, South Africa
Multiple sprinklers irrigate crops
near the capital city.

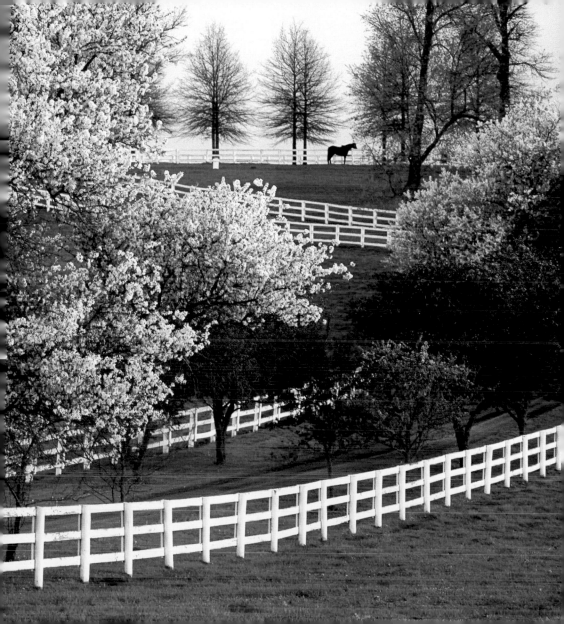

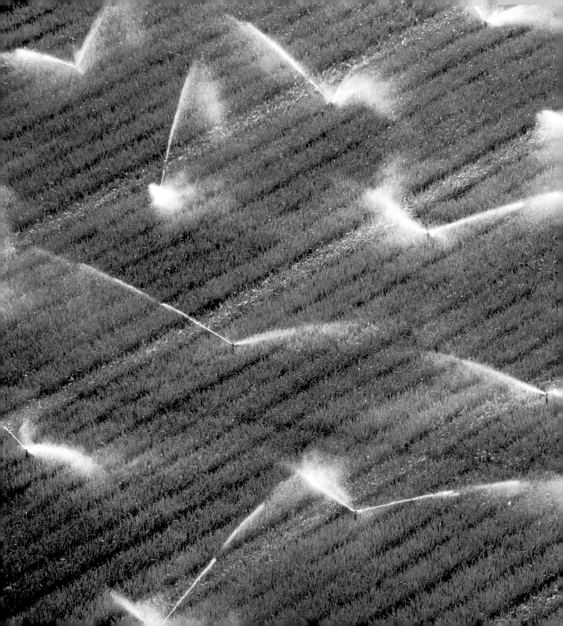

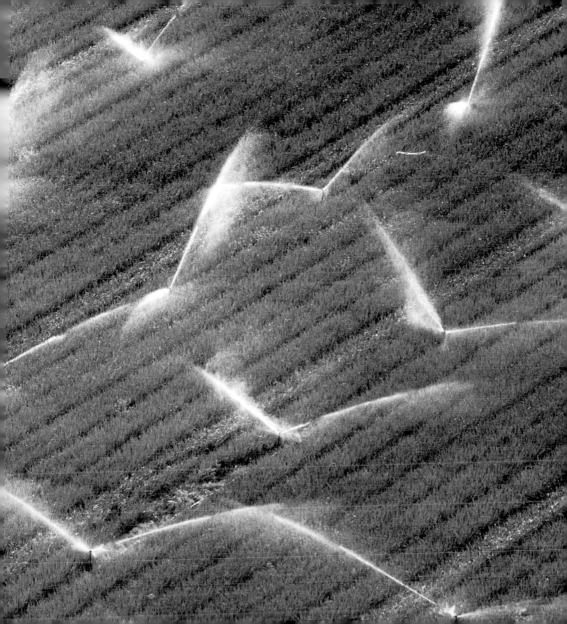

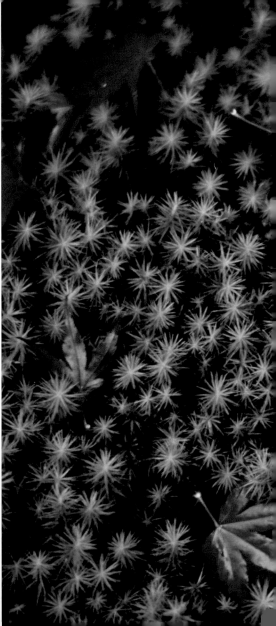

MICHAEL S. YAMASHITA

Kyoto, Japan

Fall leaves grace a patch of moss in
a temple's Zen garden.

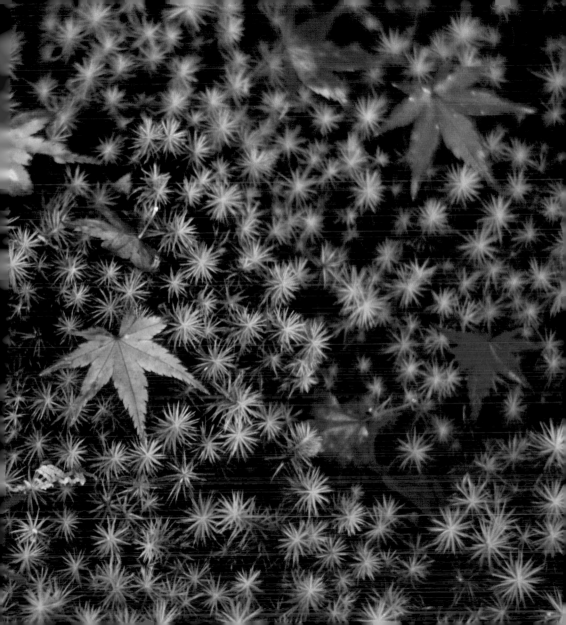

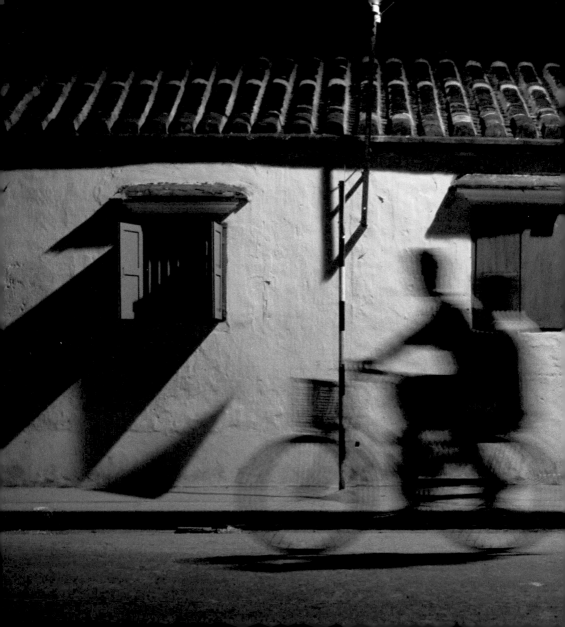

JUSTIN GUARIGLIA

Hoi An, Vietnam

A boy pedals past a green building
with blue shutters.

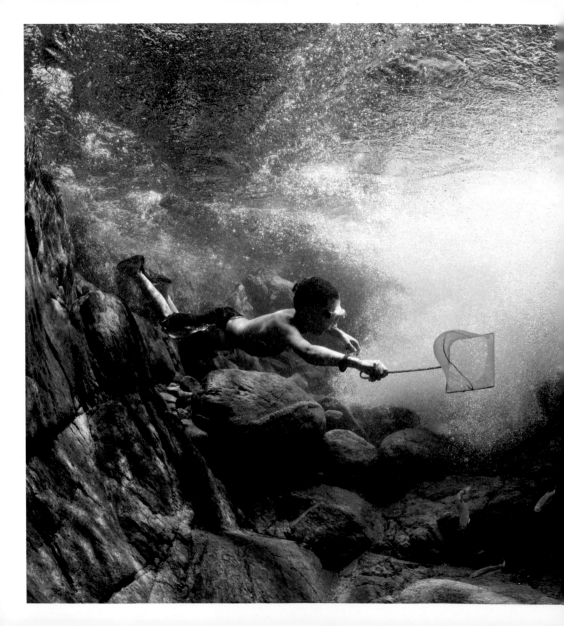

JOHN WEBB

Lafayette, California
A boy pursues a trout with a net
in a swimming hole.

Following pages

MIKE CRISS

Denali National Park, Alaska
In the distance, Denali soars to
white-capped heights.

THOMAS STERR

Maudlin, South Carolina
A single dandelion seed dances
in midair.

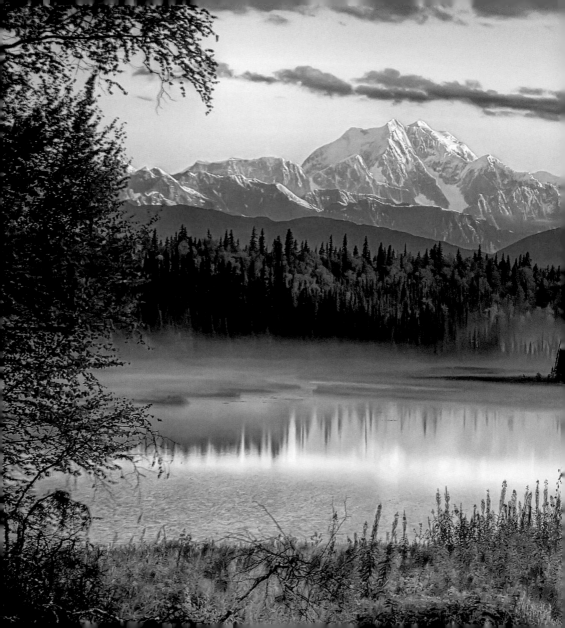

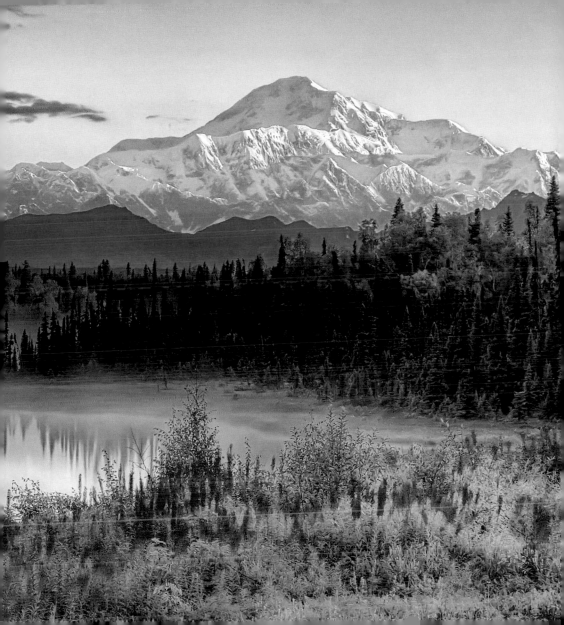

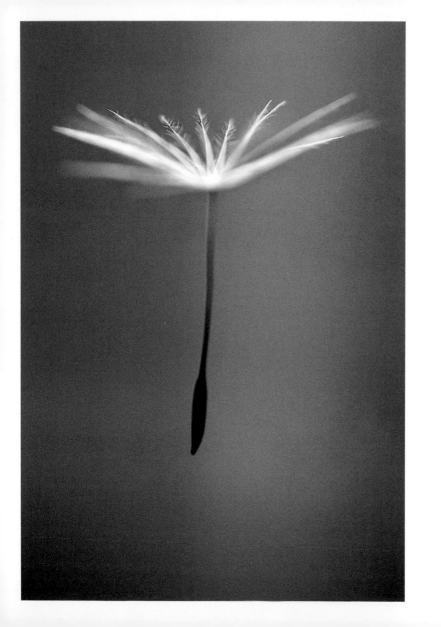

A single gentle rain

makes the grass many shades greener . . .

We should be blessed if we lived

in the present always, and took advantage

of every accident that befell us,

like the grass which confesses

the influence of the slightest dew.

~ HENRY DAVID THOREAU

DROR MADAR

Malawi, Africa
A chameleon rears back on its
hind legs.

Following pages
JODI COBB

Venice Beach, California
A bodybuilder performs pull-ups
at Muscle Beach.

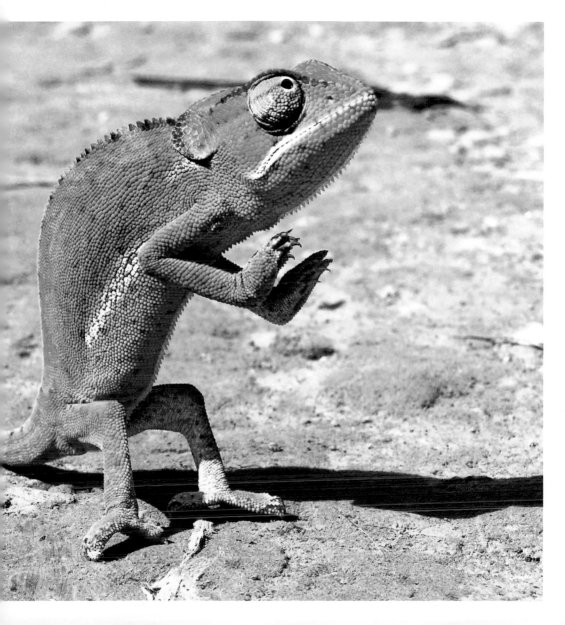

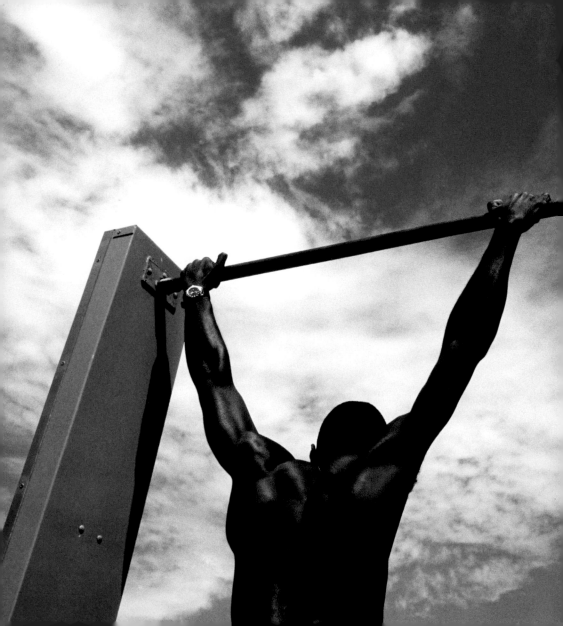

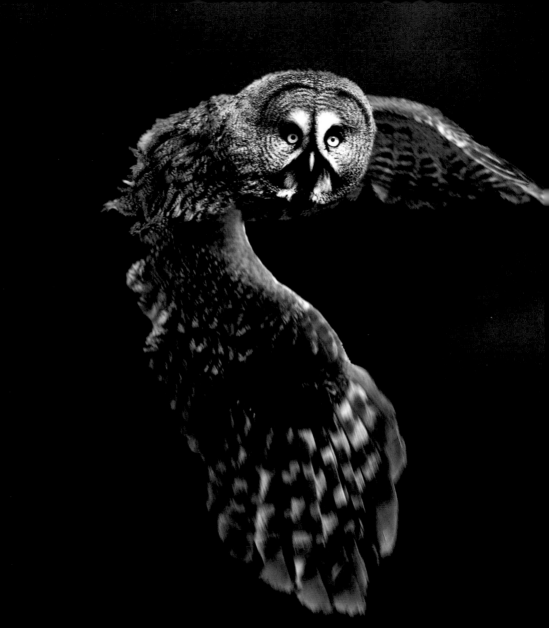

BROWN

The first paint was mud; the first pigment brown ocher. Hands dipped in dirt and water, fingers pressed on stone. Archaeologists find shells where humans 100,000 years ago ground clay and rock to make a pigment. In those ancient paintings, the color palette runs from iron oxide orange to burnt wood charcoal, a universe of color within the range of brown. For a painter, brown is a dark dead end out of which it is hard to extract clear colors. In the natural world, though, brown is as much a beginning, a force of nature, a foundation and a necessity in the cycle of life and the planet. Rocks, soil, roots, bark, mold, rot—brown, all brown. Brown soil nurtures the seed, carries the nutrients, supports the stalk. Brown becomes the seedbed for all colors.

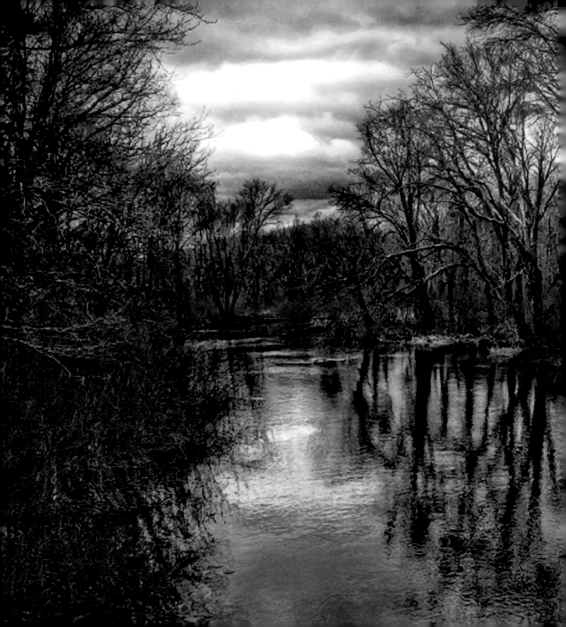

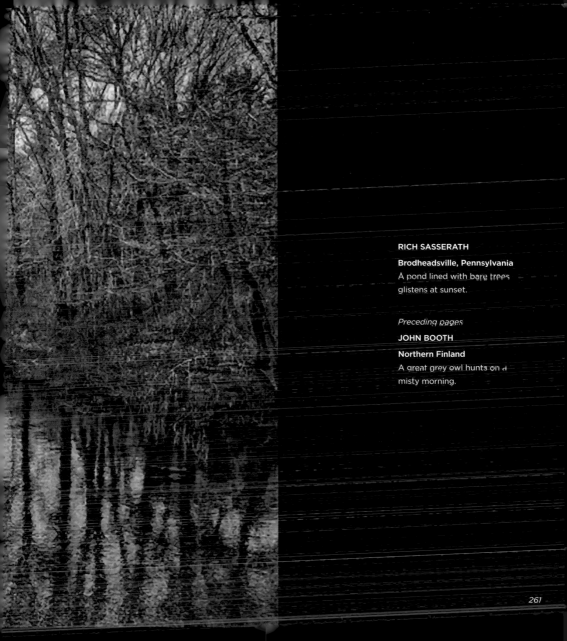

RICH SASSERATH

Brodheadsville, Pennsylvania
A pond lined with bare trees
glistens at sunset.

Preceding pages

JOHN BOOTH

Northern Finland
A great grey owl hunts on a
misty morning.

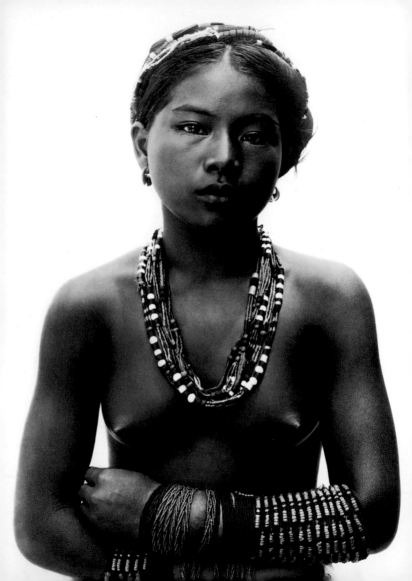

GERVAIS COURTELLEMONT

Bangkok, Siam (Thailand)

Fruits at a Bangkok market in 1934
grown in their native soil

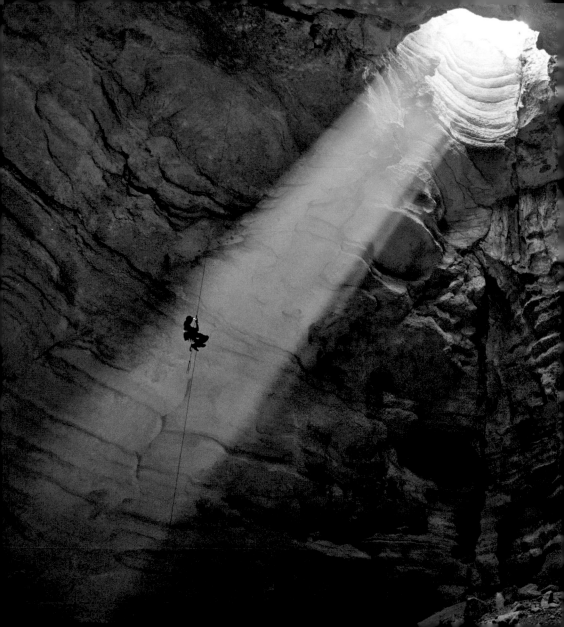

STEPHEN ALVAREZ

Majlis al Jinn, Oman
Spotlighted by a shaft of light,
a spelunker descends Majlis
al Jinn cave.

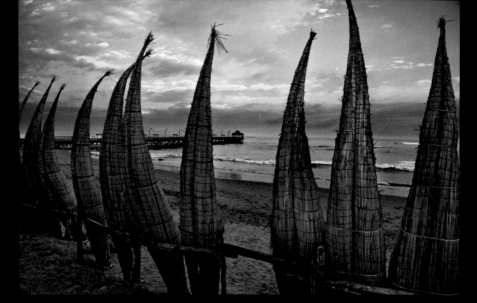

MICHAEL DE LA PAZ

Trujillo, Peru

Totora reed fishing boats line the
popular beach of Huanchaco.

Opposite

LINDA BROWN

Indianapolis Zoo, Indianapolis, Indiana

The slightly spiraled horns distinguish
the bongo antelope.

Following pages

MONTGOMERY GILCHRIST

Patagonia, Chile

A lone guanaco stands guard
over its herd in Torres del Paine
National Park.

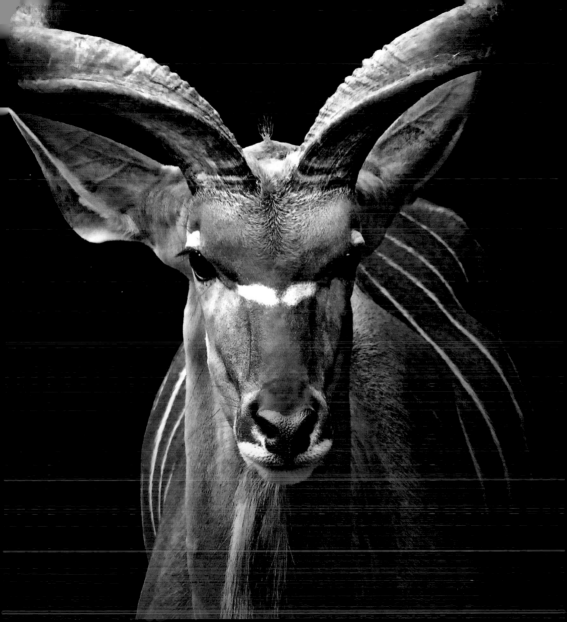

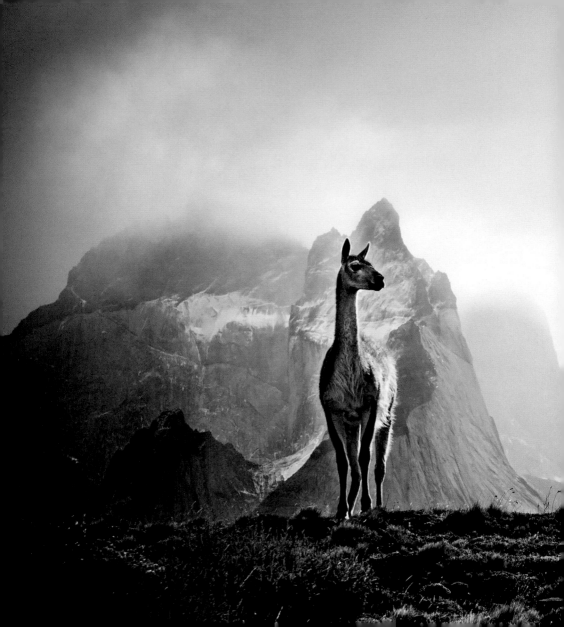

YELLOW

Yellow is color's lightest and brightest—
happy and optimistic.
Nature's gold,
it paints the landscape
with that rare and alluring element.

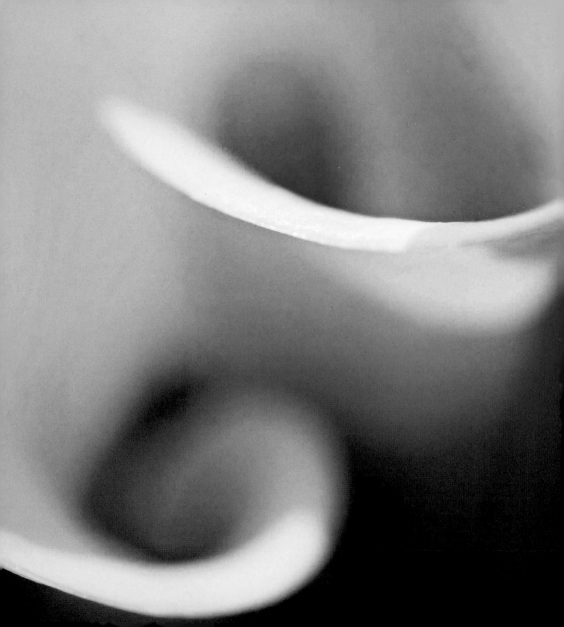

Yellow

Picture yellow as full-blown spring. Daffodils and forsythia, dandelions and daisies. Chicks just hatched, downy yellow feathers, perky eyes. Green buds rising, quickening with the invitation of new warm weather, minutes more sunlight every day. ❧ First opening shyly, pale yellow bursts forth in sumptuous bloom, its spring shine dancing in celebration. ❧ Yellow is said to symbolize the intellect, perhaps because yellow so often transcends the mundane world. The sun in the sky, the warbler flashing by, the aspen leaves ashimmer at the top of tall, tall trees ❧ Yellow is color's lightest and brightest. Nature's gold, it paints the landscape with that rare and alluring element. From the glint in the eye of a white-tailed doe, stepping into the field at sunset, to a surprise cluster of toadstools, insistent flecks of glistening yellow poking up out of moist brown mold –yellow is a welcome surprise. ❧ Yet yellow also oozes, a symptom of wounds and disease. Brimstone and sulfur bubble up and brew over, acrid essence from Earth's gut. The body, in healing, likewise exudes yellow. As time quells the pain of a bruise, black and blue turn yellow. Yellow signals natural healing, moving back into the light of health. ❧ Yellow makes connections in the world of color. It reaches out to green, sharing the brightness of growth in sunshine. At the same time it fades, growing paler, translated into a saffron-dyed garment, gauzy and loosely woven, a carefree wrap that feels the breeze amid tropic heat. Yellow disappears into clouds and whispers, coming so close to white that one wonders if it is even there.

FABRICE MILOCHAU

Fontainebleau, France
A golden light bathes a mixed
deciduous forest near Paris.

Preceding pages (272-275)
CHERYL MOLENNOR

New Port Richey, Florida
A detail displays the delicate beauty
of a yellow calla lily.

DAN PRICE

Joseph, Oregon
A lily-laden pond reflects palm trees
and an old Spanish mission.

MICHAEL E. LEWIS
Diafarabe, Mali, Africa
Yellow fabric makes a striking
contrast to the azure sky.

Following pages
JAMES L. STANFIELD
Giza, Egypt
A replica Vickers Vimy aircraft
circles the Pyramids of Giza.

JUSTIN GUARIGLIA
Shanghai, China
A bird's-eye view reveals many
levels of the Grand Hyatt hotel.

WINFIELD PARKS
Oakville, Ontario
A Canadian punch press operator
stamps out car parts in 1963.

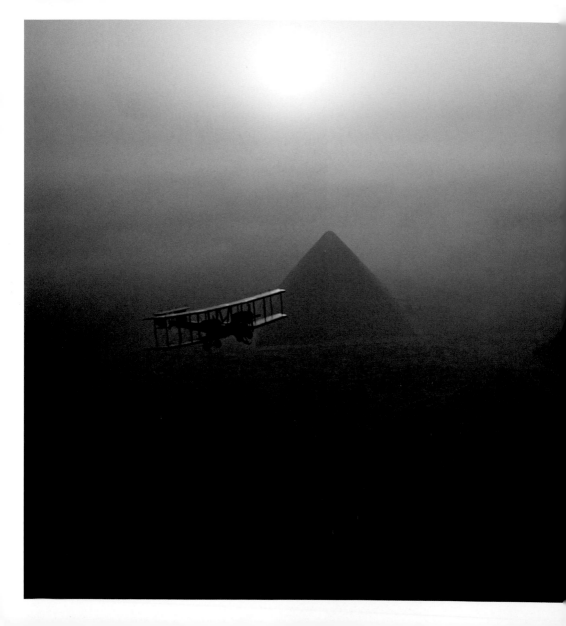

Yellow excites a warm
and agreeable impression . . .
The eye is gladdened,
the heart expanded
and cheered,
a glow seems at once to
breathe towards us.

~ JOHANN WOLFGANG VON GOETHE

The yellow fog that rubs its back

upon the window-panes,

The yellow smoke that rubs its muzzle

on the window-panes

Licked its tongue into the corners of the evening,

Lingered upon the pools that stand in drains, . . .

And seeing it was a soft October night,

Curled once about the house,

and fell asleep.

~ T. S. Eliot

JOEL SARTORE

Lincoln, Nebraska (studio shot)
Veins and spots mark the delicate
wing of a tiger swallowtail.

Following pages
MICHAEL MELFORD

Adirondack Park, New York
Lily pads rise to the surface of
Eagle Lake.

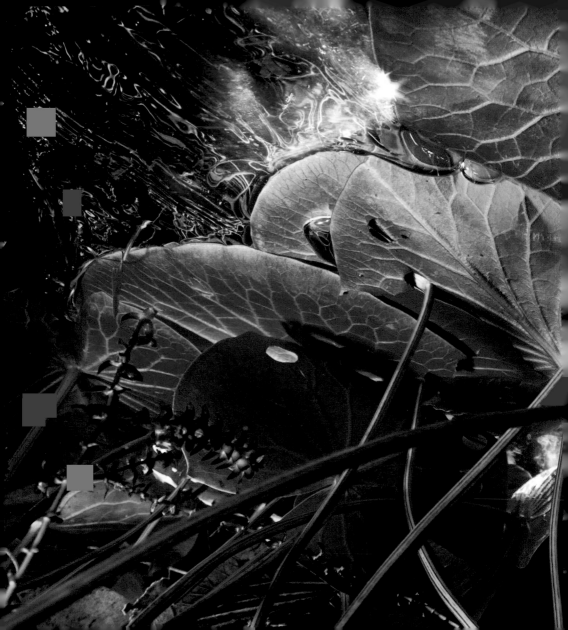

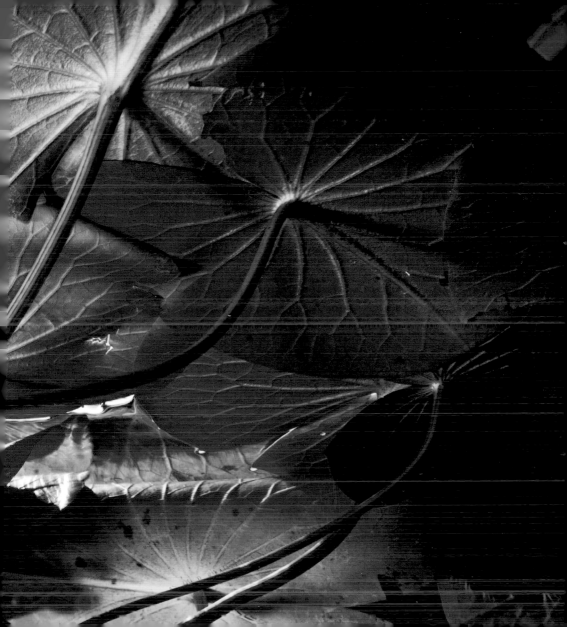

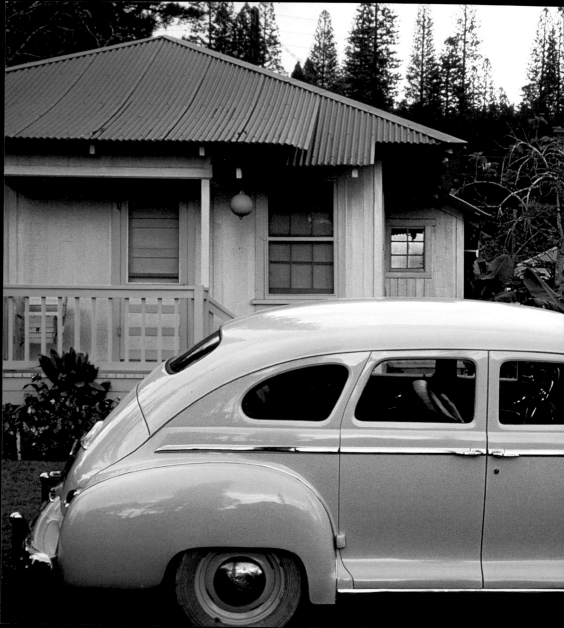

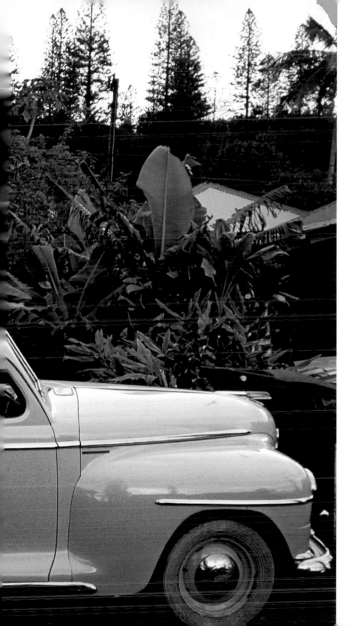

JIM RICHARDSON

Lanai Island, Hawaii
A yellow Plymouth matches a yellow
cottage in Lanai City.

JOEL SARTORE

Knoxville, Tennessee
A Malaysian golden gliding tree frog
perches on a branch.

Following pages
DAVID ALAN HARVEY

Ibiza, Spain
Revelers dance amid soapsuds at a
disco on the island of Ibiza.

MICHAEL NICHOLS

Simien Mountains National Park,
Ethiopia
A baby gelada baboon hitches a
ride on its mother's back.

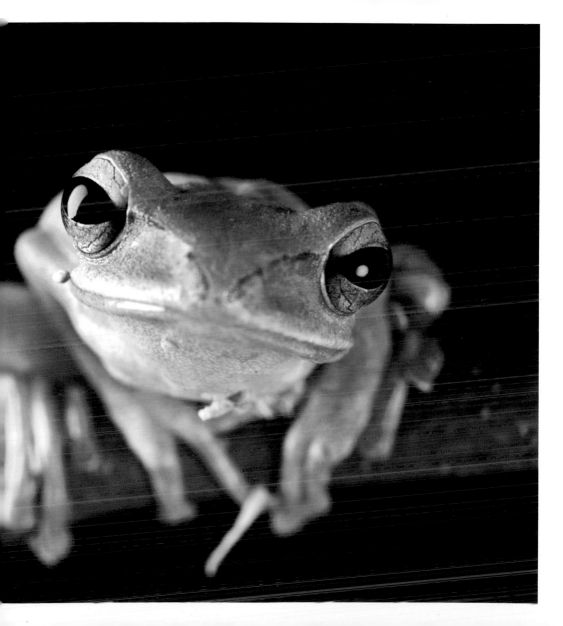

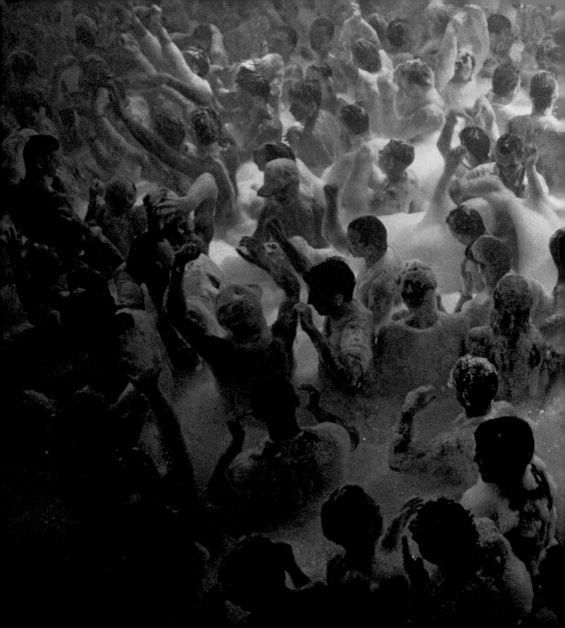

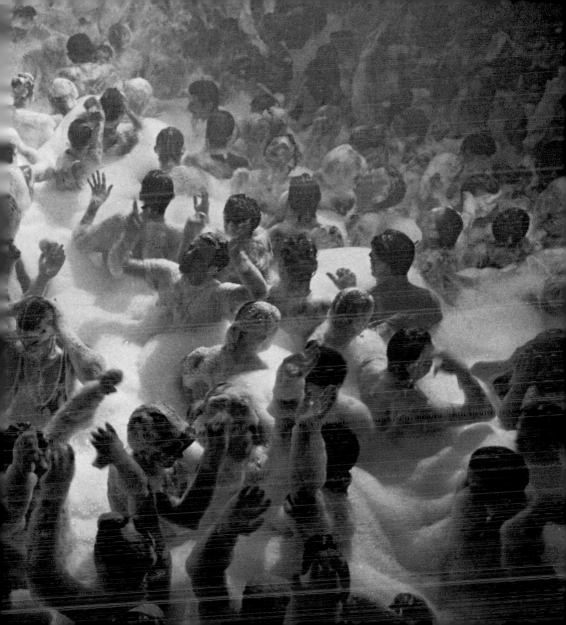

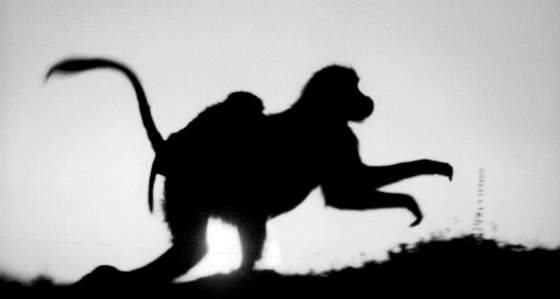

Nature rarer uses
yellow
Than another hue;

Saves she all of that

for sunsets,

—Prodigal of blue . . .

~ EMILY DICKINSON

CHRIS CARVALHO

Columbia River Gorge National Scenic
Area, Oregon and Washington
Oregon white oaks create a multihued
autumn landscape.

Following pages
MICHAEL MELFORD

Forillon National Park, Quebec
A yellow boat casts its reflection on
the water's surface.

KALPANA CHATTERJEE

New Delhi, India
Hindus throw colored powder at
a festival celebrating spring.

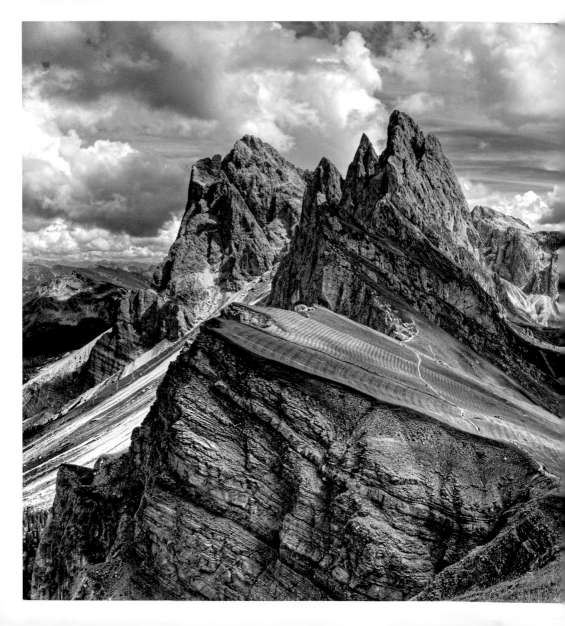

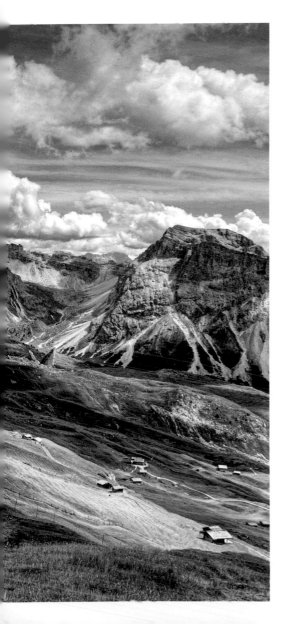

JAMES BUCHAN

Selva, Italy
Lush meadows blanket jagged
mountains in the Italian Alps.

Following pages
BENETA MARKAITYTE

Kaunas, Lithuania
Orange-tinged rose petals cluster
to create a delicate blossom.

TIM STARR

Near Golden, Colorado
A tiny ripple runs its course in
a freshwater creek.

The beauty that shimmers
in the yellow afternoons of October,
who could ever clutch it?

~ RALPH WALDO EMERSON

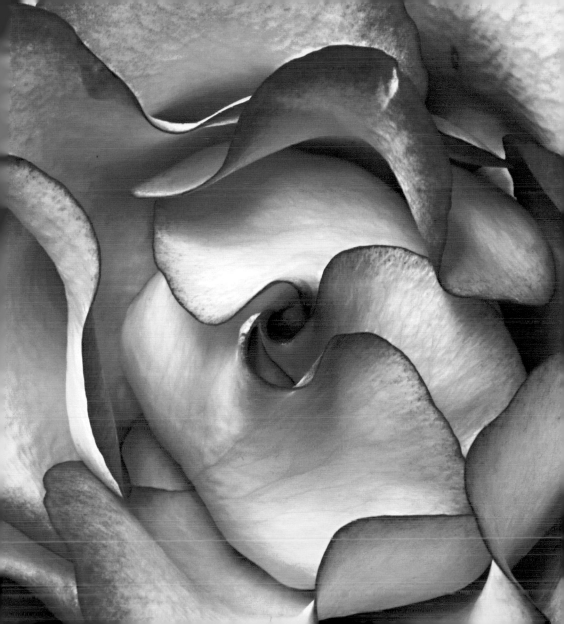

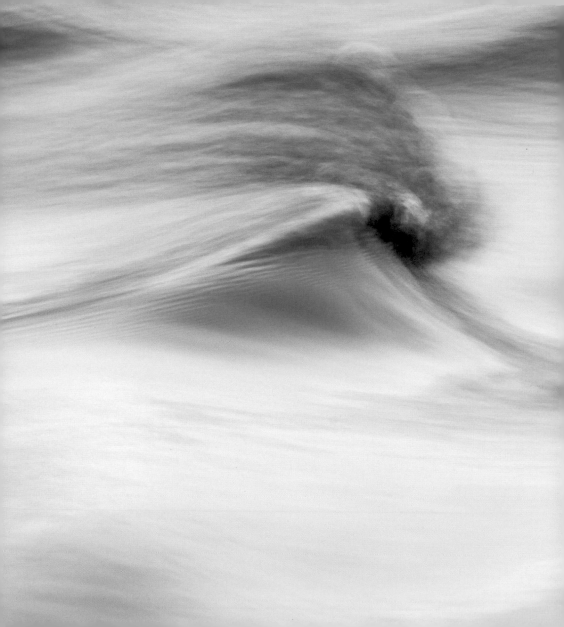

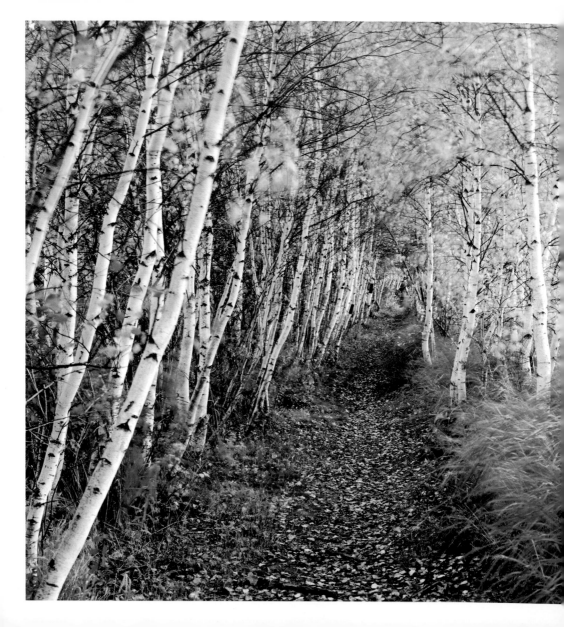

MICHAEL MELFORD

Acadia National Park, Maine
A woodland path invites visitors to
hike in the island park.

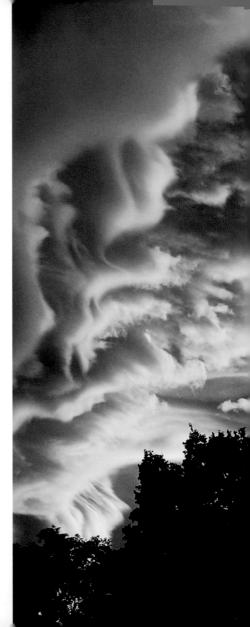

TANIS DANIELSON

Hammer Springs, near Christchurch,
New Zealand
Dramatic clouds and sunlight mix to
create an eerily beautiful sky.

Following pages
JAMES L. STANFIELD

Beypore, India
An Indian girl in traditional dress
protects herself from the rain.

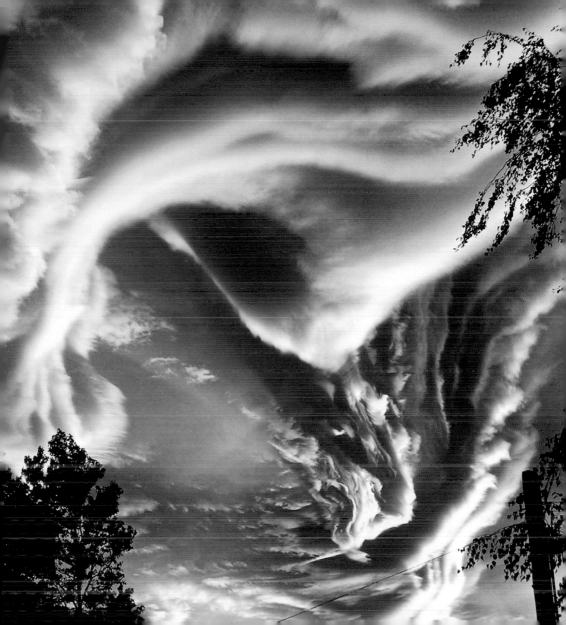

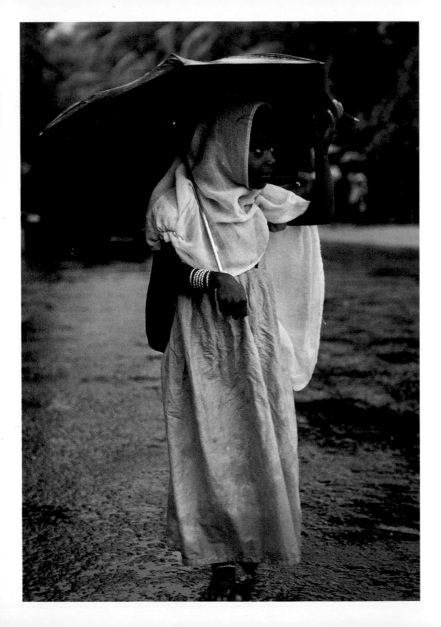

As the yellow gold
is tried in fire,
so the faith of friendship
must be seen in adversity.

~ Ovid

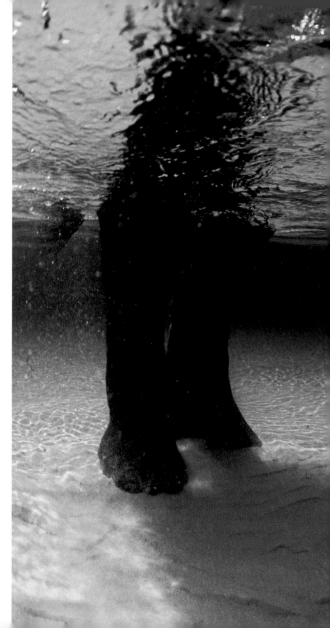

DAVID DOUBILET

Okavango Delta, Botswana
A mahout and his safari
elephant swim together
in the Okavango River.

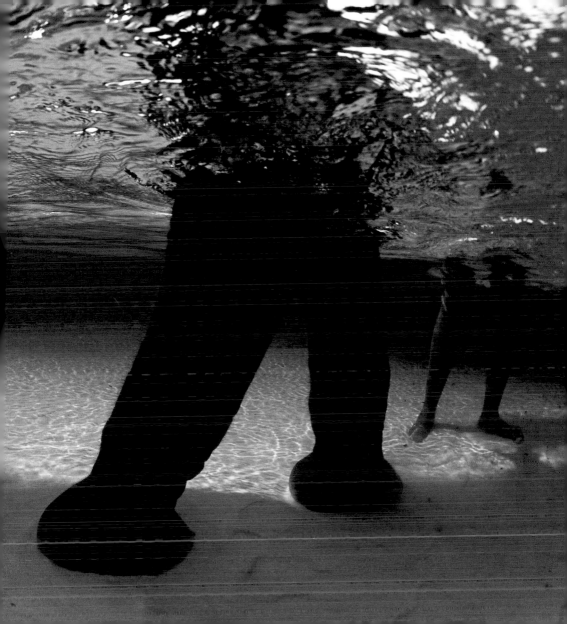

JODI COBB

Shanghai, China
Nanjing Road comes alive with
colorful lights at night.

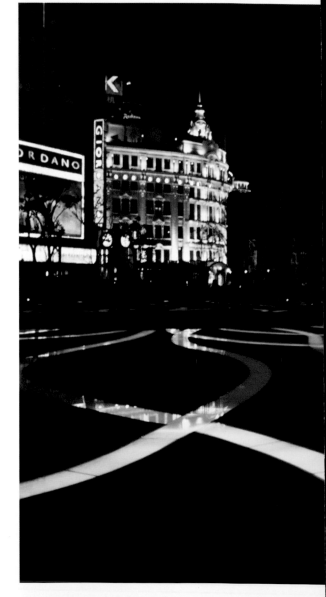

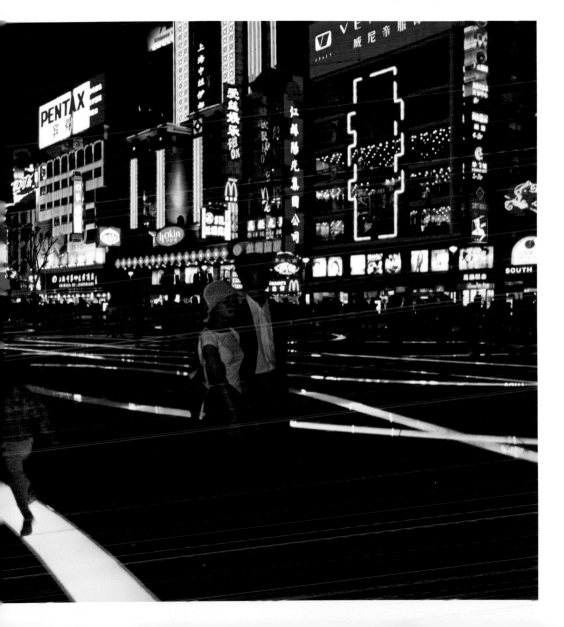

VALIO VASILEV

It's a dog's day at a local beach
where bikini-clad bathers gather.

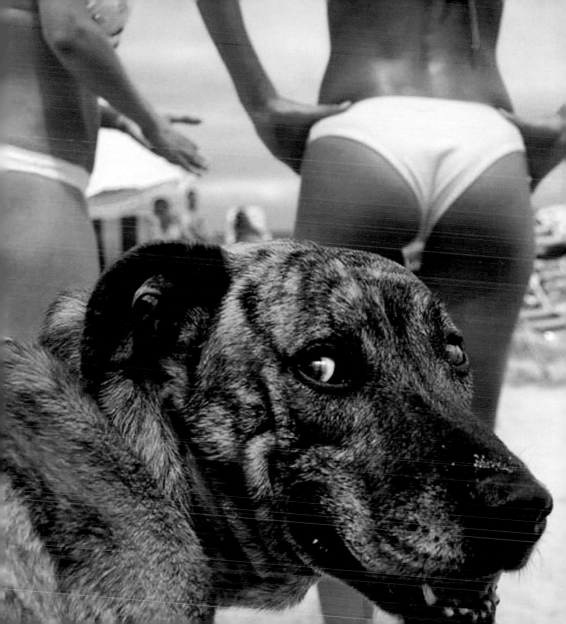

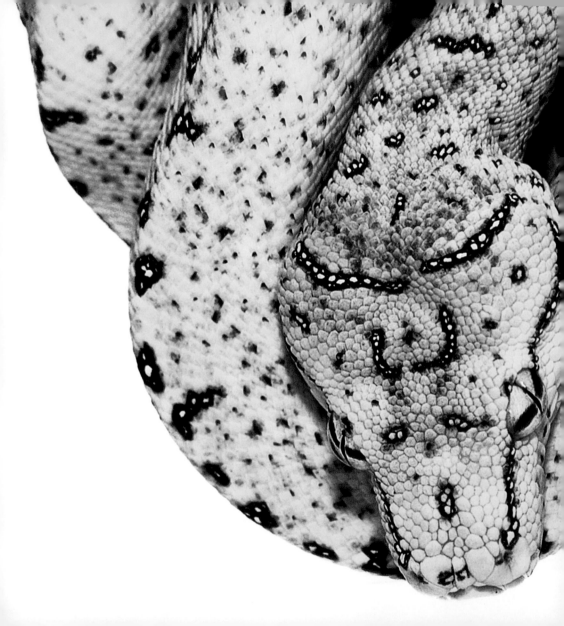

MIKE GUZMAN

Bronx, New York
A baby green tree python is
colored yellow at birth.

Following pages
BILL HATCHER

Queenstown, South Island,
New Zealand
Cottonwood leaves float down
the Shotover River.

There are painters who transform the sun to a yellow spot, but there are others who, with the help of their art and their intelligence, transform a yellow spot into the sun.

~ Pablo Picasso

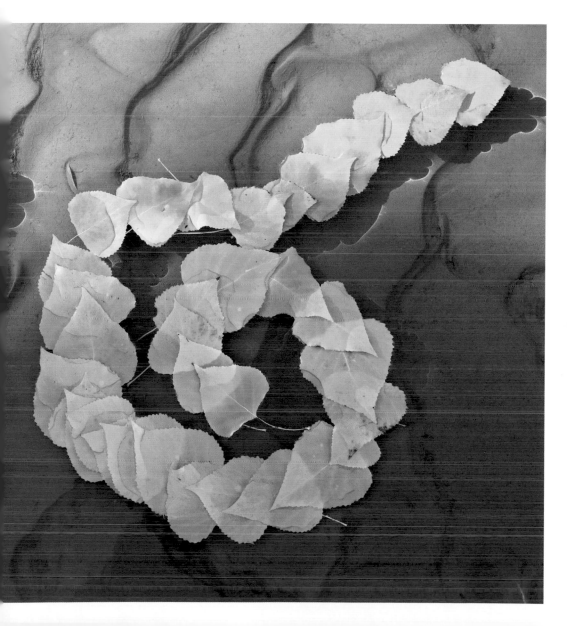

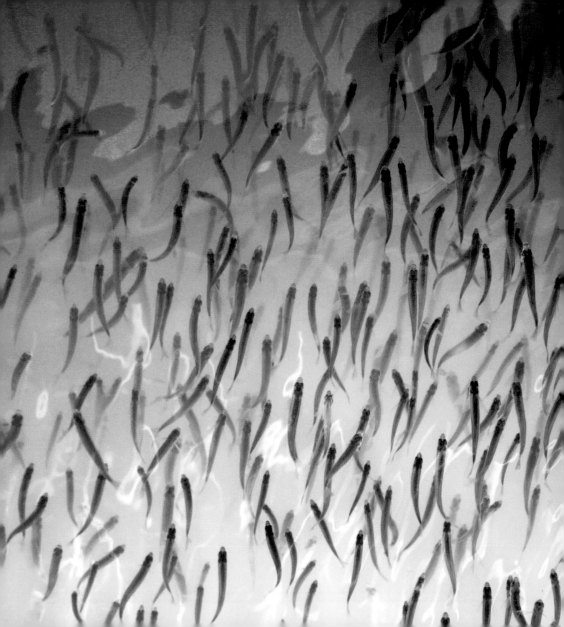

KEN RENK

Bolsa Chica Ecological Reserve,
Long Beach, California
Tiny fish scurry in the coastal
wetlands of the reserve.

Following pages
RITWIK DEY

Kolkata, India
A mask floats downriver
during a festival worshipping
a Hindu goddess.

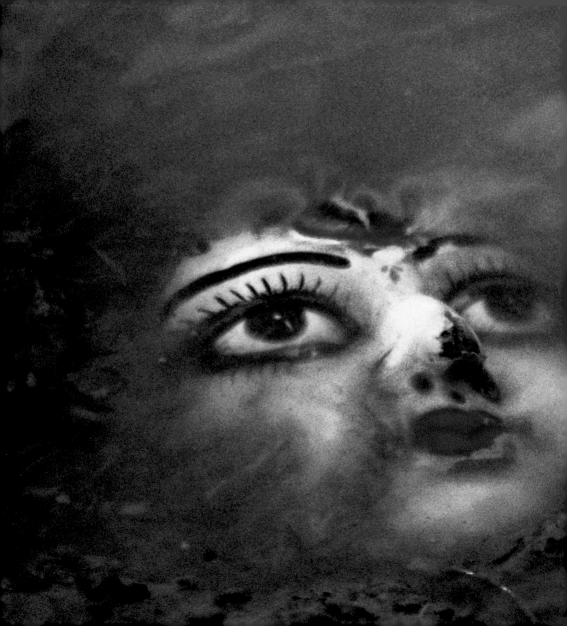

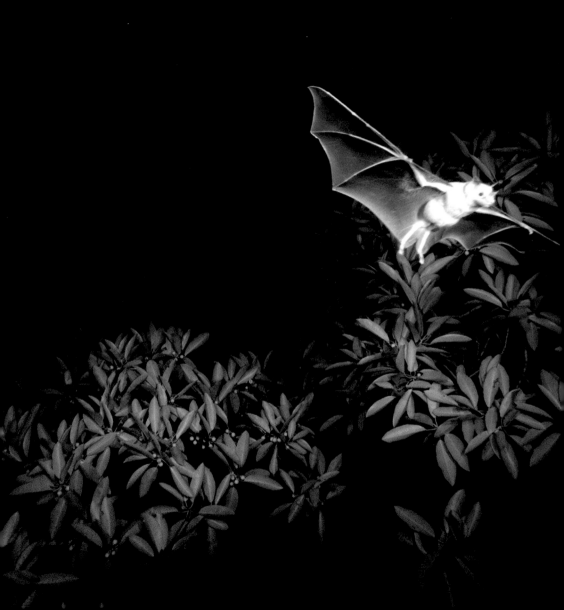

And then there is no color at all, and we plunge into black—the unknown and the unknowable. Substance without shape, presence without particulars. Connotations of evil—but perhaps that is only a fear of the dark projected onto a neutral screen. ✎ Theoretically, black is the absence of all color. And yet, conversely, black defines. Black lines distinctly generate a shape; black shadows throw that which is lighted into stark relief. Set against black, all colors step out and shine. ✎ A picture created only in black—a photograph made with black-and-white film, for example—carves out that glimpse of the world as a sculpture of light and shadow. Lines become bolder, objects gain volume, we feel as if we are looking at the scene more carefully. Stray colors do not distract from what is truly there to be seen.

BILL CURTSINGER

McMurdo Sound, Antarctica
An inch-long transparent jellyfish
glows in the dark.

Preceding pages
CHRISTIAN ZIEGLER

Barro Colorado Island, Panama
A pregnant female fruit-eating bat
approaches a fig tree.

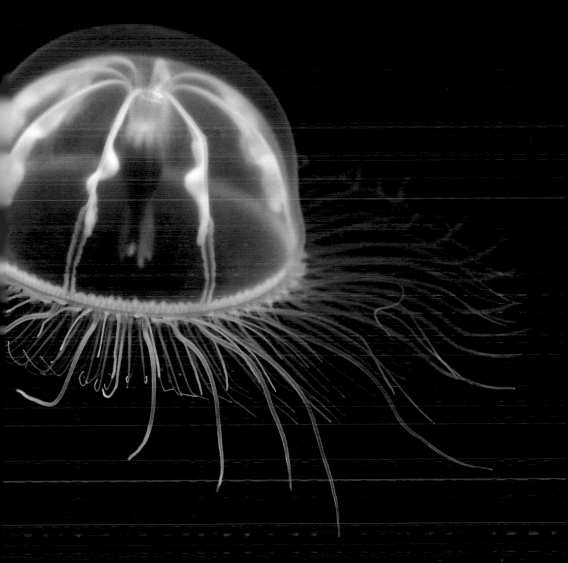

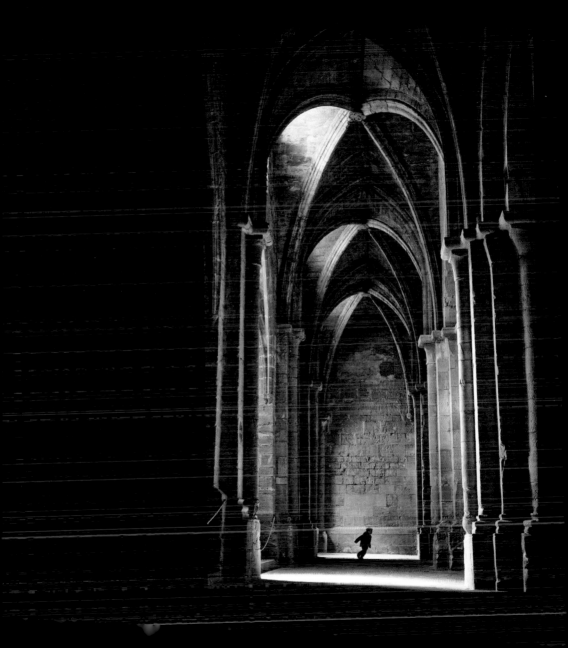

MICHAEL HANSON

Kigali, Rwanda

Boys play soccer at a village for
survivors of the Rwandan genocide.

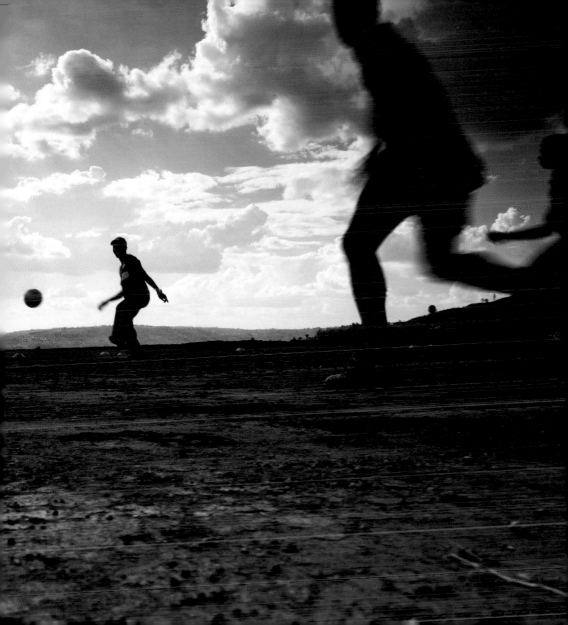

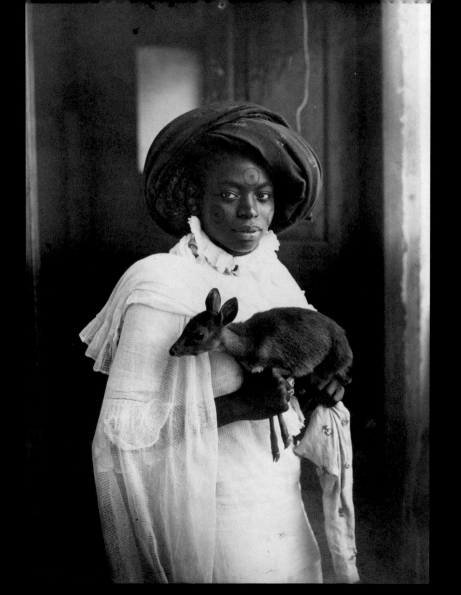

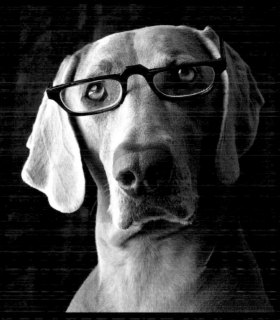

TONY R. WAGSTAFF

Ottawa, Ontario
A Weimaraner wears glasses in a studio portrait.

Opposite

UNDERWOOD AND UNDERWOOD

Mombasa, Kenya, Africa
A 1909 vintage photo shows a Kenyan woman holding a pet deer.

Following pages

ROBERTO FALCK

Ngorongoro, Tanzania
Maasai women exude the dignity for which their people are known.

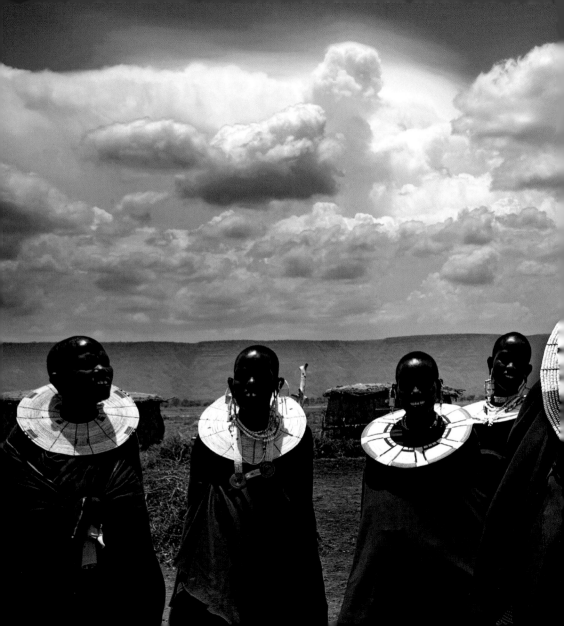

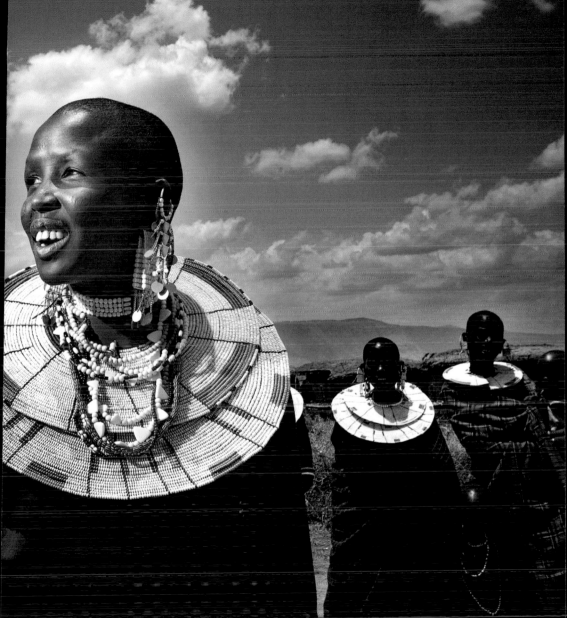

PURPLE

Of all the colors, purple smells
the most luxuriant. Imagine fresh
blossoms of lavender and rosemary
gently crushed between
thumb and forefinger.

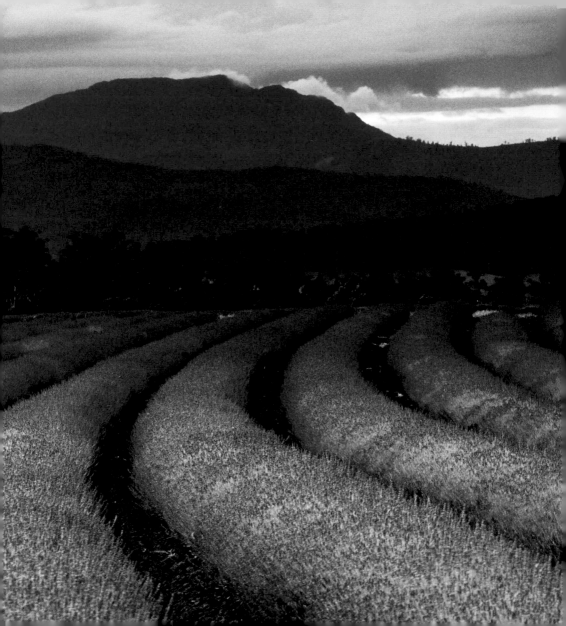

Purple

Shades of crocuses and violets, then lilacs and irises. From the shy first start of the season to the grand culmination of spring, purple is right there. Purple hums through the buds before they open and revives as they mature. Purple striates the trunks and paints the twigs of towering trees, as if that purple is the lifeblood of nature coursing through them. As below, so above. We glimpse purple in the promise of dawn before sunrise and in fast-fading stripes across evening skies after the sun goes down. ⤜ Regal and silent, velvety and voluptuous, purple is the shade of secrets and shadows. Purple whispers hide in the folds of heavy curtains. Purple possibilities lurk around every corner on a moonless night. Purple is the color of majesty and mystery. It is distant, aloof, and hazy; transcendent. One of the earliest colors collected from nature, purple was found lurking in the flesh of shellfish millennia ago. Who was the wild-eyed artist who first crushed the shell and streaked plain cloth with the richly colored phlegm of a beach-found murex? ⤜ To aspire to purple is to command both reverence and fear. The color of royal garments. The glint in a jaguar's eye. Raw rock cliffs jutting out at angles from the softer blue ridge of mountains covered with trees. ⤜ Of all the colors, purple smells the most luxuriant. Imagine fresh blossoms of lavender and rosemary gently crushed between thumb and forefinger. Breathe in the bouquet of deep red wine poured from a green bottle, splashing ever so gently inside the curve of a clear glass globe. Ah, the taste of purple.

ROBERTO PAGANI
Abbiategrasso, Italy
Dusk decorates an ancient fortress
near Milan with color.

Preceding pages (344-47)
GERD LUDWIG
Nabowla, Tasmania
Night settles over lavender fields in
northeast Tasmania.

CARY WOLINSKY
Baldev Village, Uttar Pradesh, India
Dyes mixed with water rain on
women at a festival.

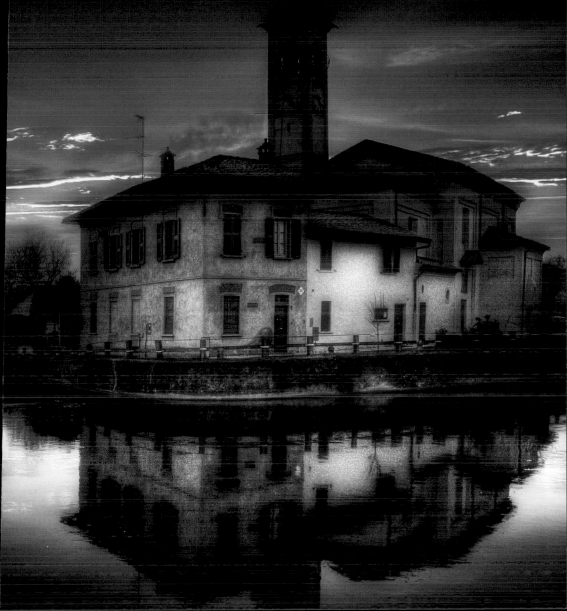

BETTY BERARD BROUSSARD

Lake Martin, Louisiana
A camera's flash fills an owl's eyes
with light on a rainy night.

Following pages

IAN FLINDT

East Mersea, United Kingdom
Sea meets sky at England's most
easterly populated island.

CATHERINE KARNOW

Paris, France
Reflections of a strip club cast neon
lights on a car in Pigalle.

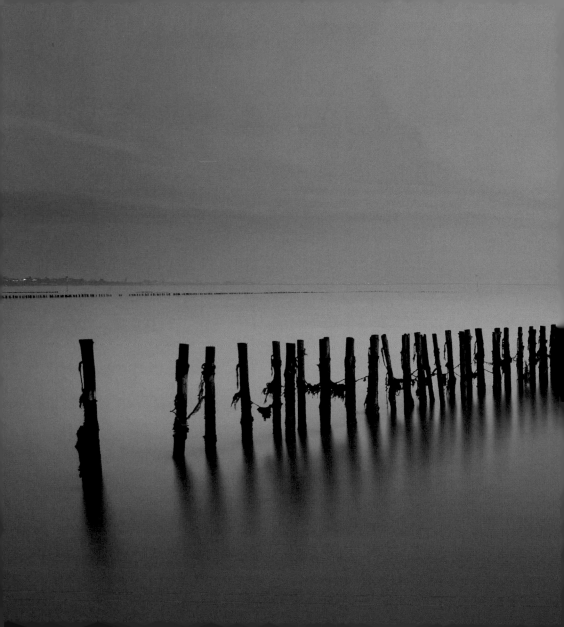

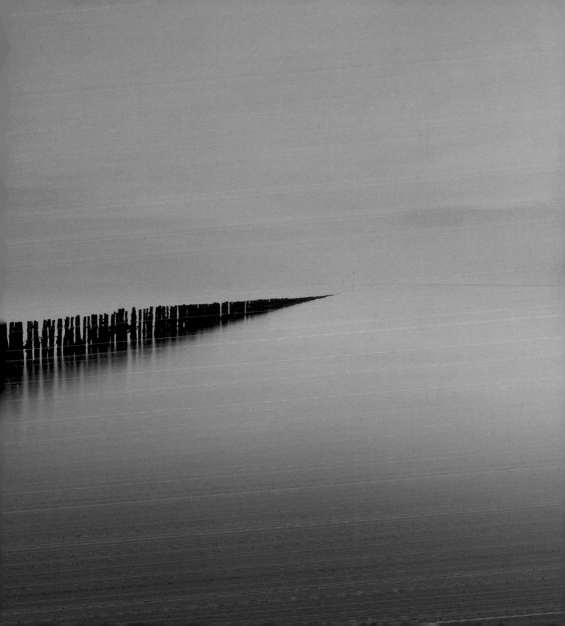

I wanted change and excitement

and to shoot off in all directions myself,

like the colored arrows

from a Fourth of July rocket.

~ Sylvia Plath

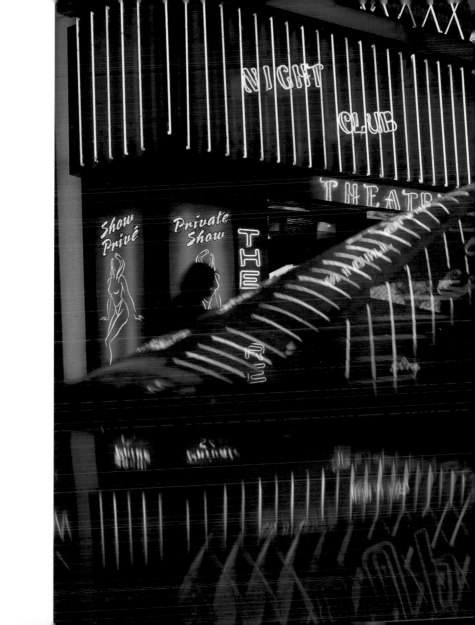

CAROLINE WOLDEN

Mount Vernon, Washington
Petals part for a sneak peek inside
a tulip during a festival.

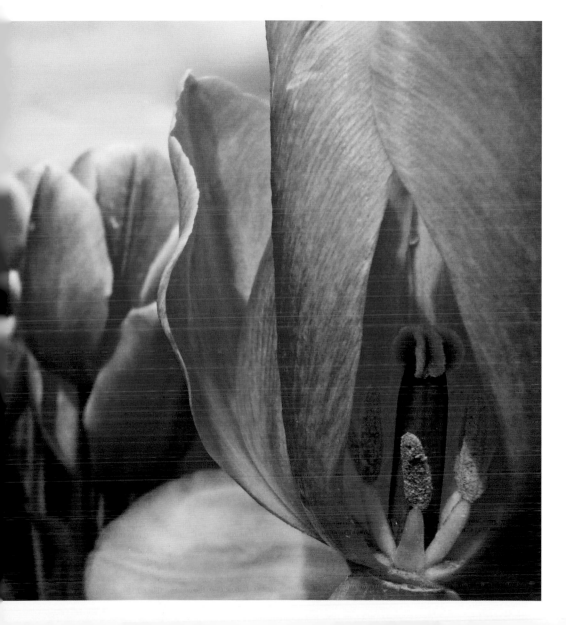

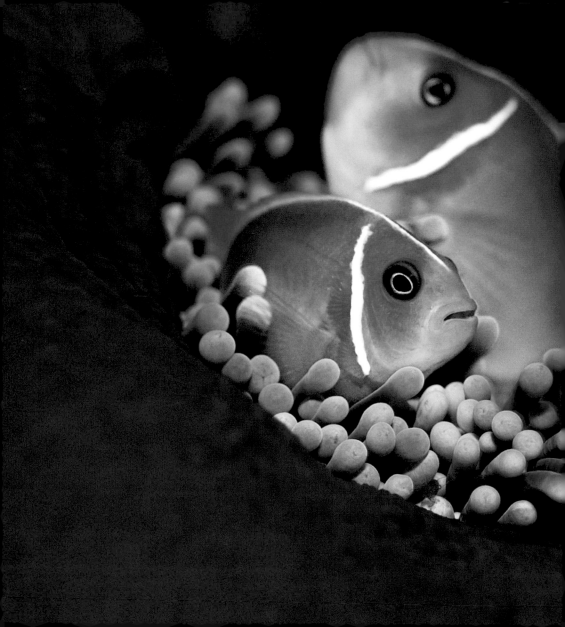

RICHARD BARNDEN

Republic of Palau
Clownfish nestle in the midst of
sea anemones

Following pages
CRISTINA IACOB

Lassen Volcanic National Park,
California
The placid waters of Lake Helen
mirror a golden sunset.

NATIONAL GEOGRAPHIC SOCIETY
ARCHIVE

Biskra, Algeria
Coins and bangles bejewel an Ouled
Nail tribal dancer, 1917.

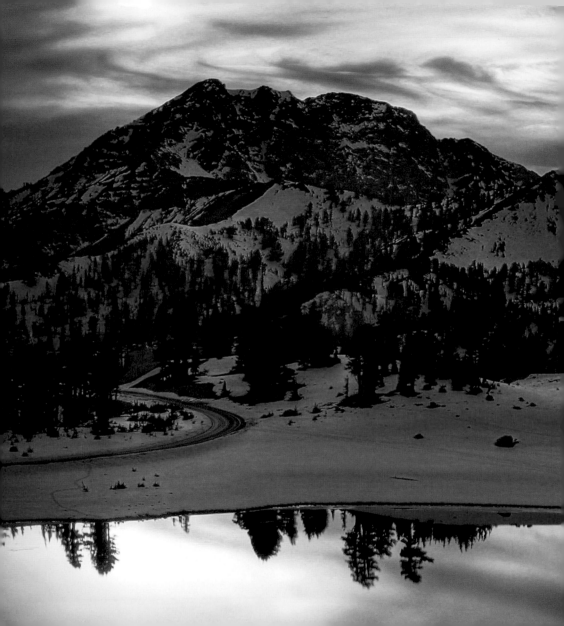

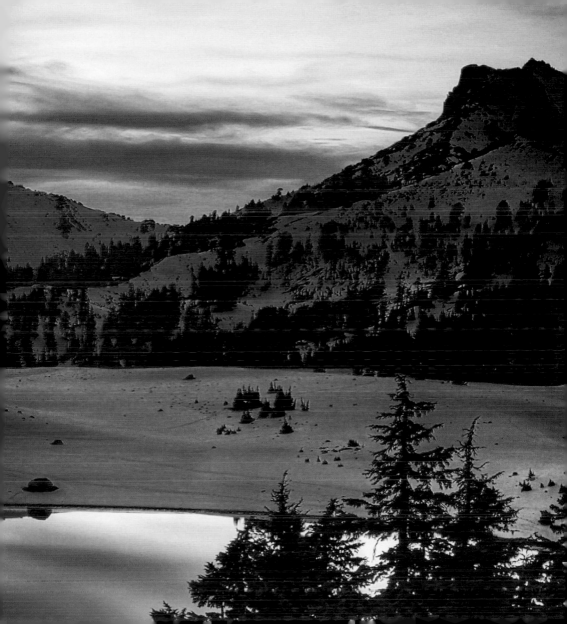

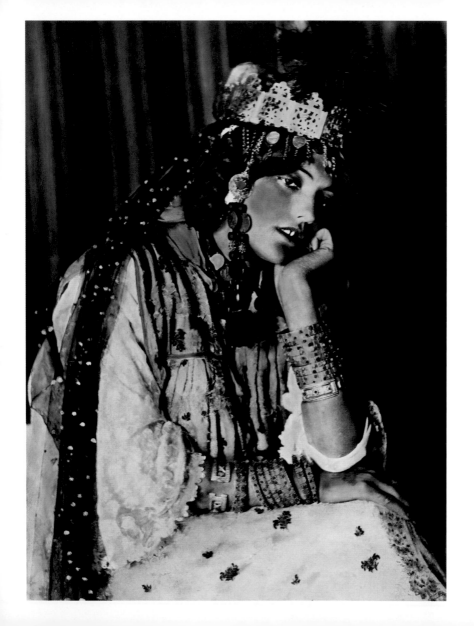

Lavender is for lovers true.

Which evermore be fain

Desiring always for to have

Some pleasure for their pain.

And when that they obtained have

The love that they require

Then have they all their

perfect joy

And quenched is the fire.

~ FROM AN ELIZABETHAN SONG

PETE MCBRIDE

Antigua, Guatemala

A man swings an incense thurible during a Good Friday procession.

Following pages

W. E. GARRETT

Guangxi Zhuang Autonomous Region, China

Multicolored light showcases limestone formations in Reed Flute Cave.

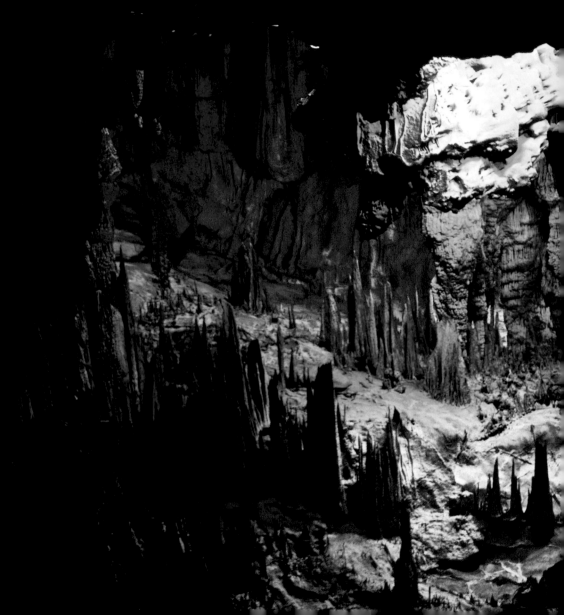

AMY WHITE AND AL PETTEWAY

Seattle, Washington

A belly dancer shows off her
painted midriff.

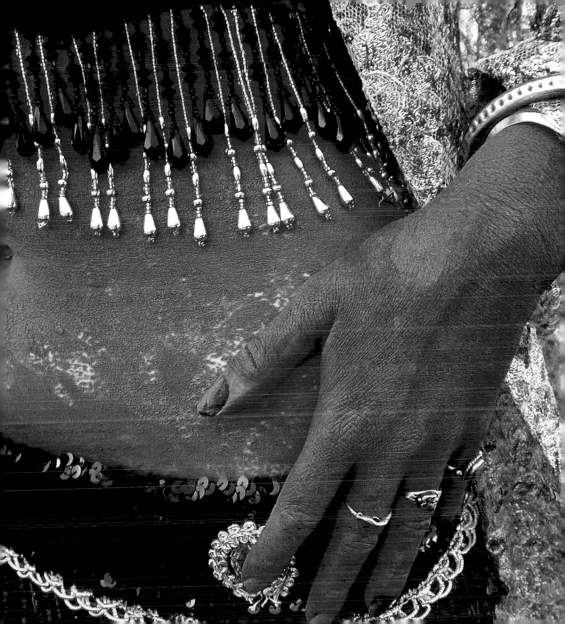

ANNIE GRIFFITHS

Yellowstone National Park,
Wyoming
Thermal waters bubble and steam in
Mammoth Hot Springs.

Following pages
BRIAN J. SKERRY

Gulf of Saint Lawrence, Canada
A whitecoat harp seal rests on ice
under a twilight sky.

JOSÉ YEE

San Jerónimo, Baja Verapaz,
Guatemala
A wine-throated hummingbird
displays its colorful neck feathers

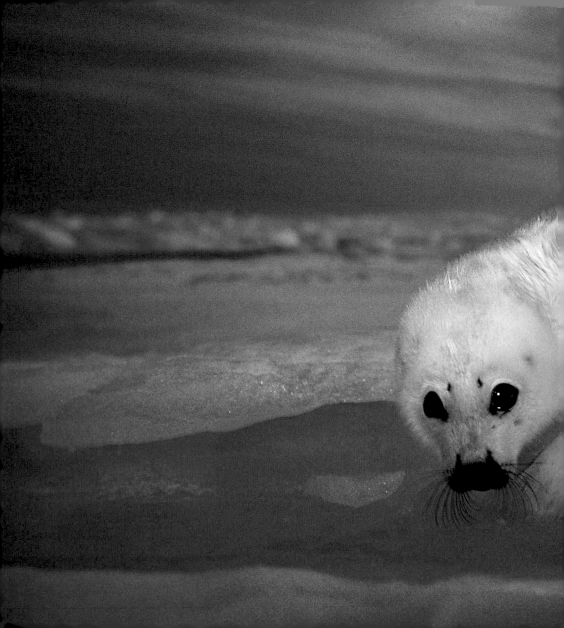

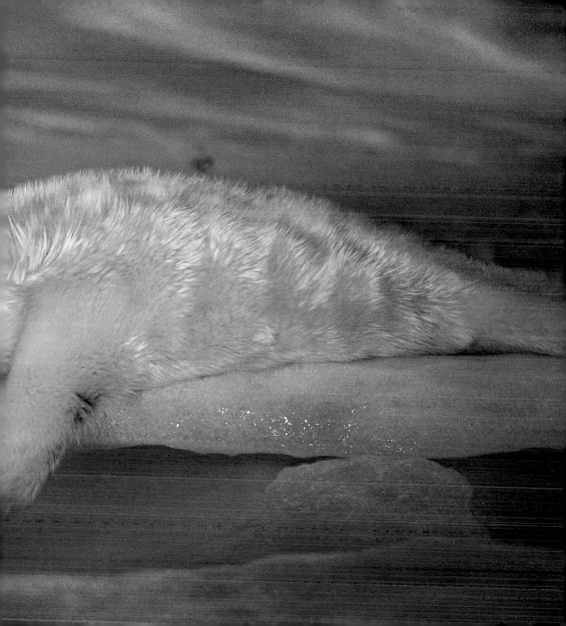

My heart leaps up

when I behold

A rainbow in the sky.

So was it when my life began,

So is it now I am a man,

So be it when I shall grow old

Or let me die!

~ WILLIAM WORDSWORTH

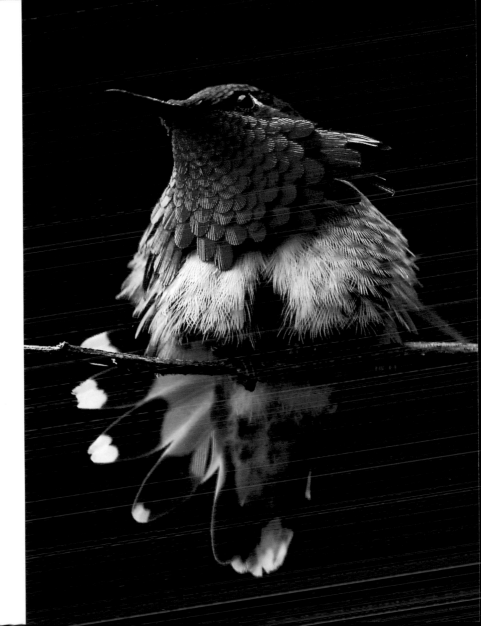

GREG FRENCH

Salisbury, Maryland
Shafts of light illuminate a large tree
in a small subdivision.

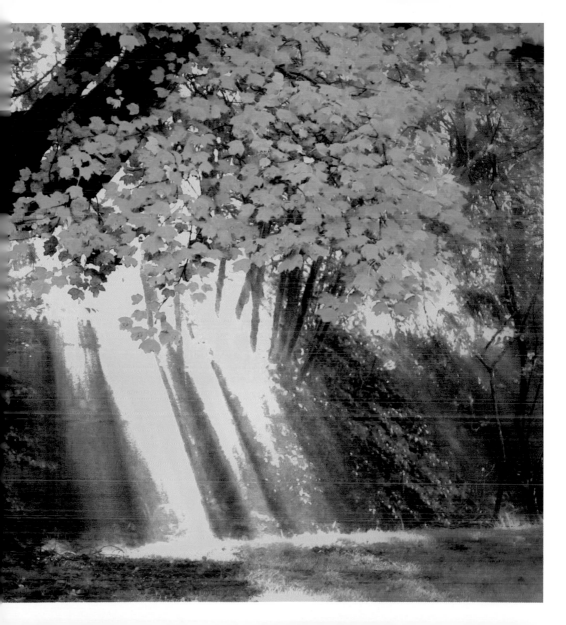

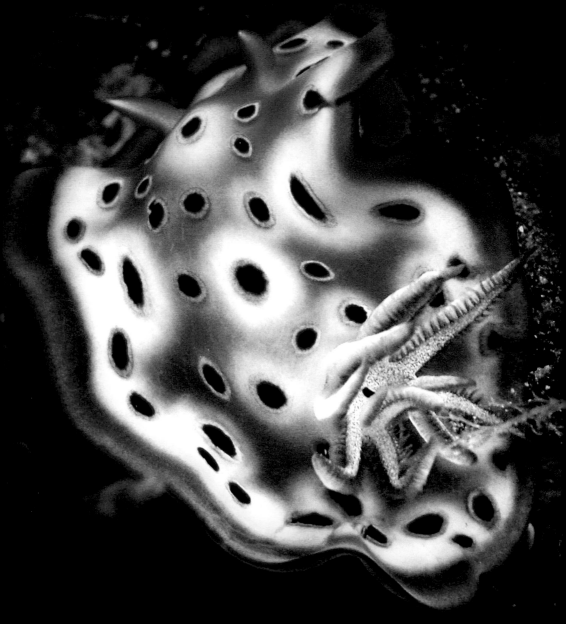

MAREE TOOGOOD

Republic of Vanuatu, South Pacific
A colorful sea slug swims
underwater near the island nation.

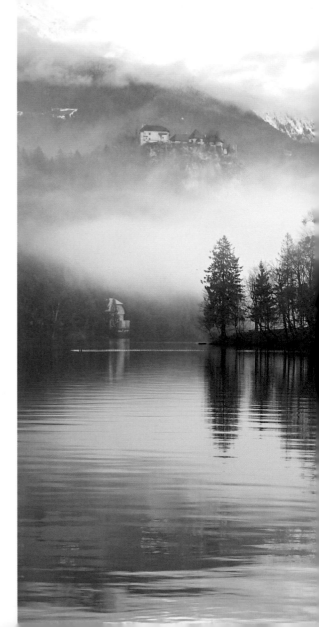

ANDREJA DONKO

Bled Island, Slovenia
After a storm, medieval Bled Castle
emerges from a veil of mist.

Following pages
JOEL SARTORE

Lincoln, Nebraska
A four-year-old girl in braids proudly
wears a tiara.

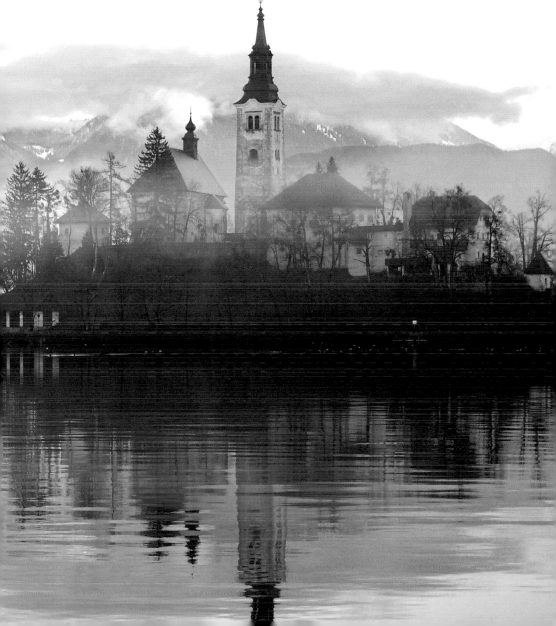

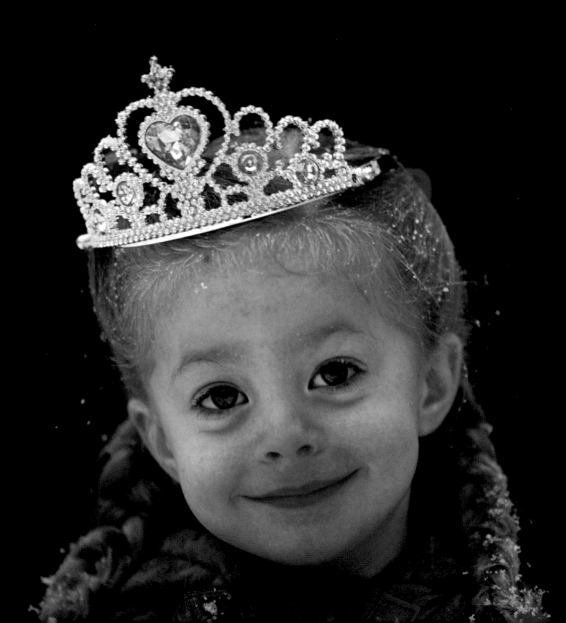

Ah, yes! I wrote the "Purple Cow"—

I'm sorry, now, I wrote it!

But I can tell you, anyhow,

I'll kill you if you quote it.

~ Gelett Burgess

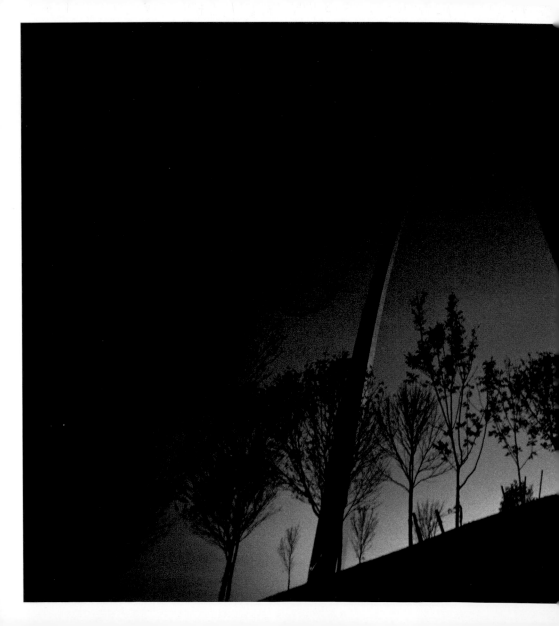

ANNIE GRIFFITHS

St. Louis, Missouri
The Gateway Arch rises over the
Mississippi River.

Following pages
SCOTT BYCROFT

Bali, Indonesia
An encroaching storm lights up the
sky toward Java.

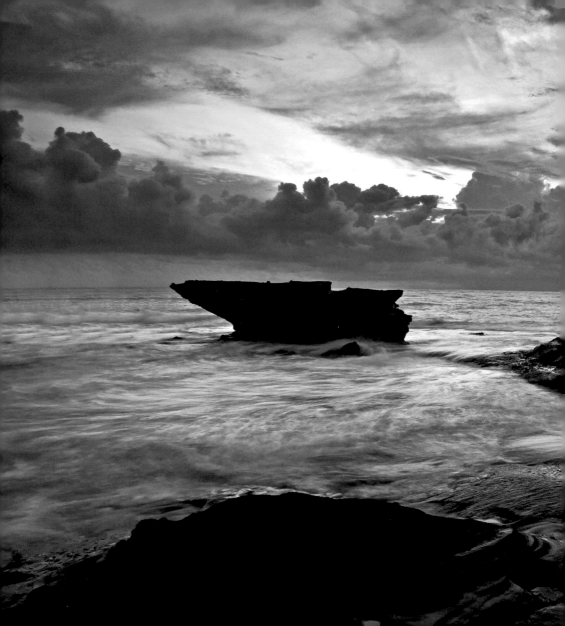

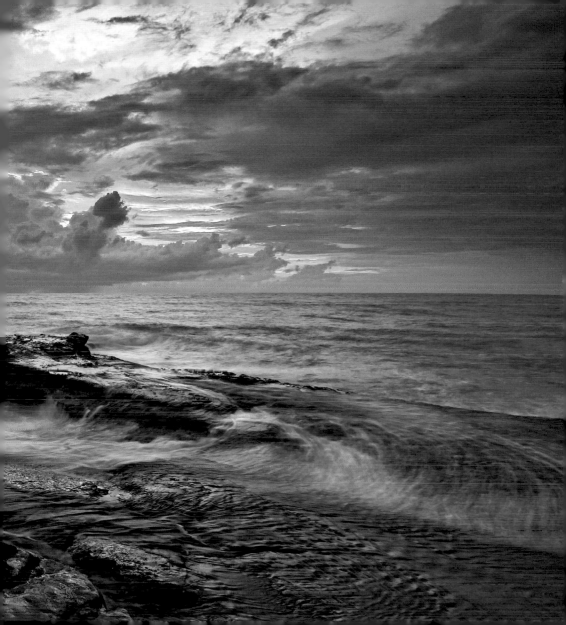

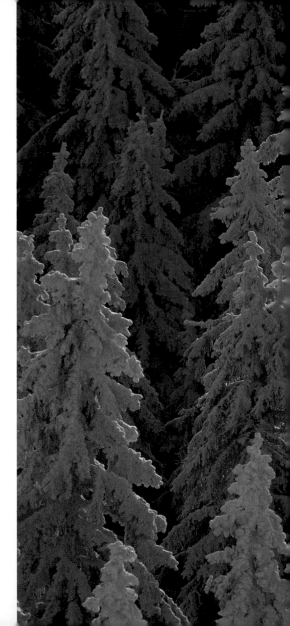

NORBERT ROSING

Nature Park Suedschwarzwald,
Germany
Snow blankets fir trees in the Black
Forest at sunrise.

Following pages
BRETT EASTON

Wollaton Hall, United Kingdom
Bucks rest in the soft grasses of the
country estate's parkland.

J. BAYLOR ROBERTS

Gastonia, North Carolina
A cotton festival queen sits amid
spools of cotton in 1941.

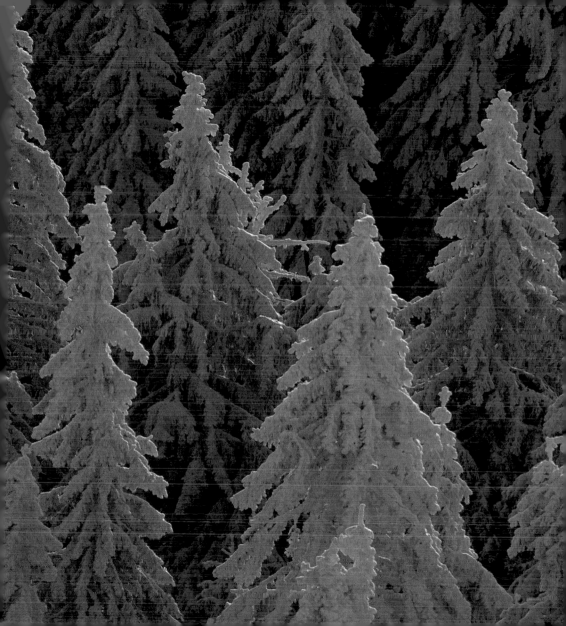

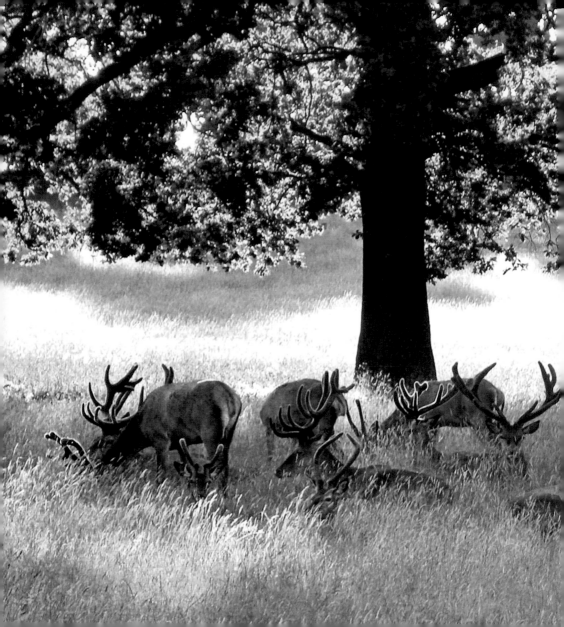

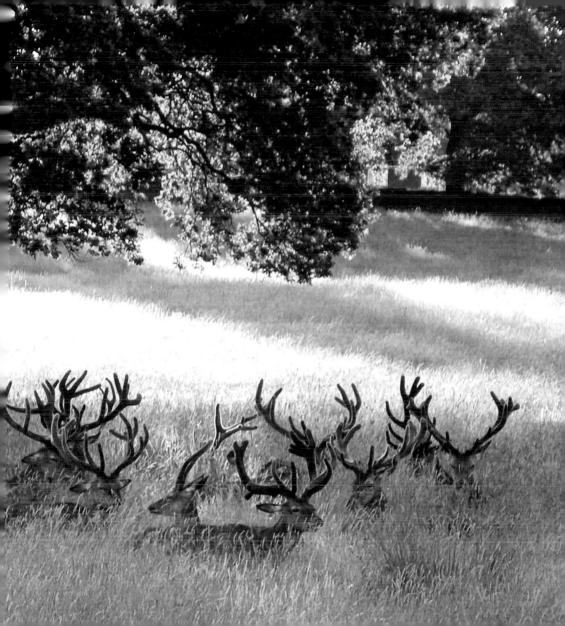

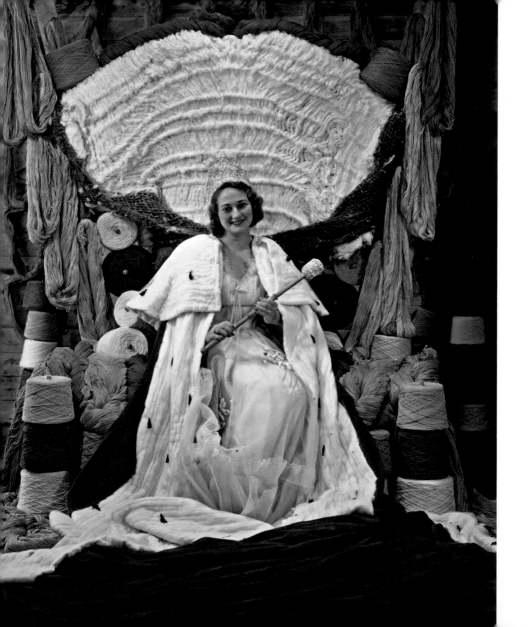

Violet is red

withdrawn from

humanity

by blue.

~ WASSILY KANDINSKY

EMANUELE PICCHIRALLO

Edinburgh, Scotland
A street artist performs with fire
during Edinburgh's Festival Fringe.

Following pages
JOSH RUSHING

Camp Bucca, Iraq
A girl wearing a hijab waits to visit
her detained father.

Colors are the smiles of Nature.

When they are extremely smiling,

and break forth into other beauty besides,

they are her laughs;

as in the flowers.

~ LEIGH HUNT

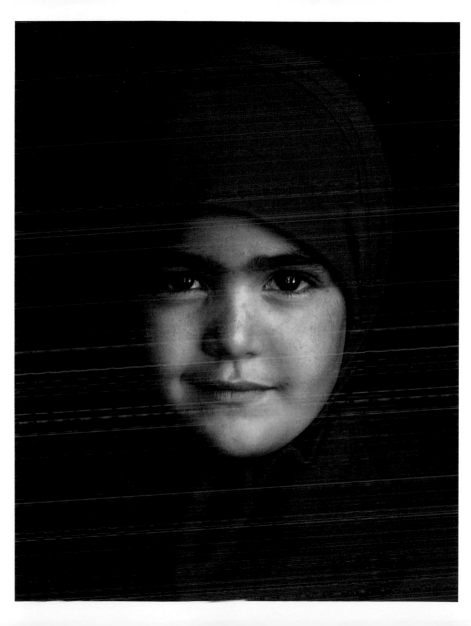

ROBERT MADDEN

Smith Island, Maryland
A full moon rises over a picket fence
at Rhodes Point.

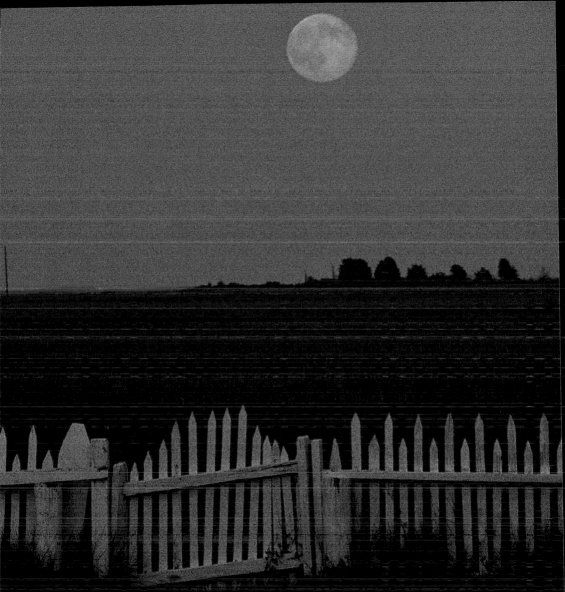

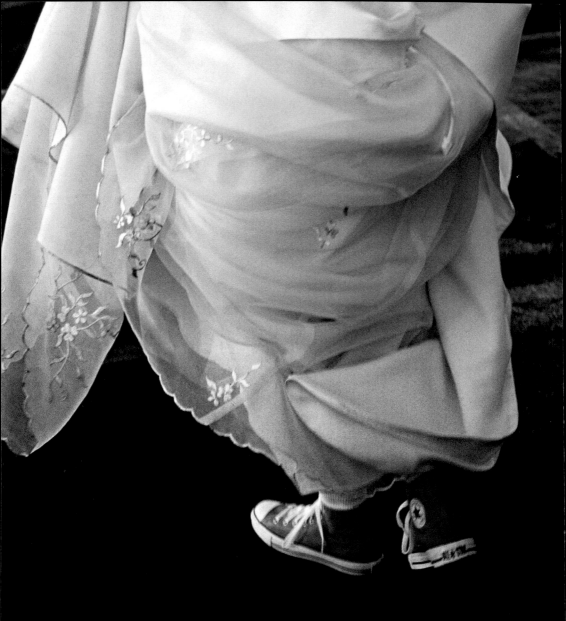

JODI COBB

Las Vegas, Nevada
A bride pairs her gown with pink
high-top athletic shoes.

Following pages
JODI COBB

Monte Carlo, Monaco
Ballet tutus await the next
performance in the Salle Garnier.

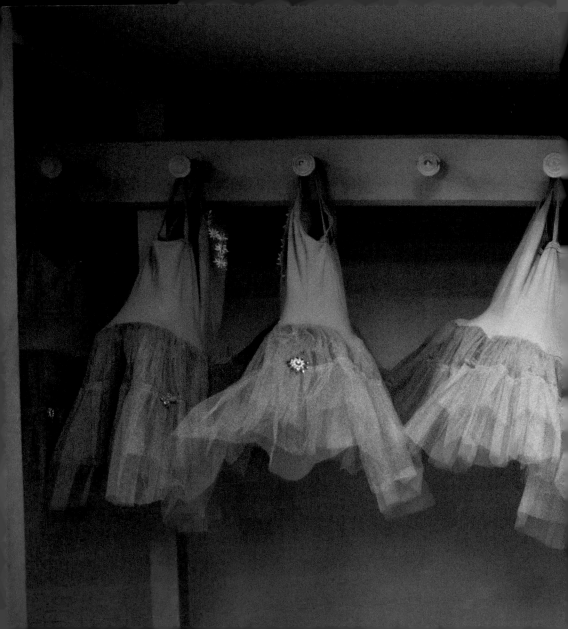

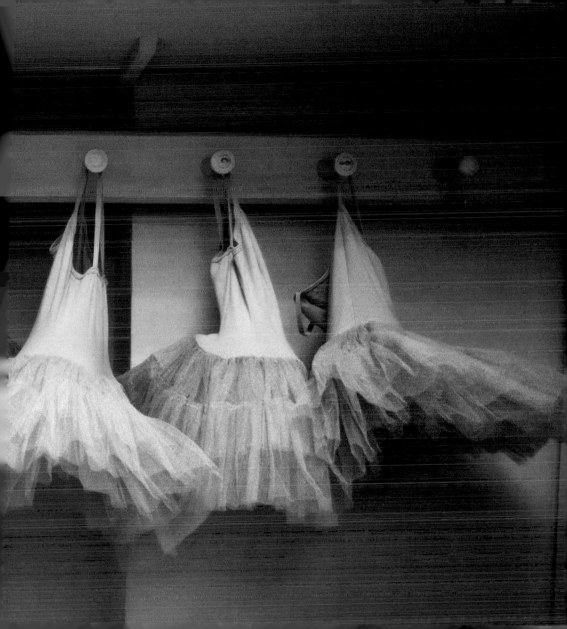

GOLD

Ships have sailed, wars have been waged, lives have been lost in the struggle to lay hands on gold. It is a hue beyond mere mortals: the color of wealth, of power, of the gods. In centuries past, to elevate a painting into an icon, the artist would apply gold leaf: fine metal hammered into delicate sheets and applied as if a paint to the surface. Hair, wings, halo, even the sunlight itself thus gilded took on intimations of the divine. ❧ Against such a history, even momentary glimmers strike us as glimpses of a better world. Slant light skipping off dappled waters. The snap of a fish tail, arcing up out of the water, an eruption of iridescence—flash, then it disappears. Shimmering autumn leaves. Rare reminders of an element rarer still —a world standard for majesty and magnificence.

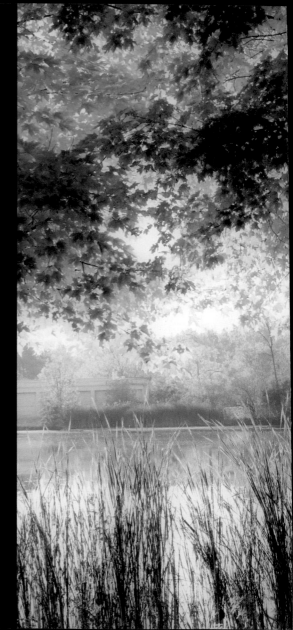

BARB THORNTON

Hines Park, Plymouth, Michigan
Autumn comes alive in the
woodland park early one morning.

Preceding pages

JORGE SAENZ

Rio de Janeiro, Brazil
A feathered dancer rides on
a hummingbird float in the
Carnival parade.

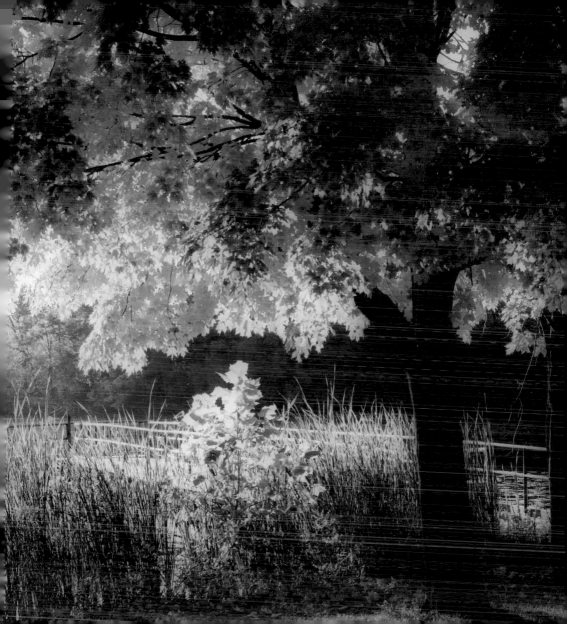

WILLIAM ALBERT ALLARD

Rarotonga Island, Cook Islands,
New Zealand
A girl enters a church after missing
a band's performance.

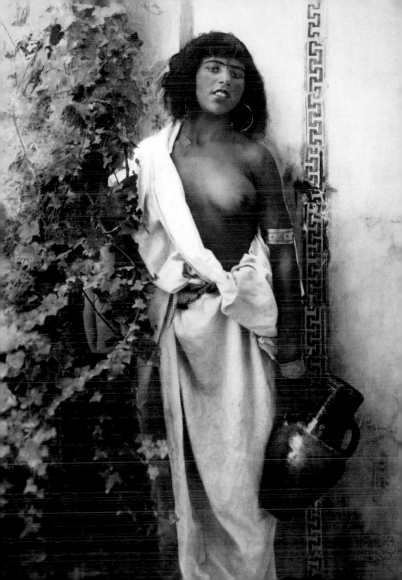

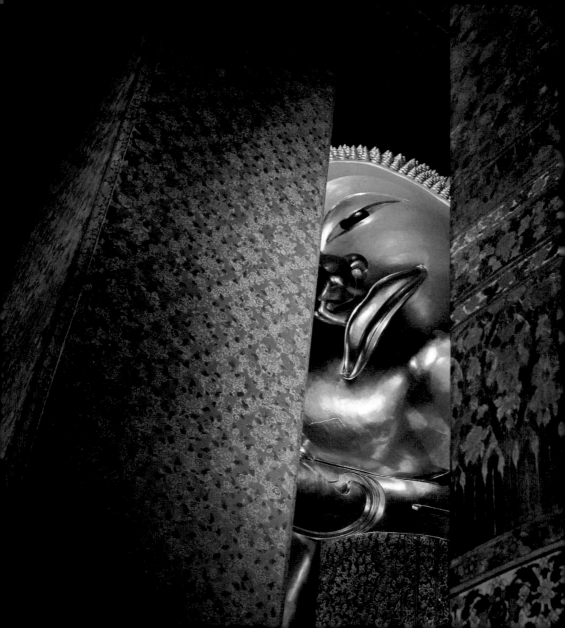

RICK WIANECKI
Bangkok, Thailand
The Buddha of Wat Pho temple
seems to peek out at visitors.

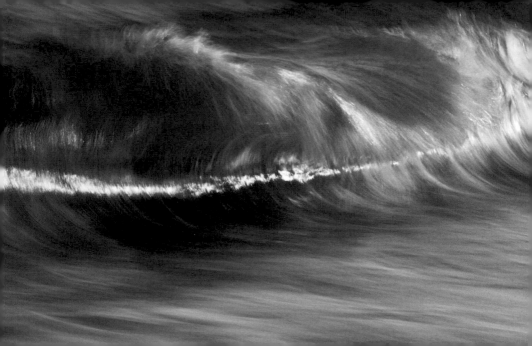

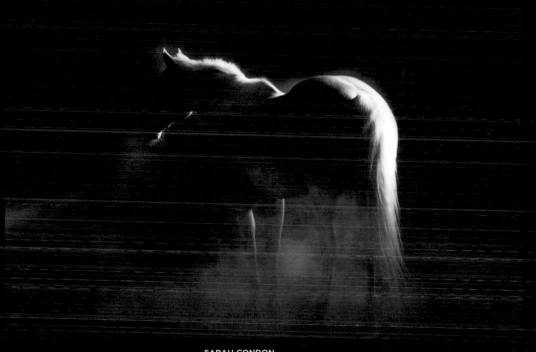

SARAH CONDON

Sennett, New York
A horse, lit by a golden light, stands
after a roll in the sand.

Opposite
MICHAEL MELFORD
Nantucket Island, Massachusetts
Sunlight reflects silver and gold on
the ocean's curling wave.

Following pages
ALEX BAIRD
Etosha National Park, Namibia, Africa
Two rhinoceroses, reflected in a pool
of water, confront each other.

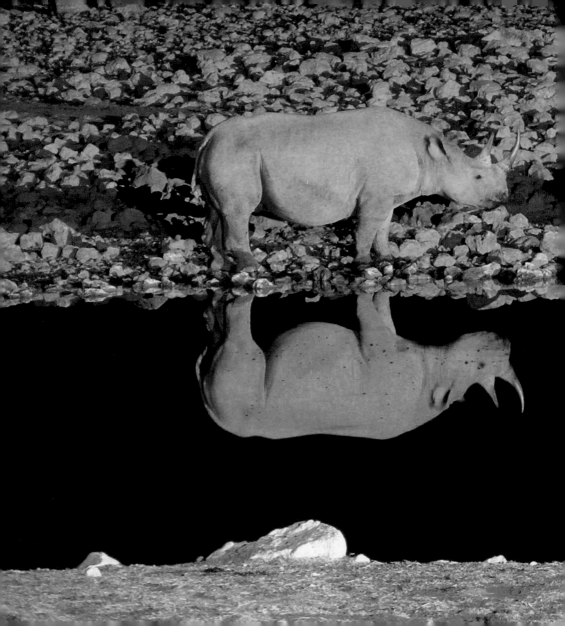

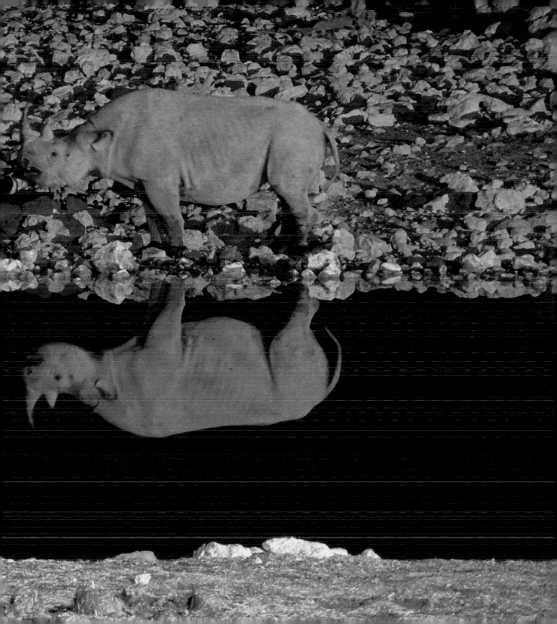

Red is loud,
red is demanding.
Red insists on being seen.
Red will not shy away,
and you cannot ignore it.

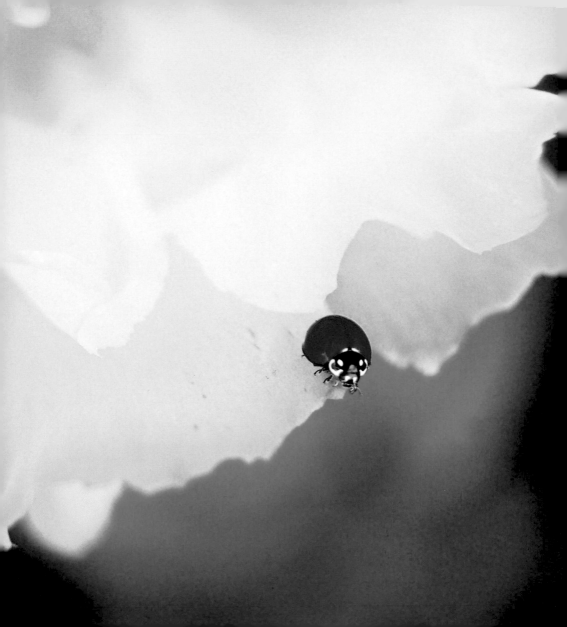

Red

When you see red, it's as if life has been cut wide open. Pure energy, the seething hot center of things. Red is loud, red is demanding. Red insists on being seen. Nature's reds allure powerfully. The hummingbird, ruby-throated jewel on the wing, darts bumblebee-like through shrubs and gardens, pausing mid-heaven to survey the possibilities, then diving intensely with the high-pitched hum of beating wings into the next nearby splash of red: the targeted blossom hiding sweet nectar. A true red in nature is a wonder to behold. The loveliest in the garden is the red, red rose. Bright red zinnias stand straight and tall all summer long. Even in autumn, when first frost turns the greens of the world temporarily brilliant, yellows, oranges, and shades of brown form the palette against which the occasional scarlet stands out, the end to which all other shades are still striving. And then each of those raucous leaves fades and falls, adding to the damp mat of black and brown under-foot. But still new reds start to ripen and hold fast in the fruits that carry on through winter, the rose hips and the holly berries. Red stops you in your tracks. When someone wears red, the garment takes the lead. Subtleties of skin and eye color fade. Quiet signs of person and complexity just peer through, barely observed, while the red shouts out and becomes the thing to notice. Loud energy, sex and blood, fire and romance—this is red. So many other colors waver across the spectrum: Blue or green? Orange or yellow? No one can doubt a red. A color so true to its nature that it can be used in signs, advertising, labels, and packaging, and it still has a heart of its own.

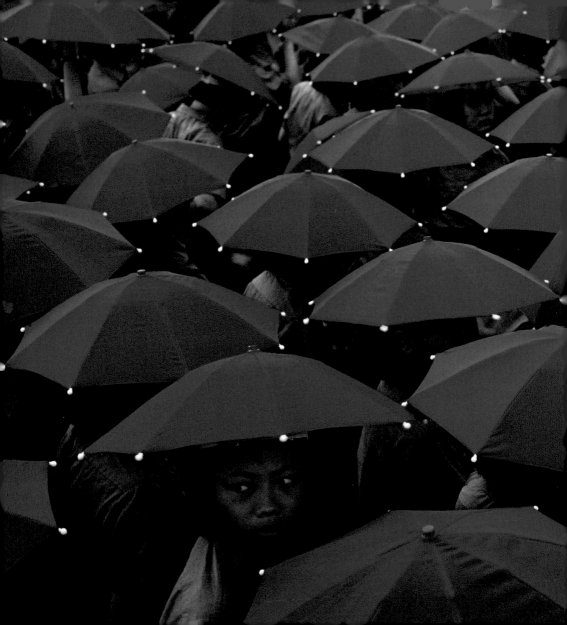

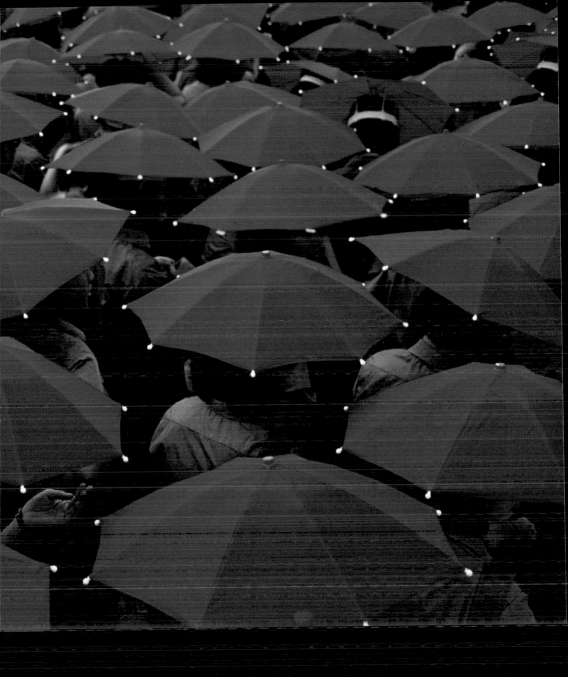

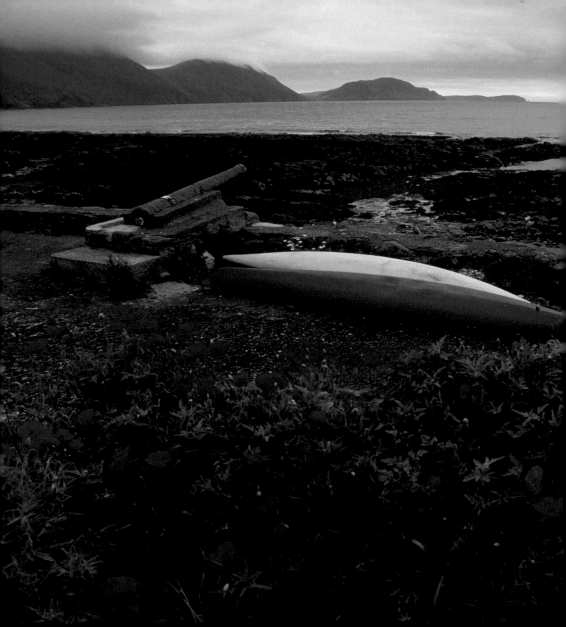

SISSE BRIMBERG

Isle of Man, United Kingdom
Red flowers and kayaks contrast
with the shoreline on a foggy day.

Preceding pages (418-21)
STEVEN STOKAN

Austin, Texas
A ladybug sits on the edge of a
prickly pear cactus's blossom.

JODI COBB

Taipei, Taiwan
Children celebrate the country's
national day with red umbrellas.

FRANKLIN PRICE KNOTT

Location and date unknown
Red silk drapes the body of a young
woman in an archival photo.

Following pages
SCOTT STULBERG

Los Angeles, California
A South Korean woman peers from
behind her red scarf.

JOSHI DANIEL

Mumbai, India
A vendor at the flower market
cradles a rose in his hands.

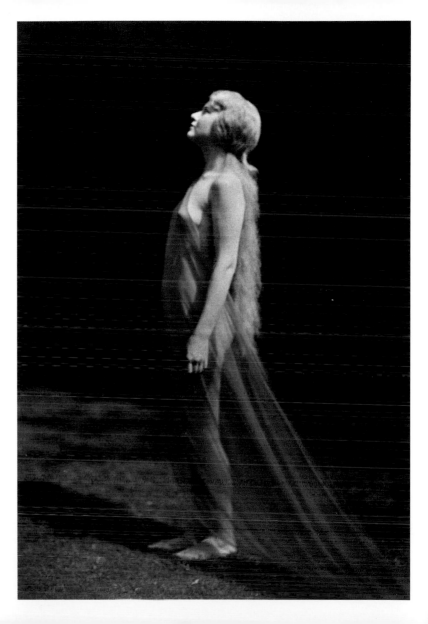

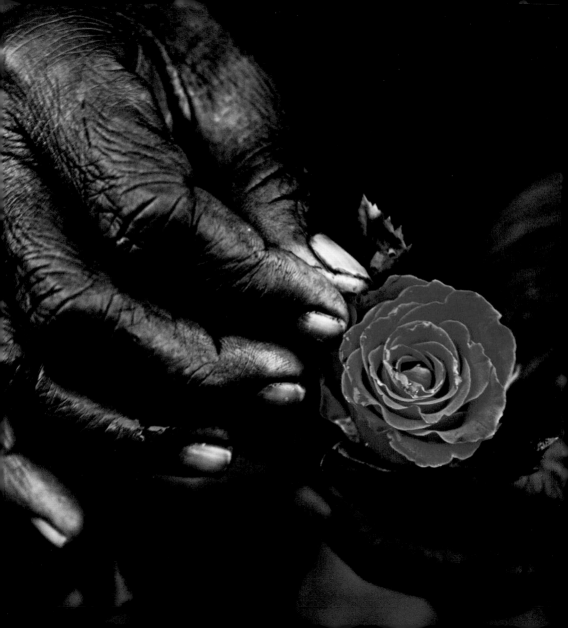

O, my luve's like a red, red rose,

That's newly sprung in June.

O, my luve's like the melodie,

That's sweetly play'd in tune.

~ ROBERT BURNS

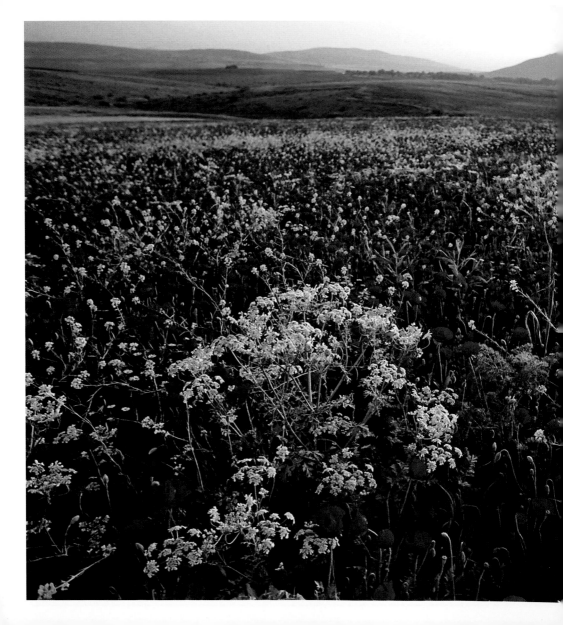

ANNIE GRIFFITHS

Galilee, Israel
Poppies bloom near Mount Tabor
during the short spring season.

JAMES P. BLAIR

Kitt Peak National Observatory,
Tucson, Arizona
A red laser illuminates imperfections
in a giant mirror at the observatory.

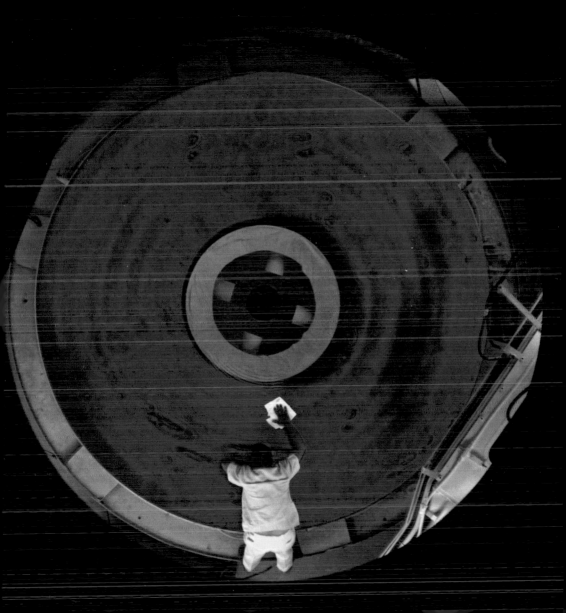

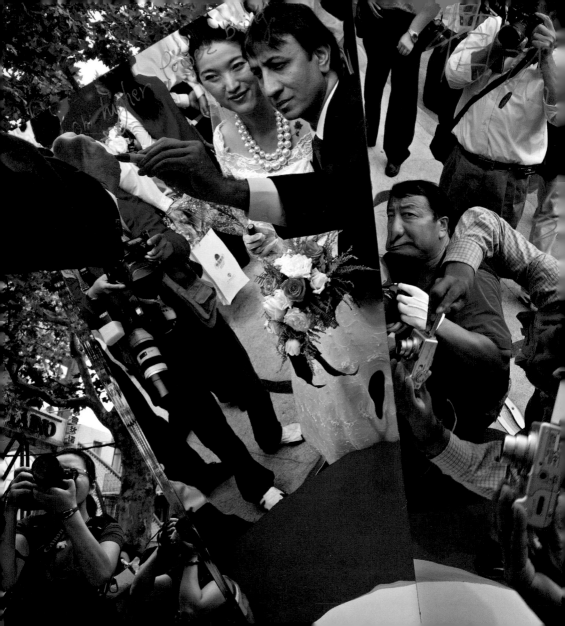

RANDY OLSON

Shanghai, China
Wedding guests sign good wishes
on a diamond-shaped mirror.

Following pages
JODI COBB

Venice, Italy
The empty Rialto market awaits
street vendors and their wares.

WENDY LONGO

Long Island, New York
Green foliage frames a red tulip on
the cusp of opening.

135

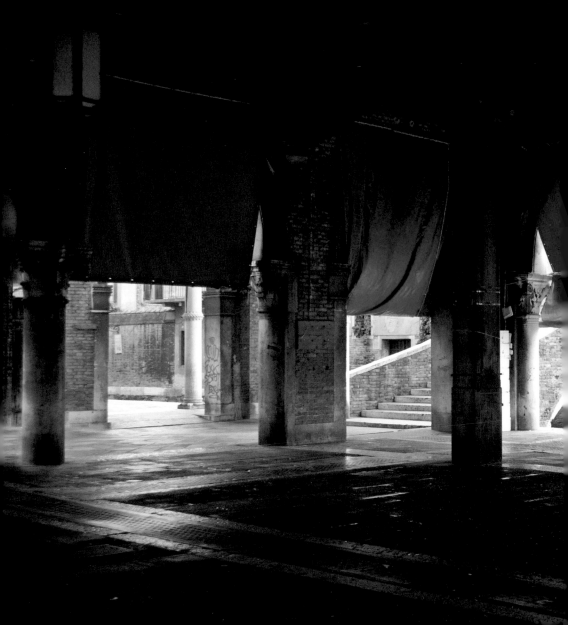

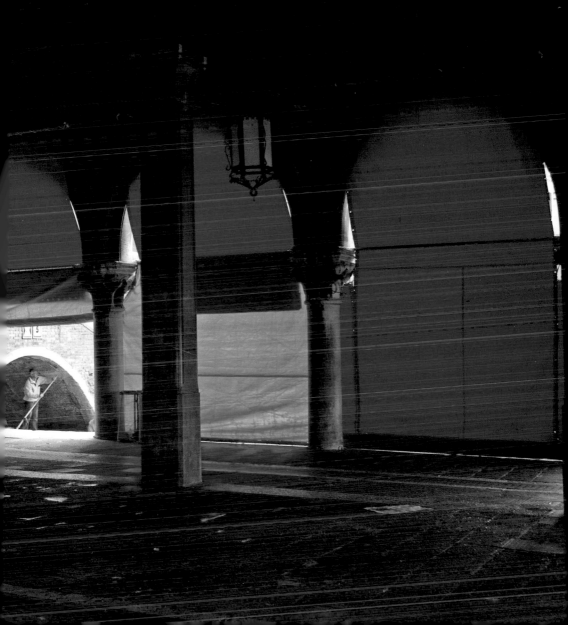

History relates many instances of

the jealousy of sovereigns

with regard to

the quality of red.

~ Johann Wolfgang von Goethe

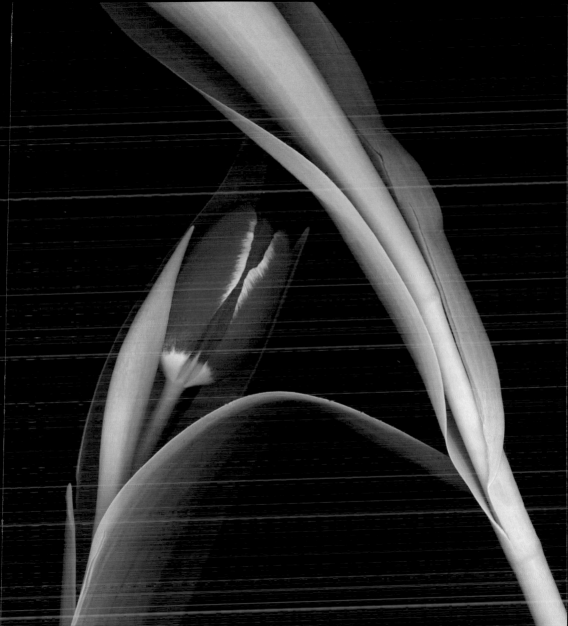

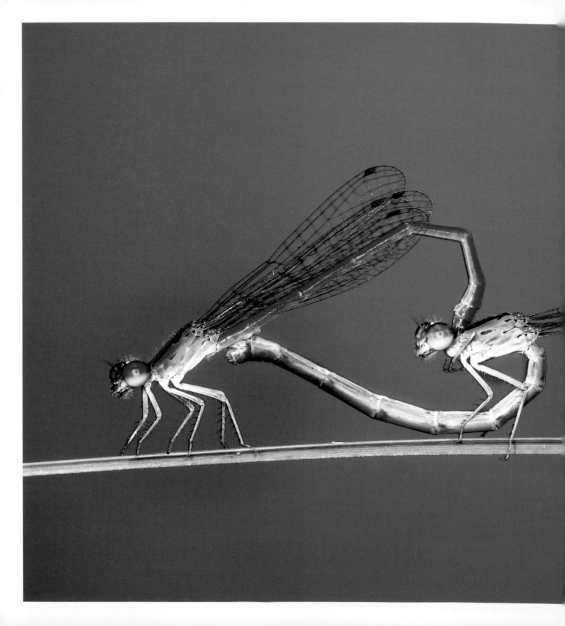

AUNDREA TAVAKKOLY

Whitsett, Texas
Damselflies mate on a blade of
grass, creating a heart shape.

Following pages
MICHAEL MELFORD

Acadia National Park, Maine
Maple leaves are ablaze with
autumn color.

CHRIS NEWBERT

Cocos Island, Costa Rica
A rosy-lipped batfish uses its fins to
walk on the ocean floor.

JODI COBB

London, England
A pedestrian is bathed in the
reflection of red lips from a
nearby billboard.

A thimbleful
of red

is redder than

a bucketful.

~ Henri Matisse

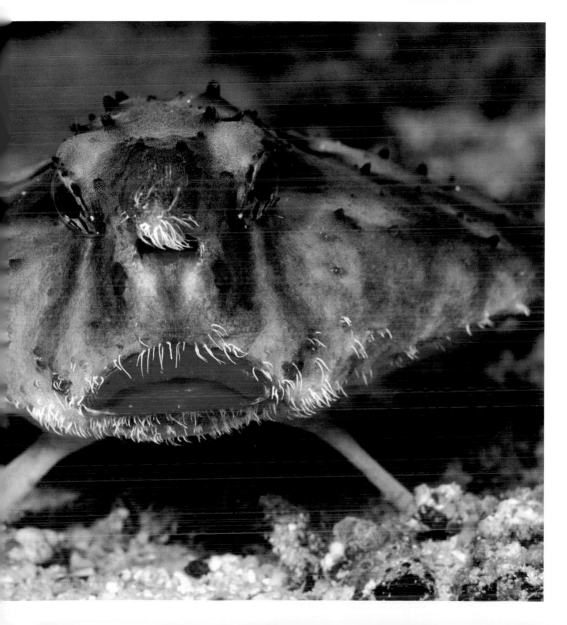

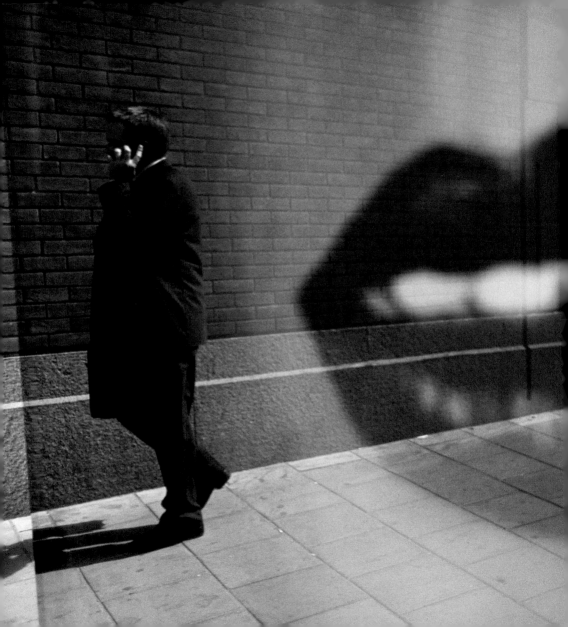

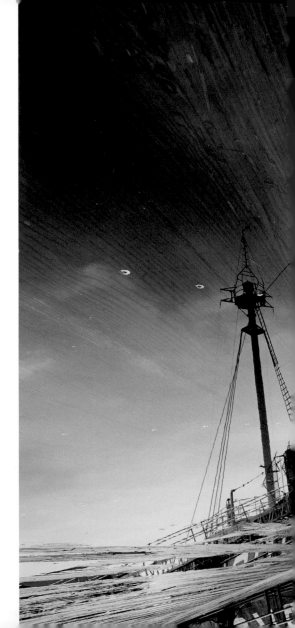

JERNEJ LASIC

New York, New York
Rain puddles on the pier reflect a
ship docked in the harbor.

Following pages
MICHAEL O'BRIEN

Broken Hill, Australia
Australian women pose before their
first lawn bowling tournament.

NARISPATH WATTHANAKASETR

East Java, Indonesia
The crater of active volcano Mount
Bromo belches smoke at sunrise.

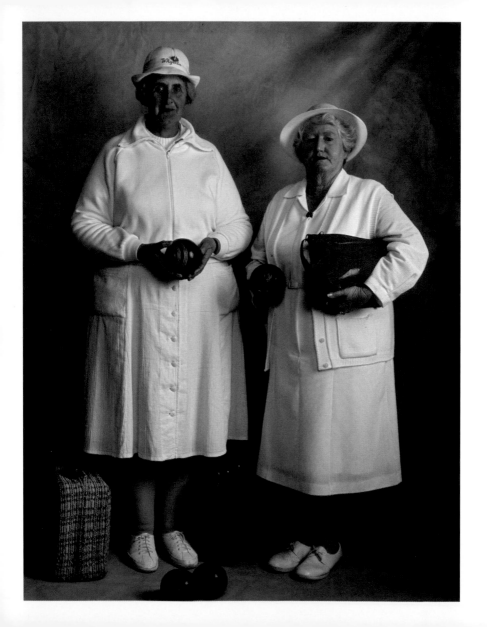

The unbounded warmth

of red has not the

irresponsible appeal of yellow,

but rings inwardly

with a determined and

powerful intensity.

~ WASSILY KANDINSKY

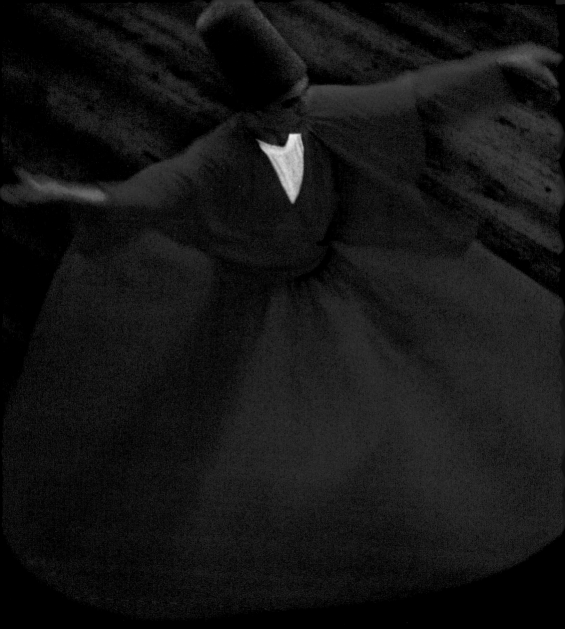

REZA

Istanbul, Turkey

A whirling dervish twirls in turns
that become increasingly dynamic.

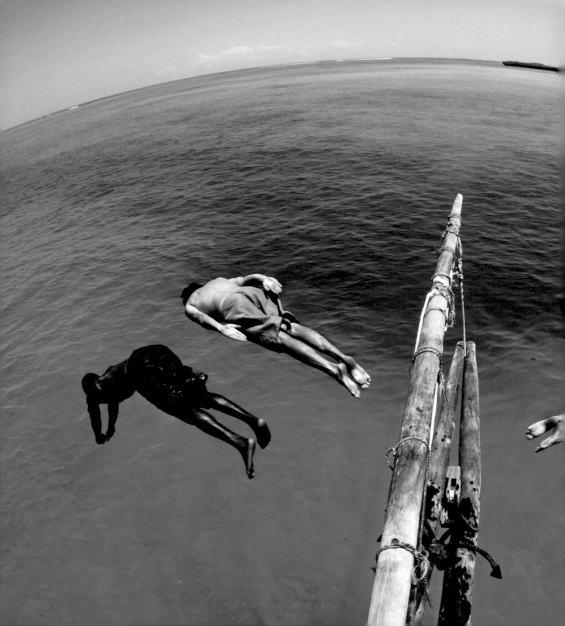

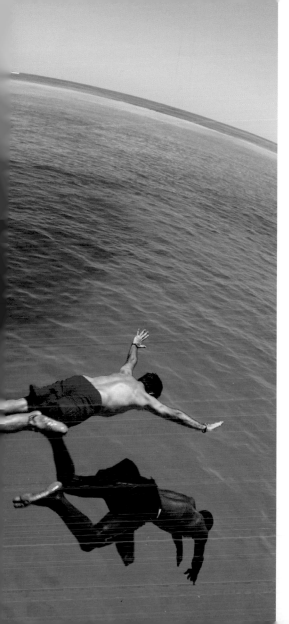

PETE MCBRIDE

Diani Beach, Kenya
Four men dive in opposite directions
into the sea.

Following pages
TIM BIEHN

Cochin, India
Red spots, sign of a Shiva devotee,
mark the face of a holy sadhu.

MEDFORD TAYLOR

Saxis, Virginia
Sea oats blow in the wind as storm
clouds gather in the distance.

I want a red to be sonorous,

to sound like a bell;

if it doesn't turn out that way,

I add more reds and other colors

until I get it.

~ Pierre-Auguste Renoir

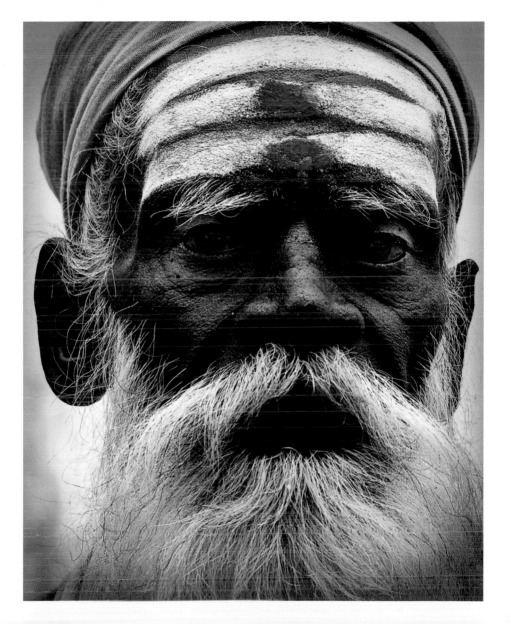

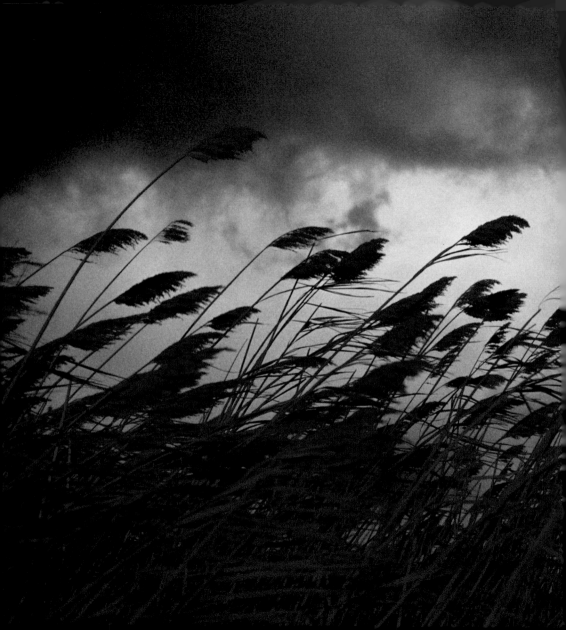

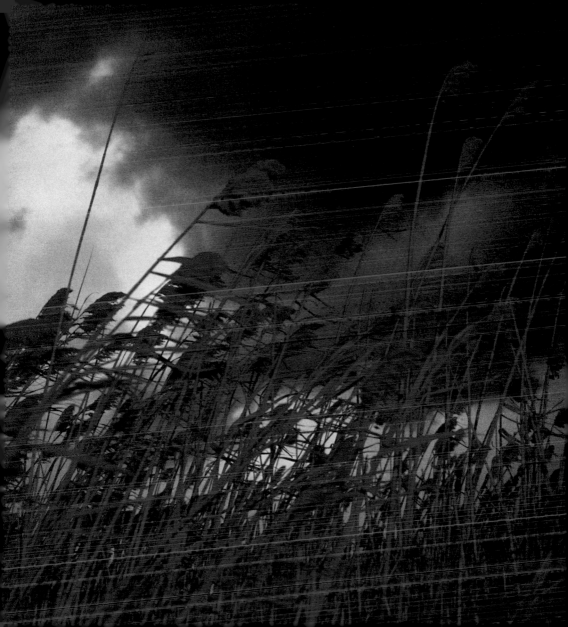

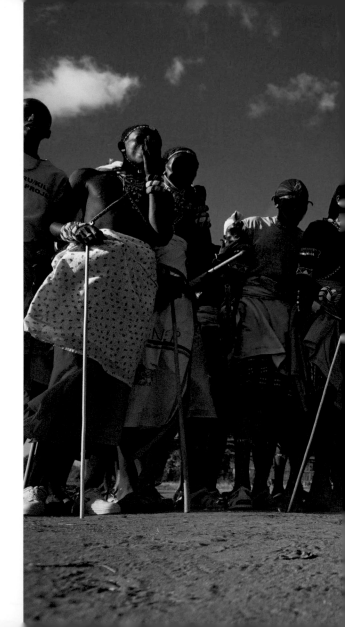

MICHAEL NICHOLS

Maralal, Kenya
Samburu tribespeople celebrate a
wedding by dancing.

Following pages
ANNIE GRIFFITHS

Badlands, North Dakota
Cars speed past a cowboy,
silhouetted against a
rock formation.

ROMONA ROBBINS

El Giza, Egypt
A stallion adorned in red gear
stands before the Great Pyramids
of Giza.

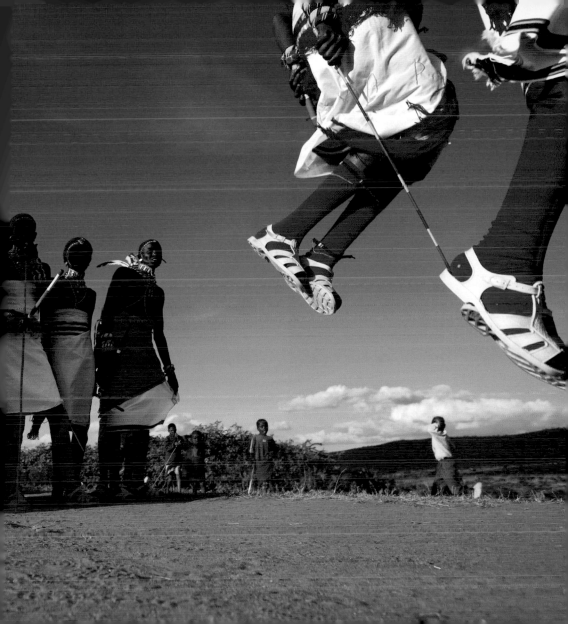

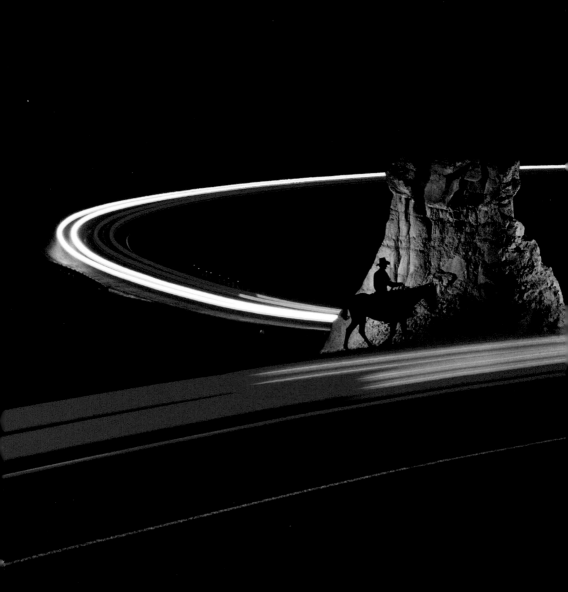

A smile that glowed

Celestial rosy red,

love's proper hue.

~ JOHN MILTON

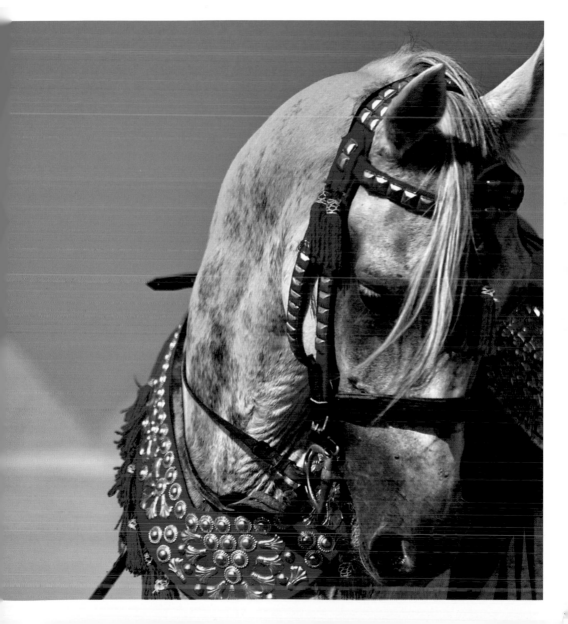

FRITZ HOFFMANN

Shenyang, China
A young bride dressed in finery
rides in a wedding festival.

GIOVANNA CEFIS

Parco della Sigurtà, Italy
A carpet of forget-me-nots is
studded with red tulips near Verona.

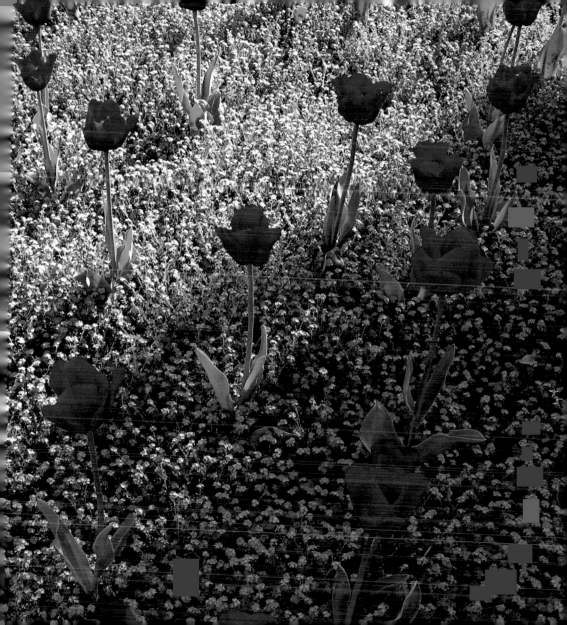

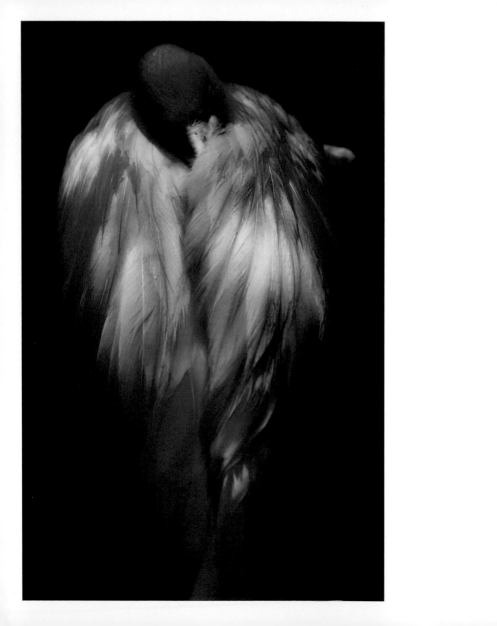

DWAYNE WATKINS

Davie, Florida
A sleeping flamingo buries its bill in
its brightly colored feathers.

OSCAR LOPEZ

San Juan, Puerto Rico
Vintage cars line a city street,
adding a sense of nostalgia to
the scene.

Following pages
BRIAN LANKER

Brooklyn, New York
Ballroom dancers perform under the
watchful eyes of judges.

ELLEN DEVENNY

Kings Mountain, North Carolina
Graceful curves of amaryllis petals
create an artistic rendering.

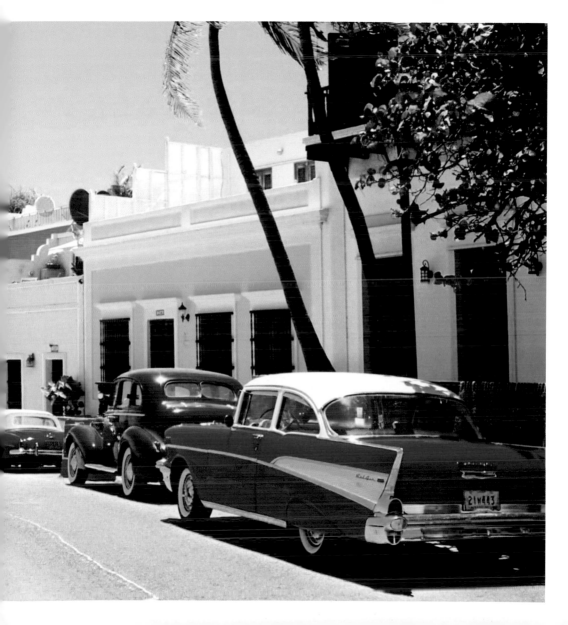

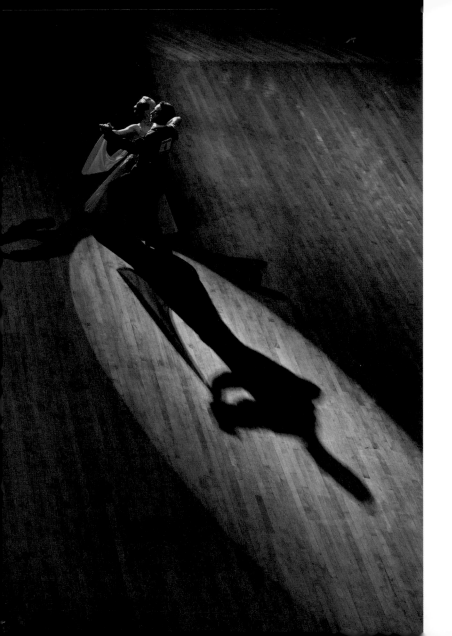

Colour is the keyboard,

the eyes are the hammers,

the soul is the piano

with many strings.

~ WASSILY KANDINSKY

ANNIE GRIFFITHS

Sydney, Australia
Fireworks explode over Sydney
Harbor at midnight.

Following pages
PETE MCBRIDE

Canyonlands National Park, Utah
A young man holds a glow-in-the-
dark Frisbee at night.

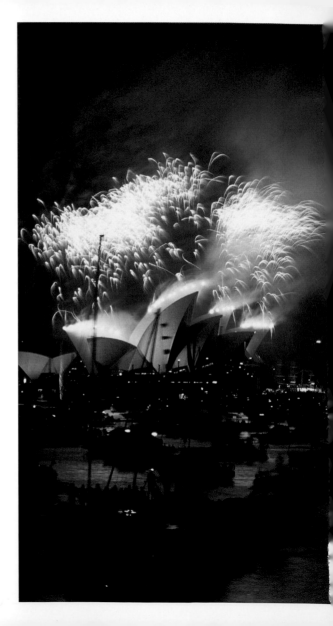

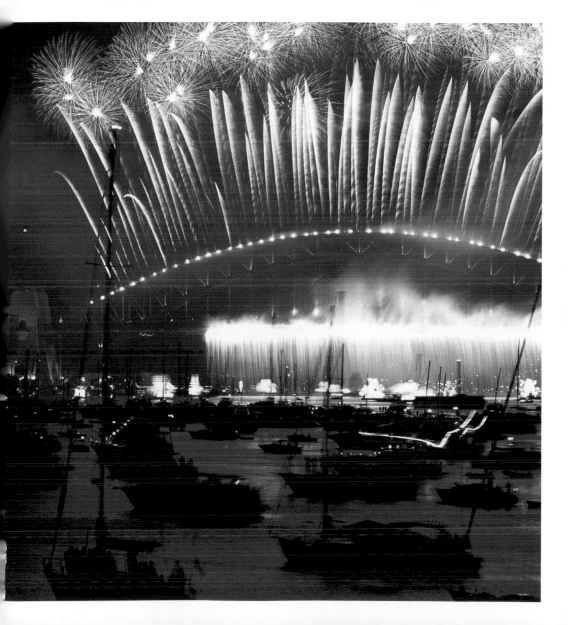

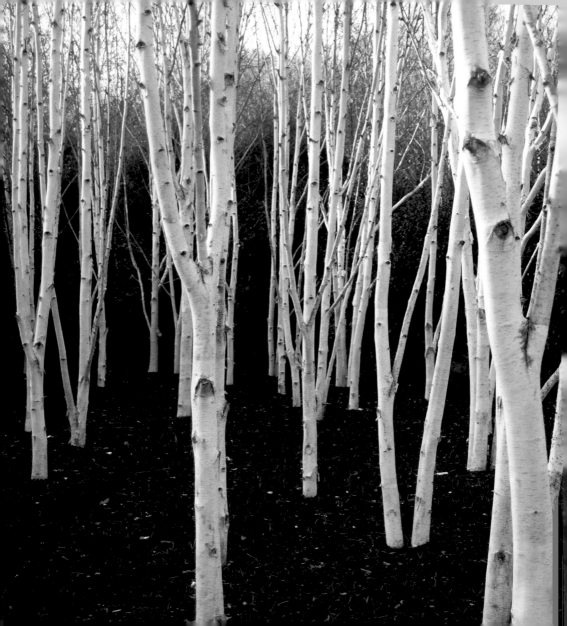

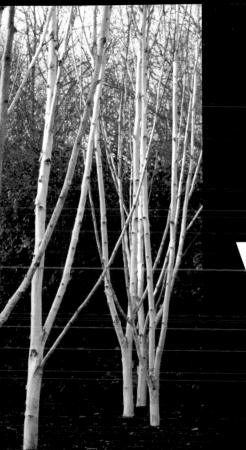

WHITE

Color of birth and beginnings; color of death and nothing-ness. Christening gowns, wedding gowns, shrouds alike: All share the pristine nature of white. ❧ White is nearly unreachable, clean and spotless, unsullied and pure. But nature can go white—in the feathers of an egret, the newness of an eggshell, thin strands of a spider's web, the barnacled forehead of an albino whale. ❧ We see white arching over-whelmingly above us in the vast Milky Way. We see white closing in upon us as we squint

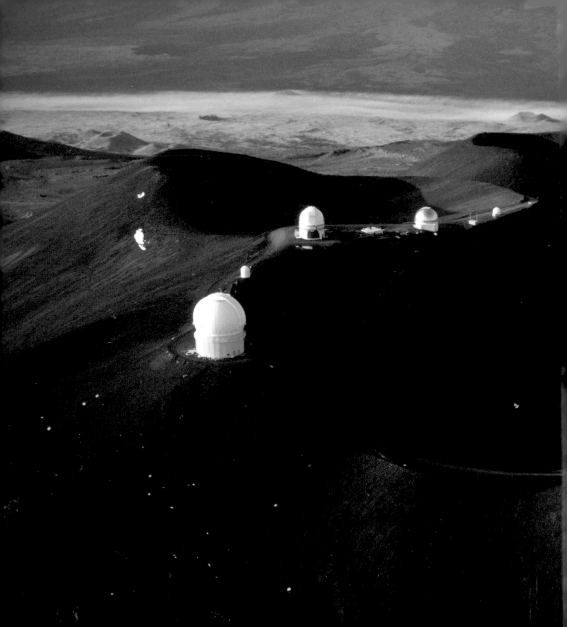

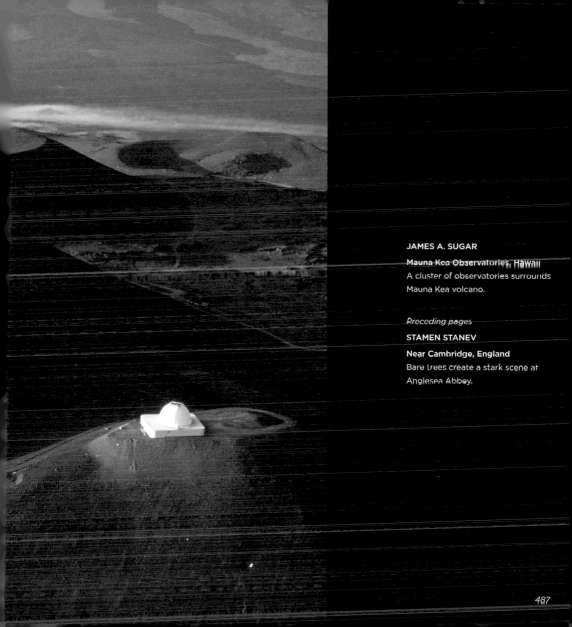

JAMES A. SUGAR
Mauna Kea Observatories, Hawaii
A cluster of observatories surrounds
Mauna Kea volcano.

Preceding pages
STAMEN STANEV

Near Cambridge, England
Bare trees create a stark scene at
Anglesea Abbey.

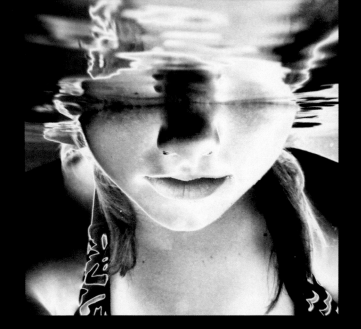

KIRK THOMPSON
Fox River Grove, Illinois
A girl makes an underwater self-
portrait, splitting her face in two.

Opposite
MACKENZIE PACKHAM

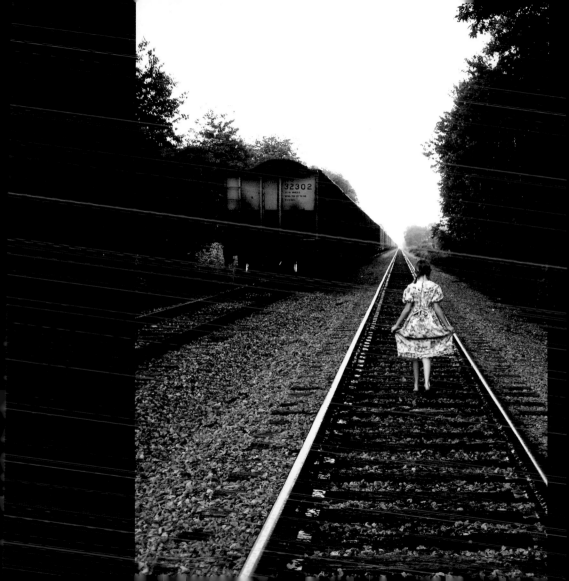

JODI COBB

Yerevan, Armenia
White laundry held with pins
dries on a clothesline.

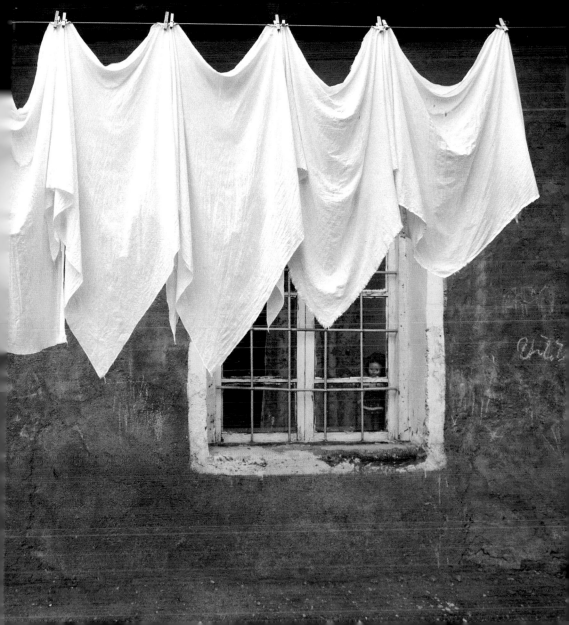

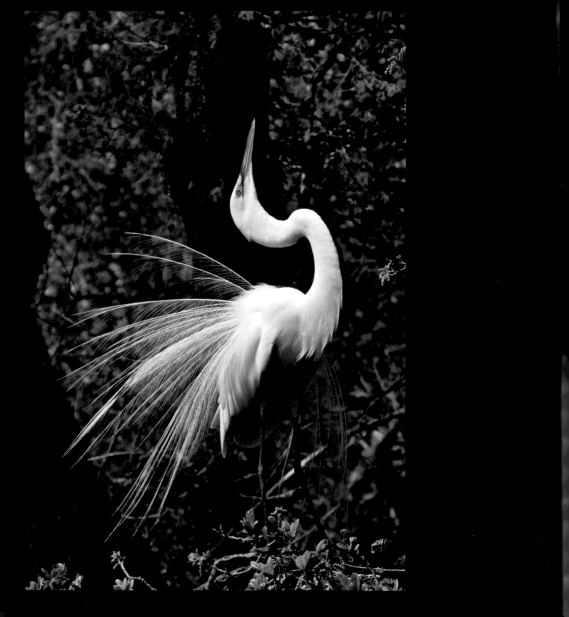

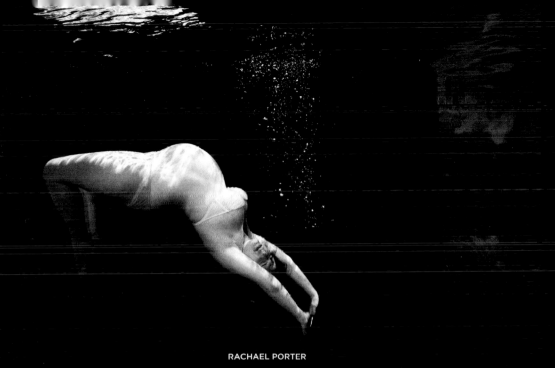

RACHAEL PORTER

Los Angeles, California
A pregnant woman makes a back
turn underwater.

Opposite
PEGGY SHERMAN

St. Augustine, Florida
An egret engages in a grand display
to impress a prospective mate.

Following pages
MICHAEL NICHOLS

Petit-Loango, Gabon Republic
A forest buffalo startles a group of
yellow-billed egrets into flight.

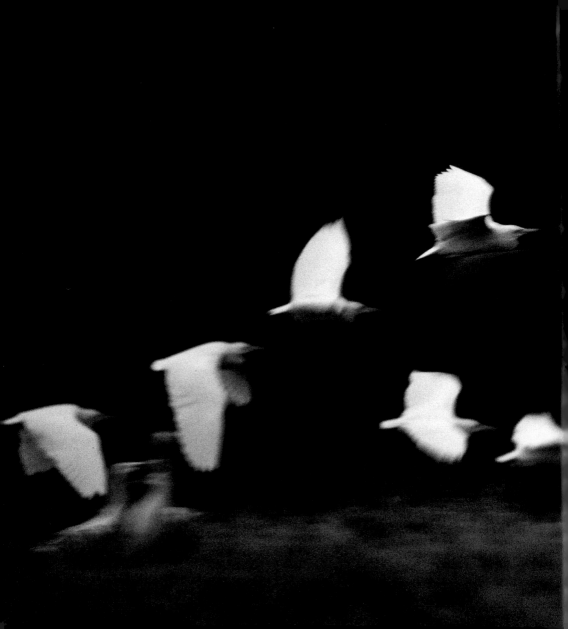

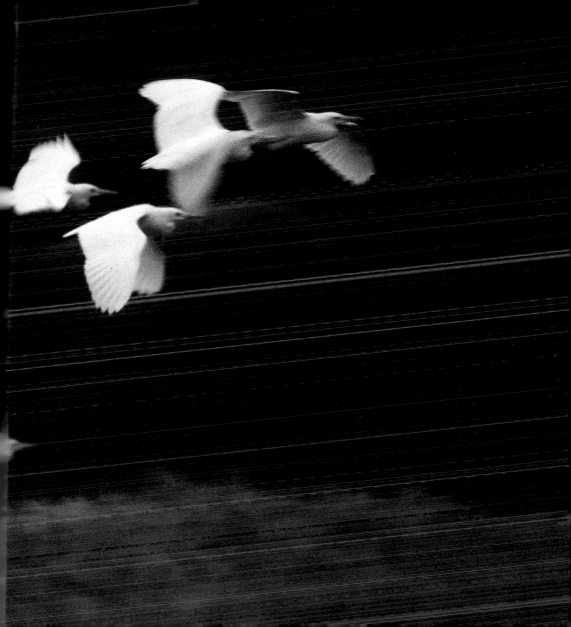

WILHELM VON GLOEDEN

Italy

A young Sicilian woman in toga-style dress poses for the German baron in 1903.

Editor's Note

On the basement level of the National Geographic Society is an unimpressive pair of doors that leads to a refrigerated room that stores the family jewels. This is where the Society's oldest and most precious photographs are kept: This is the National Geographic Image Collection. Five floors above this treasure trove, a small city of employees presides over the newer images. They catalog and caption and organize nearly 12 million images in a system that allows a photo editor to wander through more than 100 years of extraordinary images. Few things delight me more than diving in to this precious archive to find unseen images to delight our readers. For this book, I was on a quest for color. ❧ The visible color spectrum sounds simple enough: red, orange, yellow, green, blue, violet. Within these bold categories, however, lie an endless variety of shades and hues and intensities that take us on an emotional journey. Each color elicits a different response from the human brain. Cool. Hot. Soothing. Passionate. Aloof. At some point, purple becomes violet becomes pink. One shade of blue can elicit the calm of a seaside vacation. Another blue can be eerie and unsettling. Yellow drifts from light and lemony to rich and golden. ❧ No color of the spectrum stands alone. Each is emboldened or retreats in concert with the company it keeps. So a tiny red ladybug will feel more intensely red when it lights upon a yellow flower than when it chooses a green leaf. Orange with red is fiery. Orange fading to pink can be as soothing as the last breath of twilight. When multiple colors dance across the same scene, the result can be a carnival. Color is a bonus, a cherry on top of the sundae that is photography. Enjoy. ~Annie Griffiths

Images from National Geographic

Many of the images in this book are available as prints for your home or office. Use this guide to find the NG Image Number for your chosen pictures, then visit our website, *NationalGeographicArt.com,* where you can search by Image Number, find your favorites, and choose among size and framing options. While you are there, browse the many thousands of other beautiful images available from the National Geographic Image Collection.

Pages 102-3
David Burton/National
Geographic My Shot
☐ 1272729

Pages 106-7
Joel Sartore/National
Geographic Stock
☐ 1309732

Pages 108-9
Cristina Santini/
National Geographic
My Shot
☐ 1328684

Pages 110-1
Jim Richardson/
National Geographic
Stock
☐ 465877

Page 112
Sarah Leen/National
Geographic Stock
☐ 710209

Page 113
James L. Stanfield/
National Geographic
Stock
☐ 1285385

Pages 114-5
Jean Slavin/National
Geographic My Shot
☐ 1252505

Page 116
Brett Colvin/National
Geographic My Shot
☐ 1328654

Page 117
Kathrine Lloyd/National
Geographic My Shot
☐ 1399310

Pages 118-9
Avi Bender/National
Geographic My Shot
☐ 1269029

Page 122
Sean Ivester/National
Geographic My Shot
☐ 1276092

Pages 124-5
Frans Lanting/
National Geographic
Stock
☐ 1370138

Pages 126-7
Ray Chui/National
Geographic My Shot
☐ 1401364

Pages 130-1
Raymond Gehman/
National Geographic
Stock
☐ 395153

Page 135
Atanu Paul/National
Geographic My Shot
☐ 1311347

Pages 136-7
Bulent Erel/National
Geographic My Shot
☐ 1384006

Pages 138-9
Guido Tramontano
Guerritore/National
Geographic My Shot
☐ 1383005

Pages 140-1
Melissa Farlow/
National Geographic
Stock
☐ 110250

Pages 144-5
NASA
☐ 103317

Pages 148-9
Glenn Traver/National
Geographic My Shot
☐ 1249453

Pages 152-3
Pete McBride/
National Geographic
Stock
☐ 1410950

Page 154
Heli Heinonen/
National Geographic
My Shot
☐ 1384191

Pages 156-7
Joel Sartore/
National Geographic
Stock
☐ 749449

Pages 158-9
Amy White & Al
Petteway/National
Geographic Stock
☐ 1439320

Pages 164-5
Beverly Joubert/
National Geographic
Stock
☐ 1005899

Pages 166-7
Sarah Sears/
National Geographic
My Shot
☐ 1414619

Pages 168-9
Bruce Dale/National
Geographic Stock
☐ 581164

Pages 170-1
Giuliano Mangani/
National Geographic
My Shot
☐ 1328392

Page 173
Thomas J. Abercrom-
bie/National Geo-
graphic Stock
☐ 620748

Pages 174-5
Hunziker Laurent/
National Geographic
My Shot
☐ 1382399

Pages 176-7
Erik Harrison/National
Geographic My Shot
☐ 1415067

Page 178
Keith Spence/National
Geographic My Shot
☐ 1250792

Pages 180-1
Gavin Marchio/
National Geographic
My Shot
☐ 1328398

Pages 182-3
Lynn Johnson/National
Geographic Stock
☐ 1110035

Page 190
Lynn Johnson/National
Geographic Stock
☐ 1200484

Page 191
SOHO/EIT, ESA, NASA
☐ 754907

Pages 192-3
Jeffrey Chua de
Guzman/National
Geographic My Shot
☐ 1269281

Page 196
Harshal Desai/National
Geographic My Shot
☐ 1400848

Pages 198-9
Roy Samuelsen/
National Geographic
My Shot
☐ 1269293

Pages 200-1
Cheryl Molennor/
National Geographic
My Shot
☐ 1316749

Pages 202-3
Kenneth Deitcher/
National Geographic
My Shot
☐ 1252023

Pages 204-5
Manfred Kaempa/
National Geographic
My Shot
☐ 1399467

Page 206
Frans Lanting/
National Geographic
Stock
☐ 1370968

Pages 210-1
Ethan Daniels/
National Geographic
My Shot
☐ 1303398

Pages 214-5
Frans Lanting/National
Geographic Stock
☐ 1371782

Pages 216-7
Michael S. Lewis/
National Geographic
Stock
☐ 747621

Page 218
Bijitendra Mishra/
National Geographic
My Shot
☐ 1252389

Pages 220-1
J. Baylor Roberts/
National Geographic
Stock
☐ 110369

Pages 316-7
David Doubilet/National
Geographic Stock
☐ 762373

Pages 318-9
Jodi Cobb/National
Geographic Stock
☐ 997928

Pages 322-3
Mike Guzman/National
Geographic My Shot
☐ 1382936

Pages 324-5
Bill Hatcher/National
Geographic Stock
☐ 1242613

Pages 326-7
Ken Renk/National
Geographic My Shot
☐ 1399692

Pages 328-9
Ritwick Dey/National
Geographic My Shot
☐ 1328500

Pages 330-1
Christian Ziegler/
National Geographic
Image Collection
☐ 1069089

Pages 332-3
Bill Curtsinger/National
Geographic Stock
☐ 689547

Page 334
Stephen St. John/
National Geographic
Stock
☐ 1306053

Page 335
Juan Manuel Moreno/
National Geographic
My Shot
☐ 1401274

Pages 336-7
Michael Hanson/
National Geographic
Stock
☐ 1266256

Page 338
Underwood & Under-
wood/National Geo-
graphic Stock
☐ 600126

Page 339
Tony R. Wagstaff/
National Geographic
My Shot
☐ 1272667

Pages 340-1
Roberto Falck/
National Geographic
My Shot
☐ 1328343

Page 344
Gerd Ludwig/National
Geographic Image
Collection
☐ 987150

Pages 348-9
Roberto Pagani/
National Geographic
My Shot
☐ 1383087

Pages 350-1
Betty Berard Broussard/
National Geographic
My Shot
☐ 1266364

Pages 352-3
Ian Flindt/National
Geographic My Shot
☐ 1272617

Page 355
Catherine Karnow/
National Geographic
Stock
☐ 1204071

Pages 356-7
Caroline Wolden/
National Geographic
My Shot
☐ 1399361

Pages 358-9
Richard Barnden/
National Geographic
My Shot
☐ 1290512

Pages 360-1
Cristina Iacob/
National Geographic
My Shot
☐ 1252112

Page 362
NGS Archive/
National Geographic
Stock
☐ 1196184

Pages 364-5
Pete McBride/
National Geographic
Stock
☐ 1419286

Pages 366-7
Wilbur E. Garrett/
National Geographic
Stock
☐ 103111

Page 369
Amy White & Al
Petteway/National
Geographic Stock
☐ 1266051

Pages 370-1
Annie Griffiths/
National Geographic
Stock
☐ 513426

Pages 372-3
Brian Skerry/National
Geographic Stock
☐ 745661

Page 375
José Yee/National
Geographic My Shot
☐ 1313118

Pages 376-7
Greg French/National
Geogric My Shot
☐ 1252086

Page 378
Maree Toogood/
National Geographic
My Shot
☐ 1276051

Pages 380-1
Andreja Donko/National
Geographic My Shot
☐ 1251304

Page 382
Joel Sartore/National
Geographic Stock
☐ 682913

Pages 384-5
Annie Griffiths/National
Geographic Stock
☐ 404861

Page 386-7
Scott Bycroft/National
Geographic My Shot
☐ 1250879

Pages 388-9
Norbert Rosing/
National Geographic
Stock
☐ 1195645

Pages 390-1
Brett Easton/National
Geographic My Shot
☐ 1270748

Page 392
J. Baylor Roberts/
National Geographic
Stock
☐ 949714

Pages 394-5
Emanuele Picchirallo/
National Geographic
My Shot
☐ 1270631

Pages 398-9
Robert W. Madden/
National Geographic
Stock
☐ 481027

Page 400
Jodi Cobb/National
Geographic Stock
☐ 997590

Pages 402-3
Jodi Cobb/National
Geographic Stock
☐ 500522

Pages 406-7
Barb Thornton/National
Geographic My Shot
☐ 1270845

Page 409
NGS Archive/National
Geographic Stock
☐ 1196193

Pages 410-1
Rick Wianecki/National
Geographic My Shot
☐ 1399341

Page 412
Michael Melford/
National Geographic
Stock
☐ 734471

Page 413
Sarah Condon/National
Geographic My Shot
☐ 1269988

Pages 414-5
Alex Baird/National
Geographic My Shot
☐ 1316876

Page 418
Steven Stokan/National
Geographic My Shot
☐ 1328344

Pages 420-1
Jodi Cobb/National
Geographic Stock
☐ 724048

Pages 422-3
Sisse Brimberg/
National Geographic
Stock
☐ 660151

Page 425
Franklin Price Knott/
National Geographic
Stock
☐ 672633

Pages 426-7
Scott Stulberg/
National Geographic
My Shot
☐ 1328460

Page 428
Joshi Daniel/National
Geographic My Shot
☐ 1282720

Pages 430-1
Annie Griffiths/National
Geographic Stock
☐ 500767

Page 433
James P. Blair/National
Geographic Stock
☐ 1023261

Pages 434-5
Randy Olson/National
Geographic Stock
☐ 1143445

Pages 436-7
Jodi Cobb/National
Geographic Stock
☐ 1277940

Page 439
Wendy Longo/National
Geographic My Shot
☐ 1252703

Pages 440-1
Aundrea Tavakkoly/
National Geographic
My Shot
☐ 1250085

Pages 442-3
Michael Melford/National
Geographic Stock
☐ 977937

Pages 446-7
Jodi Cobb/National
Geographic Stock
☐ 657368

Pages 448-9
Jernej Lasic/National
Geographic My Shot
☐ 1383300

Pages 452-3
Narispath Watthanakas-
etr/National Geographic
My Shot
☐ 1249882

Pages 456-7
Pete McBride/National
Geographic Stock
☐ 1357137

Pages 460-1
Medford Taylor/National
Geographic Stock
☐ 394720

Pages 462-3
Michael Nichols/
National Geographic
Stock
☐ 1199435

Pages 464-5
Annie Griffiths/National
Geographic Stock
☐ 404805

Pages 466-7
Romona Robbins/
National Geographic
My Shot
☐ 1383280

Pages 470-1
Giovanna Cefis/National
Geographic My Shot
☐ 1383631

Page 472
Dwayne Watkins/
National Geographic
My Shot
☐ 1250759

Pages 474-5
Oscar Lopez/National
Geographic My Shot
☐ 1328326

Pages 478-9
Ellen Devenny/National
Geographic My Shot
☐ 1249842

Pages 480-1
Annie Griffiths/National
Geographic Stock
☐ 653717

Pages 482-3
Pete McBride/National
Geographic Stock
☐ 1394967

Pages 484-5
Stamen Stanev/National
Geographic My Shot
☐ 1250272

Pages 486-7
James A. Sugar/National
Geographic Stock
☐ 291317

Page 488
Kirk Thompson/
National Geographic
My Shot
☐ 1328907

Page 489
Mackenzie Packham/
National Geographic
My Shot
☐ 1311251

Pages 490-1
Jodi Cobb/National
Geographic Stock
☐ 689178

Page 492
Peggy Sherman/
National Geographic
My Shot
☐ 1290574

Pages 494-5
Michael Nichols/
National Geographic
Stock
☐ 684712

Page 496
Baron Wilhelm von
Gloeden/National Geo-
graphic Stock
☐ 377643

ADDITIONAL CREDITS

36-37, National Geographic Image Collection; 50-51, National Geographic Image Collection; 68-69, National Geographic My Shot; 74-75, Magnum Photos/National Geographic Image Collection; 94-95, EPA/Corbis; 104, PacificStock .com; 128, National Geographic My Shot; 132-133, National Geographic Image Collection; 142-143, Getty Images; 146-147, National Geographic My Shot; 150-151, National Geographic Image Collection; 160-161, National Geographic Stock; 163, National Geographic Stock; 184-185, National Geographic Image Collection; 186, National Geographic Image Collection; 188-189, National Geographic Image Collection; 208-209, National Geographic Stock; 213, National Geographic My Shot; 294-295, National Geographic Stock; 321, National Geographic My Shot; 346-347, National Geographic Image Collection; 397, National Geographic My Shot; 408, National Geographic Stock; 444-445, Minden Pictures/National Geographic Stock; 459, National Geographic My Shot; 476, National Geographic Image Collection; 493, National Geographic My Shot.

FURTHER READING

Victoria Finlay, *Color: A Natural History of the Palette* (Random House, 2003).

John Gage, *Color and Meaning: Art, Science, and Symbolism* (University of California Press, 1999).

Amy Butler Greenfield, *A Perfect Red: Empire, Espionage, and the Quest for the Color of Desire* (HarperCollins, 2005).

Jean-Philippe Lenclos and Dominique Lenclos, *Colors of the World: The Geography of Color* (W. W. Norton, 1999).

Alexander Theroux, *The Primary Colors: Three Essays* (Henry Holt and Co., 1994).

LIFE IN COLOR

NATIONAL GEOGRAPHIC PHOTOGRAPHS

Susan Tyler Hitchcock

PUBLISHED BY THE NATIONAL GEOGRAPHIC SOCIETY

John M. Fahey, Jr., *Chairman of the Board and Chief Executive Officer*
Timothy T. Kelly, *President*
Declan Moore, *Executive Vice President; President, Publishing and Digital Media*
Melina Gerosa Bellows, *Executive Vice President; Chief Creative Officer, Books, Kids, and Family*

PREPARED BY THE BOOK DIVISION

Hector Sierra, *Senior Vice President and General Manager*
Anne Alexander, *Senior Vice President and Editorial Director*
Jonathan Halling, *Design Director, Books and Children's Publishing*
Marianne R. Koszorus, *Design Director, Books*
Susan Tyler Hitchcock, *Senior Editor*
R. Gary Colbert, *Production Director*
Jennifer A. Thornton, *Director of Managing Editorial*
Susan S. Blair, *Director of Photography*
Meredith C. Wilcox, *Administrative Director, Illustrations*

STAFF FOR THIS BOOK

Barbara Payne, *Text Editor*
Annie Griffiths, *Illustrations Editor*
Judith Klein, *Production Editor*
Mike Horenstein, *Production Manager*
Meredith C. Wilcox, *Illustrations Specialist*
Jodie Morris, *Design Assistant*
Lori Franklin, *Image Archive Researcher*

MANUFACTURING AND QUALITY MANAGEMENT

Christopher A. Liedel, *Chief Financial Officer*
Phillip L. Schlosser, *Senior Vice President*
Chris Brown, *Vice President, NGS Book Manufacturing*
George Bounelis, *Vice President, Production Services*
Nicole Elliott, *Manager*
Rachel Faulise, *Manager*
Robert L. Barr, *Manager*

The National Geographic Society is one of the world's largest nonprofit scientific and educational organizations. Founded in 1888 to "increase and diffuse geographic knowledge," the Society works to inspire people to care about the planet. National Geographic reflects the world through its magazines, television programs, films, music and radio, books, DVDs, maps, exhibitions, live events, school publishing programs, interactive media and merchandise. *National Geographic* magazine, the Society's official journal, published in English and 33 local-language editions, is read by more than 60 million people each month. The National Geographic Channel reaches 435 million households in 37 languages in 173 countries. National Geographic Digital Media receives more than 19 million visitors a month. National Geographic has funded more than 10,000 scientific research, conservation and exploration projects and supports an education program promoting geography literacy. For more information, visit www.nationalgeographic.com.

For more information, please call 1-800-NGS LINE (647-5463) or write to the following address:

National Geographic Society
1145 17th Street N.W.
Washington, D.C. 20036-4688 U.S.A.

For information about special discounts for bulk purchases, please contact National Geographic Books Special Sales: ngspecsales@ngs.org

For rights or permissions inquiries, please contact National Geographic Books Subsidiary Rights: ngbookrights@ngs.org

ISBN 978-1-4262-1451-6

The Library of Congress has cataloged the 2012 edition as follows:

Life in color : National Geographic photographs / edited by Annie Griffiths ; text by Susan Tyler Hitchcock ; foreword by Jonathan Adler.
 p. cm.
 ISBN 978-1-4262-0962-8 (hardcover : alk. paper)
 1. Photography, Artistic. 2. Color photography.
 3. Colors--Psychological aspects. I. Belt, Annie Griffiths, 1953- II. Hitchcock, Susan Tyler. III. National Geographic Society (U.S.)
 TR655.L535 2012
 778.6--dc23
 2012011112

Printed in China
14/PPS/1